VIETNAM WAR
HELICOPTER ART

Advance Praise for *Vietnam War Helicopter Art*

"The military tradition of 'tagging' aircraft ostensibly grew from the squadron flashes painted on the fuselages of World War I airplanes. During World War II, this resulted in the common practice of pilots and crews giving their airplanes pet names with a specific, personalized meaning. While much has been done to record the evidence of this during the world wars, Brennan's volume is the first real attempt to catalog the depth and breadth of that tradition during the Vietnam era."

—R. S. Maxham, Director of the U.S. Army Aviation Museum, Fort Rucker, Alabama

"John Brennan has assembled a masterpiece."

—Hugh L. Mills Jr., C Troop, 16th Cavalry

"This is another way to pay tribute to the vets. There was nothing very glamorous in this war or about flying. It was exhausting, often frustrating, sometimes gratifying, and always dangerous work. The fact that people had the time, enthusiasm, and materials to decorate their aircraft says something about those of us who served. We produced some of the most colorful, provocative, imaginative, and artistic creations ever seen on aircraft."

—Bob Chenoweth, 4th Transportation Company/120th Assault Helicopter Company/58th Aviation Company

"Thanks for the work you're doing. I hope it makes young ones down the line realize that we flew with courage, fought like banshees, and the ones we lost died like warriors."

—Greg Monroe, 187th Assault Helicopter Company

"Thanks for taking the time to put these pages of history together for those who never made it back—and maybe some of their children who know little or nothing about this era."

—Clarence Jackson, 17th Assault Helicopter Company

"Seeing these pictures again sends chills down my back."

—David Kilborn, 147th Assault Support Helicopter Company

"We grew up on these helicopters in Vietnam. You never get over them."

—Jim Demumbreum, 57th Assault Helicopter Company

VIETNAM WAR
HELICOPTER ART

U.S. Army Rotor Aircraft

JOHN BRENNAN
Foreword by Chris Evans

STACKPOLE
BOOKS

Published by
STACKPOLE BOOKS
5067 Ritter Road
Mechanicsburg, PA 17055
www.stackpolebooks.com

Cover design by Caroline M. Stover

Front cover photo: THE EXECUTIONER (see page 75 for details)

Printed in the United States of America

10 9 8 7 6 5 4 3

Library of Congress Cataloging-in-Publication Data

Brennan, John, 1948–
 Vietnam War helicopter art : U.S. Army rotor aircraft / John Brennan ; with a foreword by Chris Evans.
 pages cm
 ISBN 978-0-8117-1031-2
 1. Military helicopters—Decoration—United States. 2. Vietnam War, 1961–1975—Art and the war. I. Title.
 UG1233.B75 2012
 959.704'348—dc23
 2012006356

CONTENTS

FOREWORD

Mention the Vietnam War and images of helicopters slashing over thick green jungle and watery brown rice paddies instantly spring to mind. What the horse was to the cavalry of the Civil War, the helicopter was to the U.S. Army in Vietnam, especially the air cavalry. Unlike World War II and Korea, the war in Vietnam ushered in the concept of "air mobility"—using helicopters to ferry troops to specific locations to engage in battle and then, the battle over, take the troops back out again. This was a far cry from the methodical march in earlier conflicts where every yard of territory was occupied as an army pushed ever forward en masse. In addition to transporting troops, the versatility of the helicopter saw it provide tactical air support, supply, reconnaissance, and—perhaps most crucial—medical evacuation of the wounded.

Much as the Stackpole Military History Series began with several World War II titles and then expanded to explore other conflicts, the Stackpole Military Photo Series now moves to the war in Southeast Asia. In addition to marking the first book in this new series of wartime photographs that isn't about World War II, *Vietnam War Helicopter Art* is also the first full-color book in the series. Since color film was widely available in the 1960s, the Vietnam War became the first in history to be significantly photographed in color.

Whether it was knights on horseback with shields emblazoned with their coat of arms or fighter and bomber pilots dedicating their planes to a girlfriend, wife, or even a cartoon character, soldiers going into battle have always found ways to personalize their weapons and vehicles. The pilots and aircrew flying helicopters in Vietnam were no different. And with the many large, flat surfaces available on rotor aircraft like the Huey, their creative talents really took flight!

The author of this book is no stranger to helicopters in war. John Brennan served a twelve-month tour in the Mekong Delta region of Vietnam in 1970–71, where he was assigned to the U.S. Army's 114th Assault Helicopter Company as a Flight Operations Coordinator. It was during his tour that he saw firsthand the varied and colorful names, cartoons, and other paintings that crews were adorning their helicopters with. He never forgot those images, and after the war, he embarked on a multi-year project to track down as many images as he could. But John didn't stop there. Wherever possible, he interviewed the crews to find out where they served, who came up with the artwork, and what it meant to them.

The following book is a meticulously researched and visually stunning collection of funny, dark, sexy, and even downright strange artwork that flew the skies of Vietnam on everything from gunships to Dustoffs and on helicopter types as varied as the AH-1 Cobra and CH-54 Flying Crane. The art served as good-luck charms, personal messages, warnings to the enemy, and a way to stand out and say, "There might be a lot of helicopters in Vietnam, but this one is mine." From the nose of a Huey wearing a very mean-looking "Thunder Chicken" to rocket pods painted up like beer cans, the creativity and skill of the men who painted these works of art are matched only by their bravery, dedication, and, above all, their loyalty and friendship to one another.

Chris Evans
Editor
Stackpole Books

INTRODUCTION

This collection of helicopter artwork represents a showcase of mostly never-before-seen images that reflect the bond between man and machine. Although now more than forty years old, these photos nonetheless offer a peek into the American character as it expressed itself in paint on metal—insightful and nostalgic, undeniably authentic and true. Ultimately, the book is a personal attempt to rectify an oversight long perpetuated by history's fickle hand and to secure some overdue recognition for those men whose creativity placed morale-building images on an otherwise green void.

For this book, nose art is considered to be any markings, including stylistically rendered aircraft names, that personalized a helicopter—in contrast to official military markings, such as unit and platoon designations. These official markings are not featured here. Nor are unit and platoon nicknames or crew names and nicknames.

Although a great deal of ground is covered, this book is an exploration of the subject, not an exhaustive study. Many inroads were made and new territory examined, yet much remains unexplained, with countless images unseen. Unfortunately, all units and all aircraft types are not represented in this volume. I relied heavily on responses from veterans, and the range of photos reflects those reponses. Furthermore, I selected photos based on clarity, quality, and content. Less than 5 percent passed muster on all three counts. Without a doubt, the best nose art images from the Vietnam War were captured on 35mm Ektachrome and Kodachrome slide film.

That these photos have survived to the present is a testament to their owners, all Vietnam veterans, each in their own way determined to document for posterity a world and reality that do not exist anymore. Someday, somewhere, someone will be grateful that a picture was taken and saved.

AH-1 COBRA

Manufactured by Bell Helicopter, the AH1-G Huey Cobra was a single-engine helicopter with two pilots—an aircraft commander and co-pilot/gunner—that provided aerial fire support with rockets, grenades, and miniguns. It served in Vietnam from 1967 to 1973, losing 279 from all causes. More than 300 named Cobras are documented, including *Duit Tuit* and *Mean Motha*.

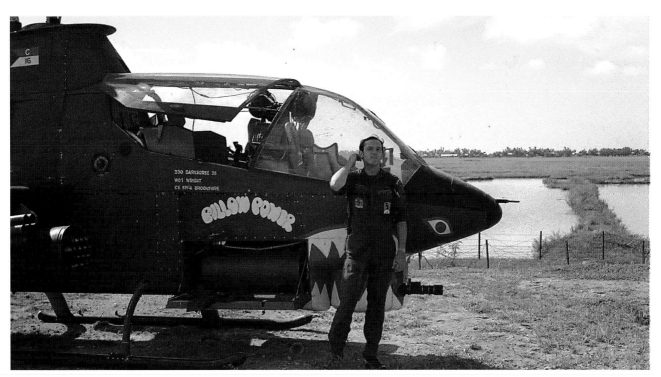

PILLOW POWER. AH-1G, 66-15330. C Troop, 16th Cavalry. Can Tho, 1972. Piloted by Dan Wright AC and maintained by Brookshire CE. Pictured is scout pilot Tim Kolberg. Named, according to Greg Thacker, because the pilot sat on a pillow to see out. Accrued 2,340 flight hours, serving in C Troop from March 1972 to January 1973. HUGH MILLS

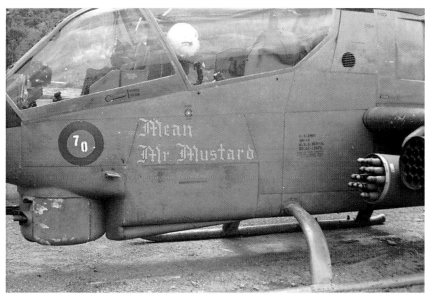

MEAN MR. MUSTARD. AH-1G, 67-15670. C Battery, 2nd Battalion, 20th Aerial Rocket Artillery. Phuoc Vinh, 1971. Fuselage art administered by Mac McMillan. Named for the 1969 Beatles tune. Accumulated 1,723 flight hours between August 1968 and June 1972. During the Battle of An Loc, this helicopter was lost to ground fire on June 20, 1972, with the loss of both pilots, Edwin Northrup and Stephen Shields. DON MATHER

1

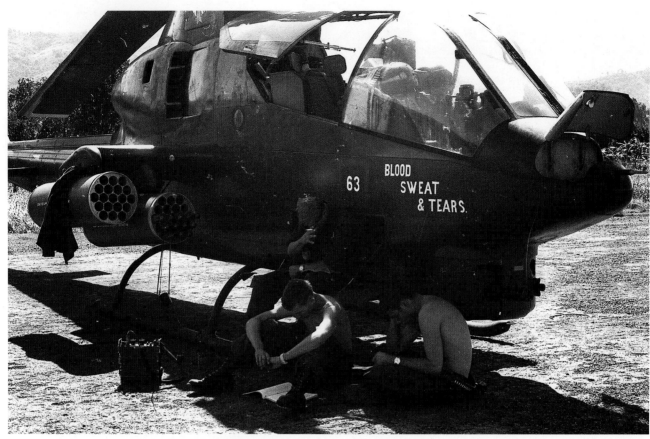

BLOOD SWEAT & TEARS. AH-1G, 68-15063. B Battery, 2nd Battalion, 20th Aerial Rocket Artillery. 1970. Maintained by Mike Cole CE. Pictured are Jim Gramke (shirtless on right) and Bill Hoffman (seated on ammo bay door); the third is unknown. Cole said the hours spent with the Cobras were "truly a lot of blood, sweat, and tears." Survived Vietnam from April 1969 to January 1972, with 2,080 flight hours, having served in B Battery from April 1969 to March 1971. PAULA HUCKLEBERRY

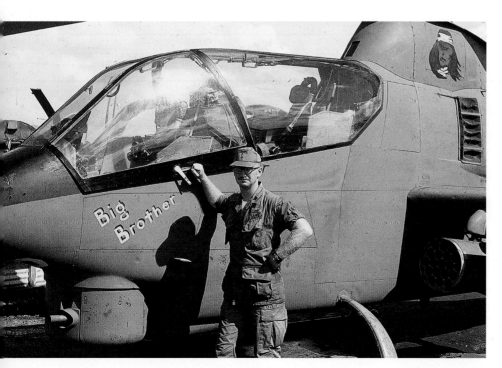

BIG BROTHER. AH-1G, 67-15457. A Troop, 7th Squadron, 1st Cavalry. Vinh Long, 1970. Unit test pilot Dave Bradley stands next to it. Maintained by Paul Cupp CE. The blue-tinted windshield made night flying challenging. Survived Vietnam from March 1968 to March 1973, with 3,027 flight hours, having served with A Troop from March 1968 to October 1970. DAVE BRADLEY

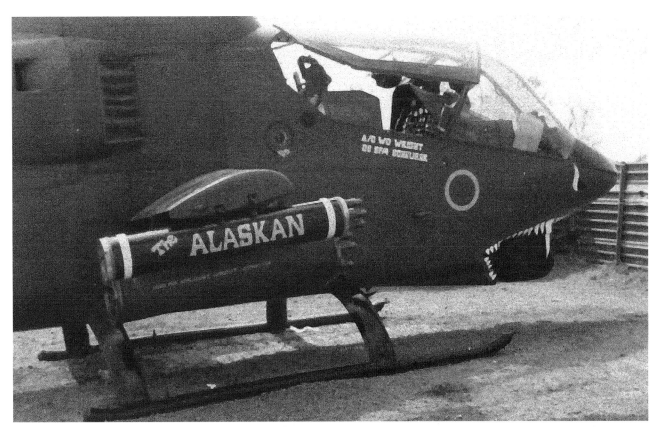

THE ALASKAN. AH-1G, 67-15752. C Troop, 1st Squadron, 9th Cavalry. Phuoc Vinh, summer 1969. Piloted by Grover Wright AC and maintained by Ed Scheurer CE. Rocket launcher artwork by Wright. Wright was a graduate of West Anchorage High School in Alaska and was the first to paint shark teeth in C Troop. Accumulated 1,739 flight hours between December 1968 and October 1971, serving with C Troop from December 1968 to March 1971. Crashed on October 22, 1971, as part of a different unit, killing both pilots. GROVER WRIGHT

WE THE PEOPLE. AH-1G, 68-15067. 11th Armored Cavalry Regiment. III Corps, 1971. Named for the first three words of the U.S. Constitution. One of eleven individually named Cobra gunships in the 11th during this period that displayed similar balloon lettering on the fuselage. Survived Vietnam from April 1969 to February 1972, amassing 2,146 flight hours exclusively with the 11th.
FRANK DILLON

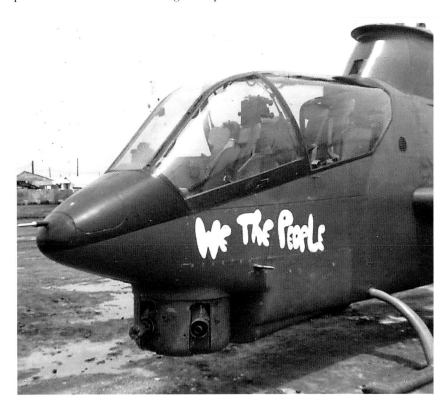

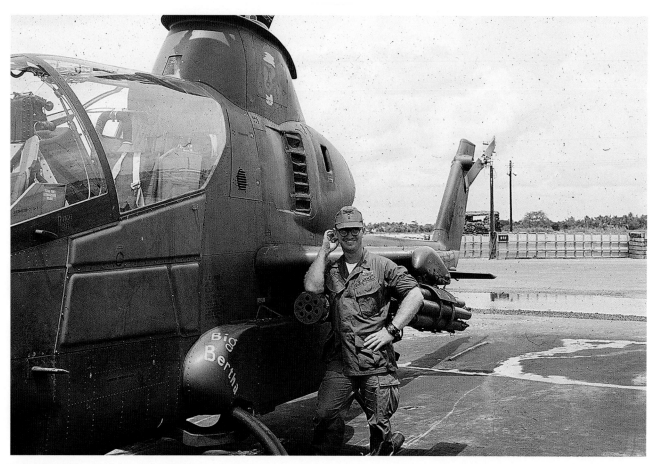

BIG BERTHA. AH-1G, 69-16422. A Troop, 7th Squadron, 1st Cavalry. Vinh Long, 1970. Piloted by Rob Nelson AC and maintained by Paul Cupp CE. Pictured is Dave Bradley, the only pilot in A Troop to wear fatigues while flying because of an allergic reaction to the official Nomex flight uniform. Nelson loved this Cobra: "I could slug it out with the .51-cal antiaircraft we were encountering." Survived Vietnam from June 1970 to February 1972, with 1,416 flight hours, having served in A Troop from June to December 1970. DAVE BRADLEY

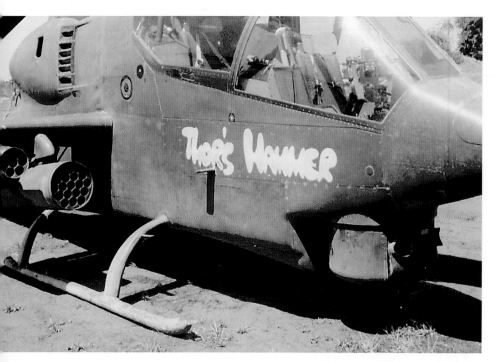

THOR'S HAMMER. AH-1G. 11th Armored Cavalry Regiment. Xuan Loc, III Corps, November 1968. Thor is the Norse thunder god said to create lightning with his hammer. One of eleven individually named Cobra gunships in the 11th during this period that displayed similar balloon lettering on the fuselage. GRADY STOGNER

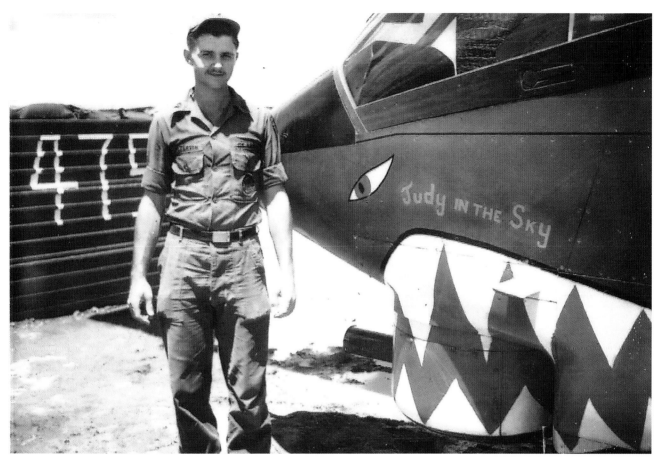

JUDY IN THE SKY. AH-1G, 67-15475. C Troop, 7th Squadron, 1st Cavalry. Vinh Long, 1968. Piloted by Rob Bailey AC and maintained by Mike Peterson CE (pictured). Gunship name is a parody of the 1967 hit tune "Judy in Disguise (With Glasses)" by John Fred and His Playboy Band. This helicopter had two names: JUDY IN THE SKY, Peterson's preference, on the left side and MAR, Bailey's preference, on the right. Accumulated 3,127 flight hours from March 1968 to December 1971, exclusively in C Troop. MIKE PETERSON

SPECKLED PECKER. AH-1G, 67-15842. 114th Assault Helicopter Company. Vinh Long, April 1971. Piloted by Jeff Cox AC (pictured) and maintained by Ron Mull CE. Artwork by Oscar from Vinh Long village. This 3rd Platoon gunship with the double-entendre name survived Vietnam from February 1969 to February 1972, accumulating 1,122 flight hours, having served in the 114th from September 1970 to February 1972. The red markings at the left of the photo are Viet Cong flags, each denoting ten KIAs. "Business was still good in the Delta in 1971," says Cox. JEFF COX

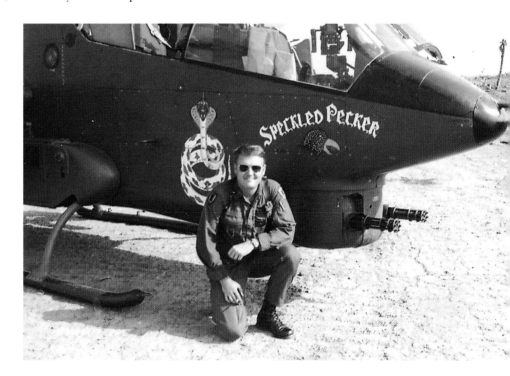

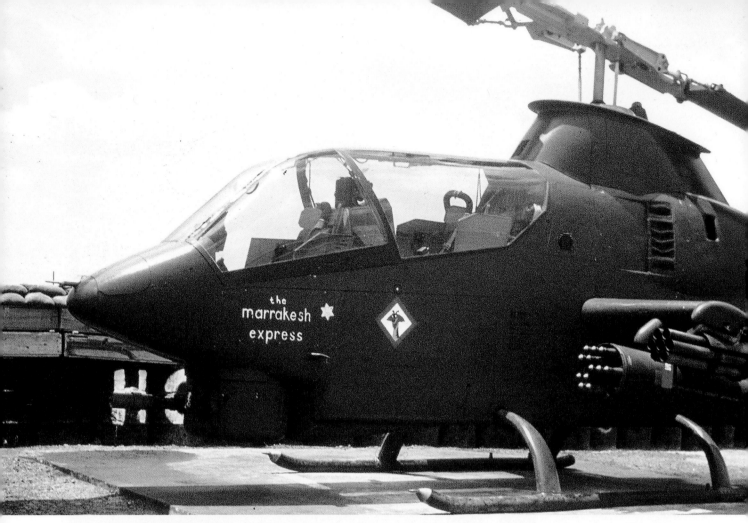

THE MARRAKESH EXPRESS. AH-1G. D Company, 229th Assault Helicopter Battalion. Quan Loi, 1970. Name derived from the 1969 song by Crosby, Stills, and Nash. The Smiling Tiger graphic was created by the Walt Disney Studios in 1967 expressly for D Company's gunships. U.S. ARMY AVIATION MUSEUM

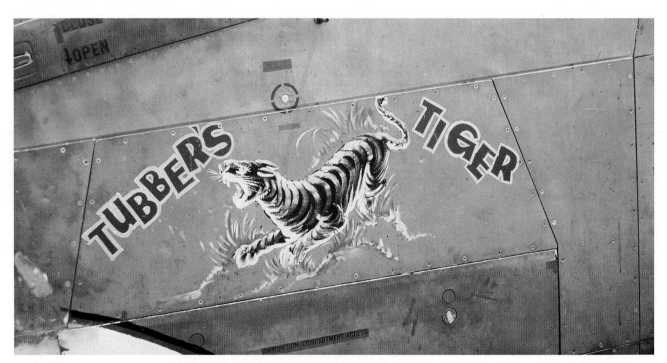

TUBBER'S TIGER. AH-1G, 67-15758. C Troop, 16th Cavalry. Can Tho, 1971. Piloted by Wayne Burk AC. Named after Burk's wife, whose nickname was "Tubs." This is the second incarnation of this name on a C Troop gunship. The first one, 67-15798, was shot down on March 21, 1971. LENNART LUNDH

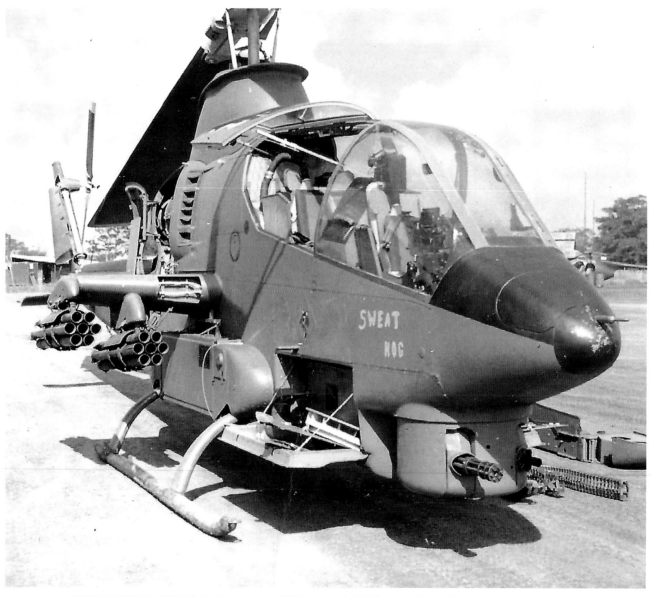

SWEAT HOG. AH-1G. D Company, 229th Assault Helicopter Battalion. Quan Loi, 1970.
Maintained by Bill Walton CE. BILL WALTON

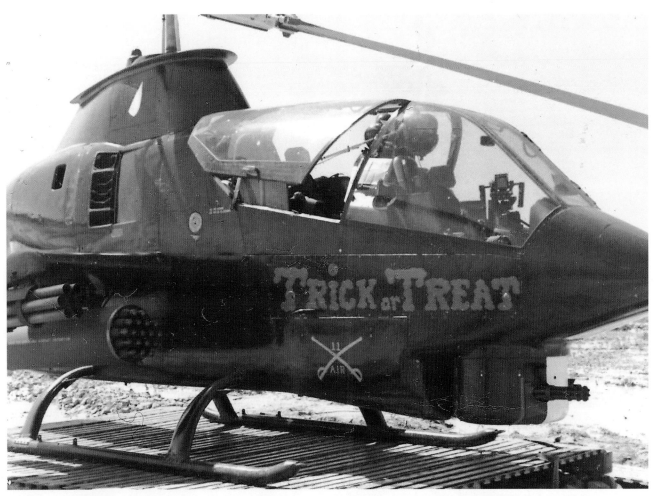

TRICK OR TREAT. AH-1G, 68-15122. 11th Armored Cavalry Regiment. Tay Ninh, 1970. Survived Vietnam from June 1969 to February 1972, accumulating 1,983 flight hours, having served exclusively with the 11th. WILLIAM POWIS

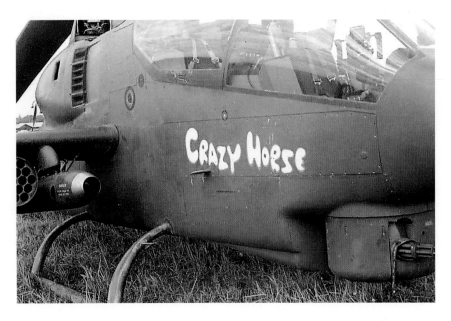

CRAZY HORSE. AH-1G. 11th Armored Cavalry Regiment. Tay Ninh, November 1969. One of eleven individually named Cobra gunships in the 11th during this period that displayed similar balloon lettering on the fuselage. GRADY STOGNER

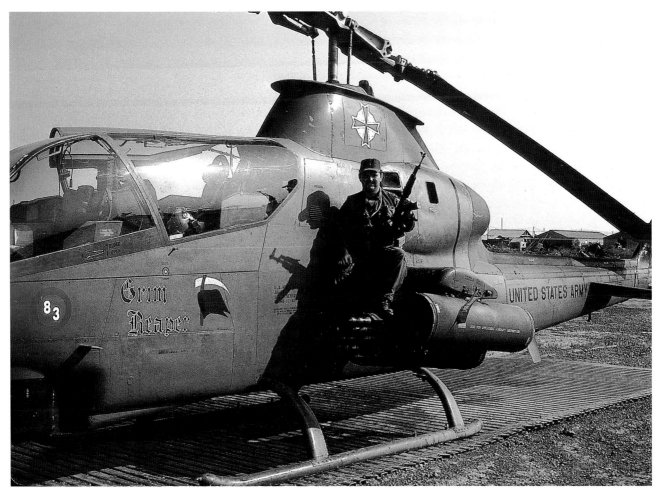

GRIM REAPER. AH-1G, 68-15183. C Battery, 2nd Battalion, 20th Aerial Rocket Artillery. Phuoc Vinh, 1971. Piloted by Neil "Mac" McMillan (pictured) and maintained by "Axe" Knowlton CE. Survived Vietnam from June 1969 to February 1973, with 2,139 flight hours, having served in C Battery (redesignated F Battery, 79th, in June 1971) from November 1970 to February 1972. Fuselage artwork rendered by McMillan. NEIL MCMILLAN

HAVE GUN WILL TRAVEL. AH-1G. 11th Armored Cavalry Regiment. Tay Ninh, November 1969. Named after a television Western and a "for hire" gunman. One of eleven individually named Cobra gunships in the 11th during this period that displayed similar balloon lettering on the fuselage. GRADY STOGNER

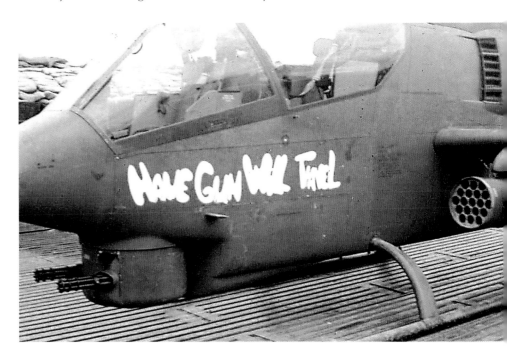

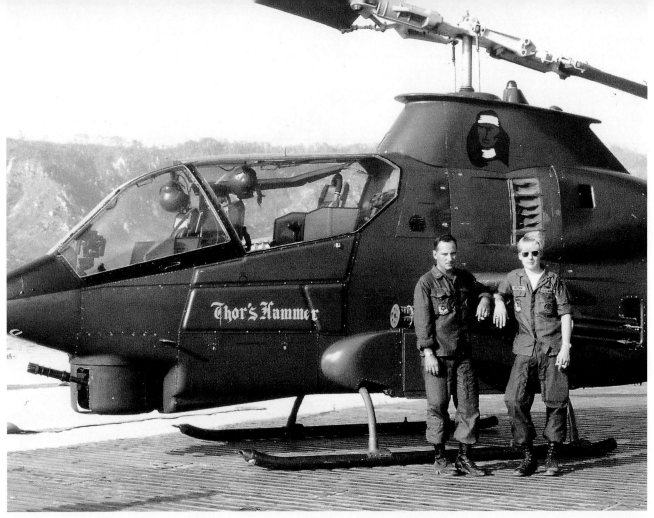

THOR'S HAMMER. AH-1G, 67-15536. A Troop, 7th Squadron, 1st Cavalry. Tri Ton, IV Corps, March 1971. Piloted by John Cattilini AC (left), Bruce Bottger CP/Gunner (right), and maintained by Lunquist CE. Cattilini is credited as the originator of the name and artwork. Survived Vietnam from August 1968 to February 1972, accumulating 2,385 flight hours, having served in A Troop from August 1970 to February 1972. JOHN CATTILINI

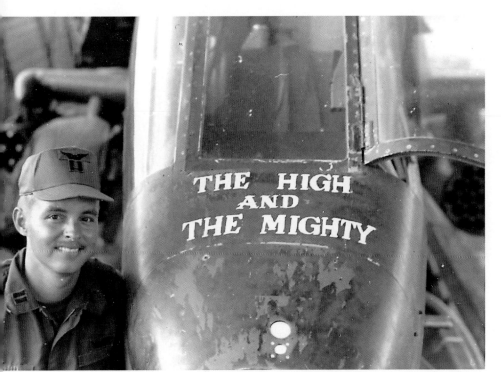

THE HIGH AND THE MIGHTY. AH-1G, 67-15868. 187th Assault Helicopter Company. Tay Ninh, 1970. Piloted by Rick Renaud AC (pictured). Name based on a 1952 aviation novel by Ernest K. Gann and the 1954 film starring John Wayne. Served entirely in the 187th from February 1969 to September 1970, compiling 1,358 flight hours. Loss to inventory on September 6, 1970. RICK RENAUD

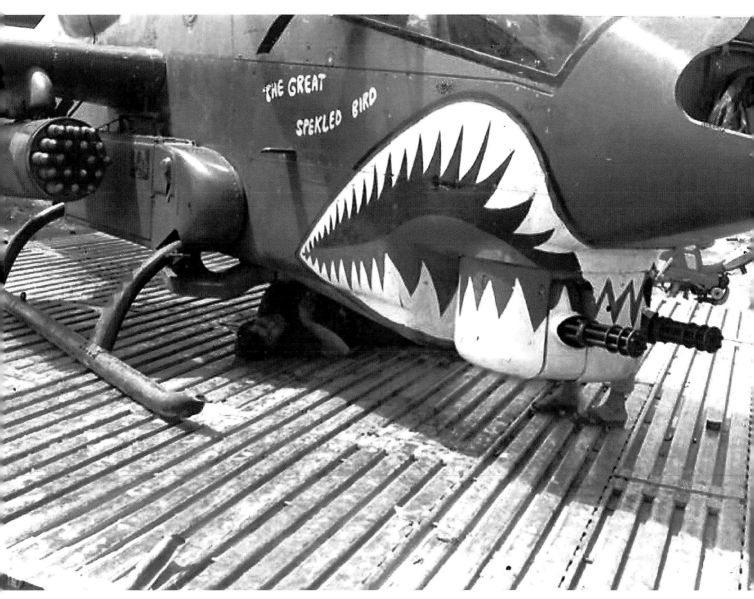

THE GREAT SPEKLED BIRD. AH-1G, 67-15798. C Troop, 16th Cavalry. Can Tho, 1971.
Piloted by George Hawkins AC and maintained by Jack Vick CE. Accumulated 1,251 flight
hours from December 1968 to March 1971, including a short stint with C Troop from
October 1970 to March 1971. Loss to inventory on March 21, 1971. JACK VICK

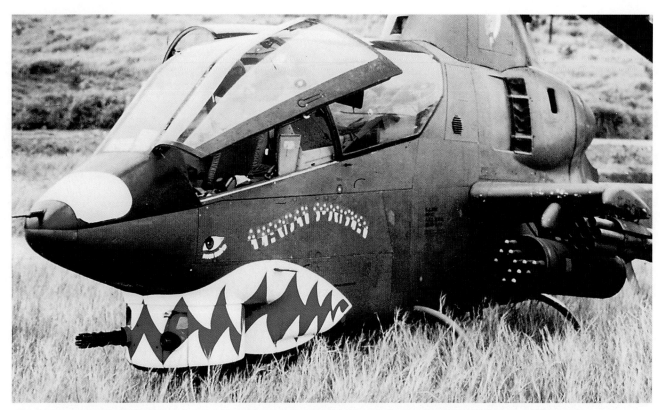

AMERICAN SPORTSMEN. AH-1G, 68-15166. C Troop, 7th Squadron, 1st Cavalry. IV Corps, 1971. Piloted by James Drury AC and Dayne Smith CP. A popular American hunting magazine shares this name. Artwork by local Vinh Long artist. Survived Vietnam from September 1969 to January 1973, with 1,898 flight hours, having served in C Troop from January 1971 to November 1971. ALLEN BILLS

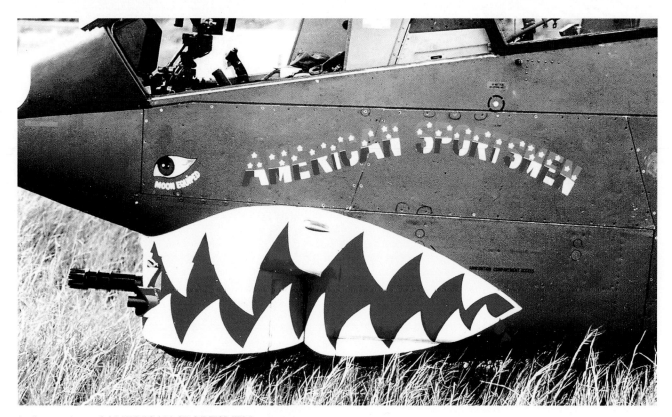

A closer view of AMERICAN SPORTSMEN. ALLEN BILLS

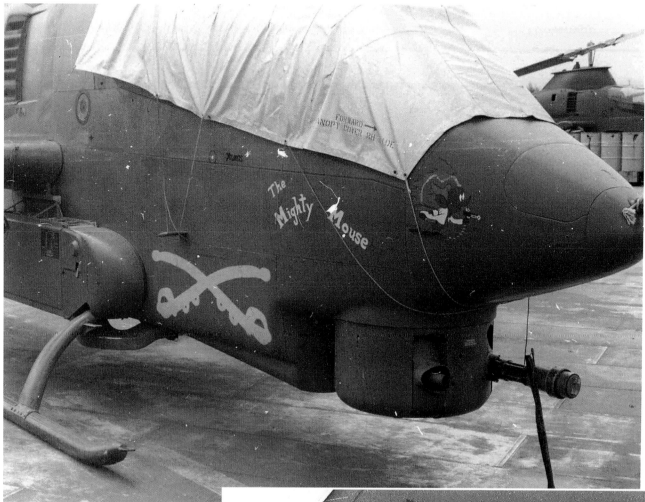

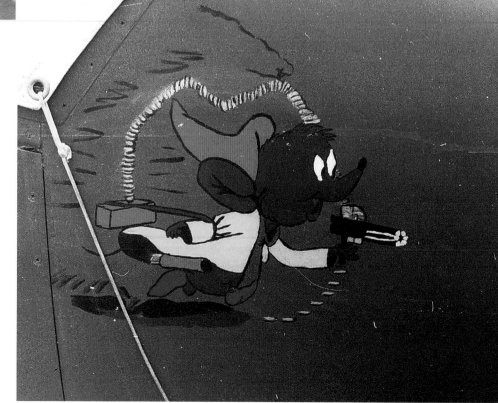

THE MIGHTY MOUSE. AH-1G, 68-17078. D Troop, 1st Squadron, 1st Cavalry. Chu Lai, 1970. Piloted by Nick Lappos AC and maintained by Gary Kane CE. Named after the animated superhero. Survived Vietnam from March 1970 to February 1973, with 1,906 flight hours, having served in D Troop from March 1970 to June 1972.

RUSS ELDERBAUM VIA MIKE GUSTIN

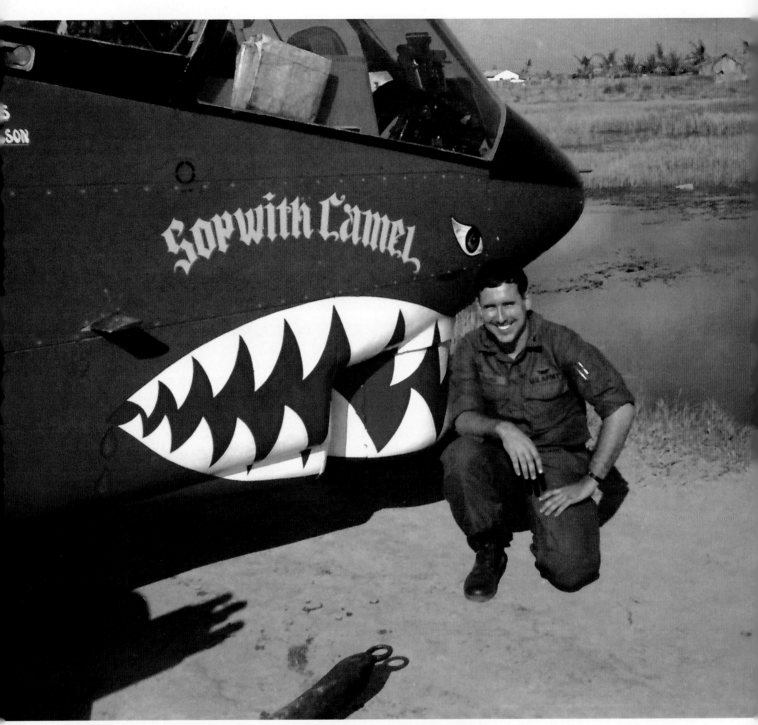

SOPWITH CAMEL. AH-1G, 66-15294. C Troop, 7th Squadron, 1st Cavalry. Vinh Long, 1970. Piloted by Allen Bills AC, Rick Holder CP/Gunner (pictured), and maintained by J. W. Johnson CE. A small Snoopy graphic and Comanche headdress were also painted on the doghouse rotor housing. The Sopwith Camel, a World War I biplane, was Snoopy's preferred aircraft for pursuing the dastardly Red Baron. Accumulated 1,247 flight hours from February 1968 to February 1971, serving in C Troop from October 1970 to February 1971. Loss to inventory on February 9, 1971. RICK HOLDER

Another look at SOPWITH CAMEL. ALLEN BILLS

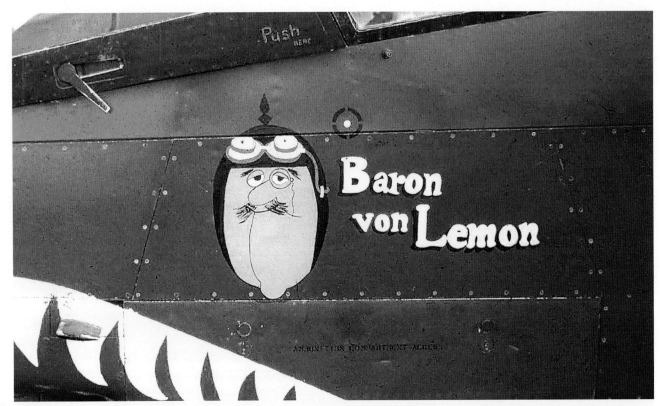

BARON VON LEMON. AH-1G. D Troop, 1st Squadron, 4th Cavalry. Phu Loi, 1969. Named after a cartoon character, here replicated on the aircraft fuselage, created by the Pillsbury Company in 1967 to promote a powdered drink of the same name. TOM MIKULSKI

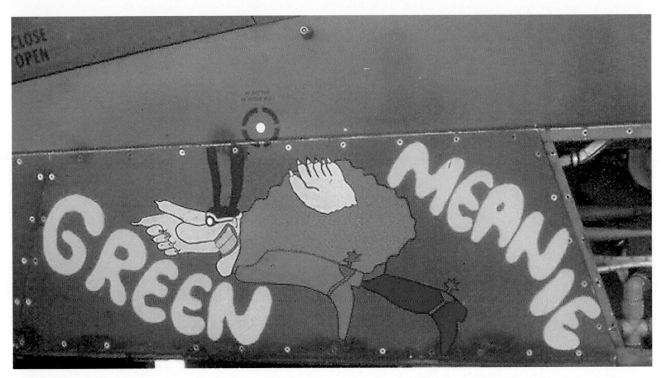

GREEN MEANIE. AH-1G, 67-15526. D Troop, 1st Squadron, 4th Cavalry. Phu Loi, 1969. Piloted by John Loftice AC and Mike Cassady CP. The Beatles' animated musical fantasy film of 1968, *Yellow Submarine*, featured evil warmongers called Blue Meanies. Accrued 1,269 flight hours, all with D Troop, from November 1968 to February 1970. Loss to inventory because of a tail rotor failure on February 24, 1970. TOM MIKULSKI

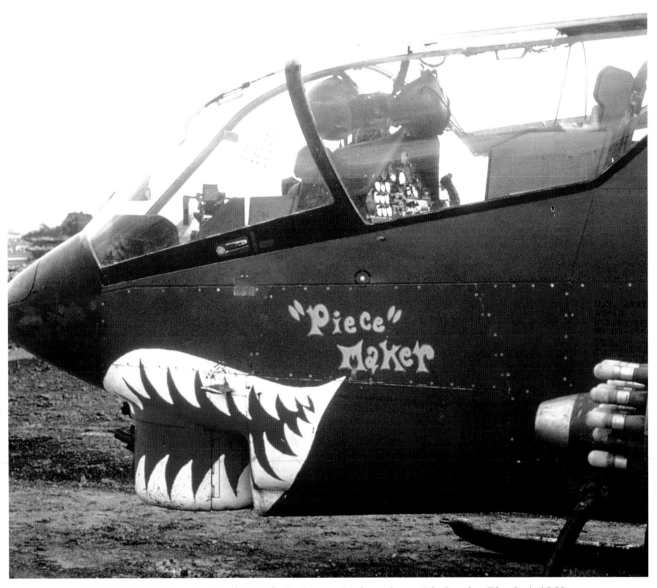

"PIECE" MAKER. AH-1G, 67-15507. D Troop, 1st Squadron, 4th Cavalry. Phu Loi, 1969. Piloted by John Loftice AC. Survived Vietnam from January 1968 to December 1970, accumulating 1,964 flight hours, serving in D Troop from November 1968 to February 1970. LENNART LUNDH

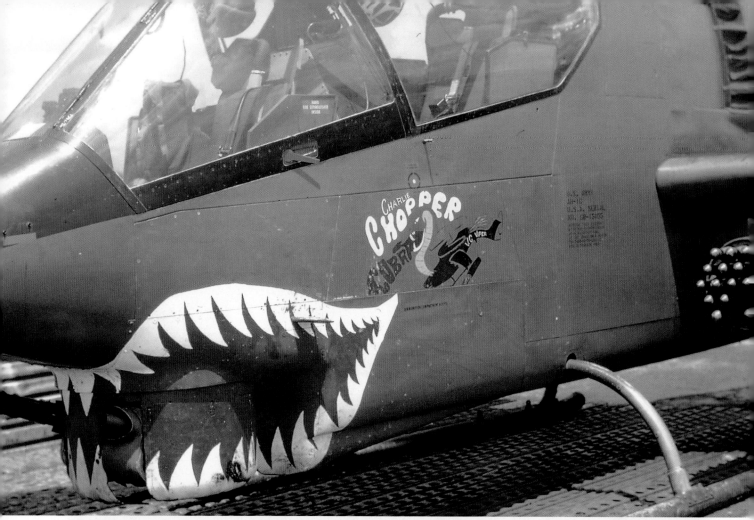

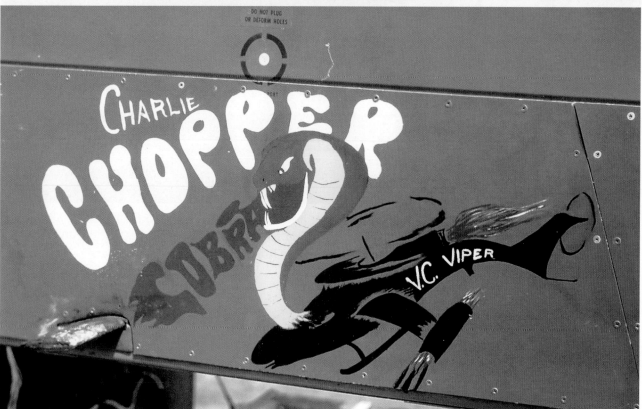

CHARLIE CHOPPER. AH-1G, 68-15055. D Troop, 1st Squadron, 4th Cavalry. Phu Loi, 1969. Accumulated 2,973 flight hours from April 1969 to January 1973, serving in D Troop from April 1969 to January 1971. Loss to inventory on January 15, 1973. TOM MIKULSKI

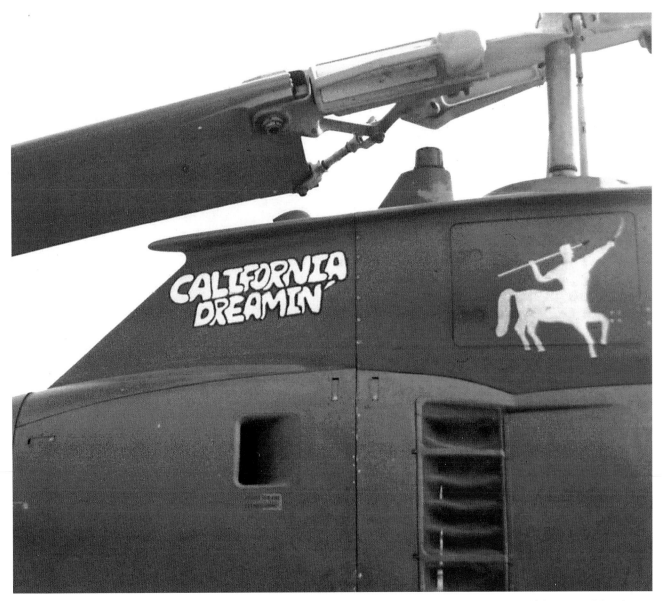

CALIFORNIA DREAMIN'. AH-1G, 68-15135. D Troop, 3rd Squadron, 4th Cavalry. Cu Chi, 1970. Named for the 1965 song by the Mamas and Papas. Inscribed on the right rotor pylon was CALIFORNIA DREAMIN' for Rudy Pares, the pilot; on the left side was KANSAS KILLER for crew chief Don Vaugh. Survived Vietnam from August 1969 to December 1971, with 2,057 flight hours. GARY SCHMIDT

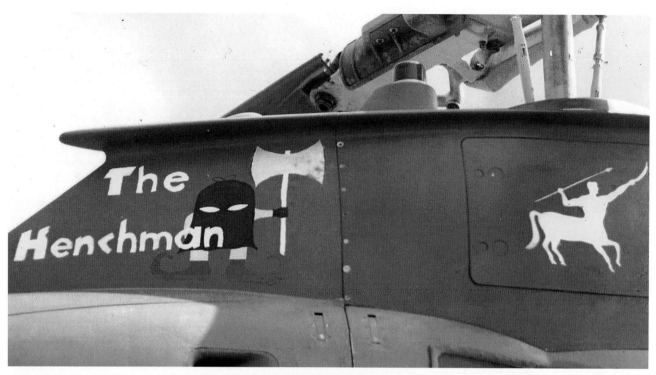

THE HENCHMAN. AH-1G, 67-15827. D Troop, 3rd Squadron, 4th Cavalry. Cu Chi, 1970. Piloted by Warrant
Officer Olsen and maintained by Gary Schmidt CE, who also did the artwork. Accumulated 2,324 flight hours
from January 1969 to February 1972, including a one-year stint (January 1969 to February 1970) with D Troop.
Shot down and auto-rotated into a rice paddy near Tay Ninh during the Cambodian campaign; the crew survived.
GARY SCHMIDT

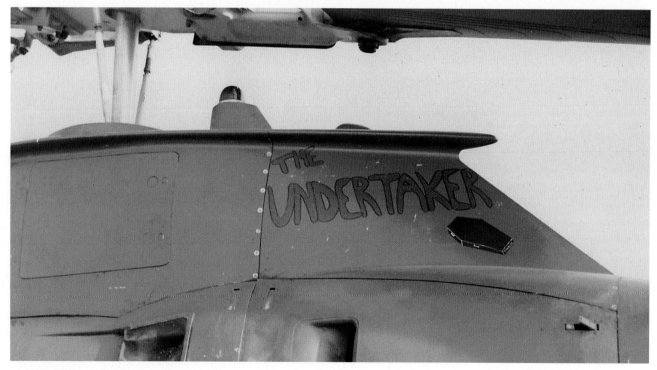

THE UNDERTAKER. AH-1G, 67-15776. D Troop, 3rd Squadron, 4th Cavalry. Cu Chi, 1970. Piloted by CWO
Bruce Sikkema AC and maintained by Dan Coles CE. Lettering and artwork by Gary Schmidt. Previously known as
BETTY BOOBS after Sikkema's wife. Survived Vietnam from December 1968 to December 1971, compiling 2,173
flight hours, serving in D Troop from December 1968 to May 1971.GARY SCHMIDT

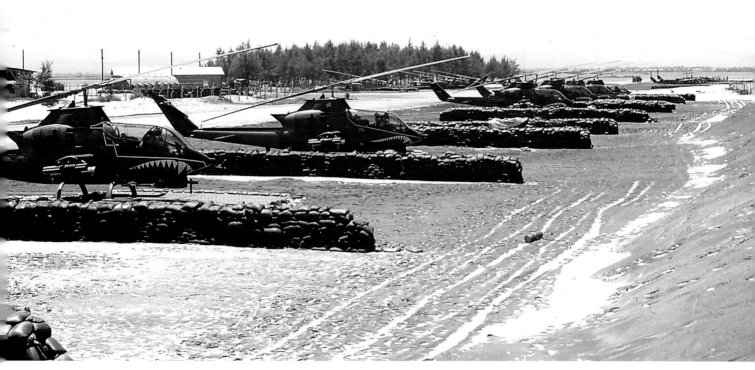

Aircraft of F Troop, 4th Cavalry. Tan My Island, 1972. According to Dan Keirsey, "Tan My was an abandoned naval station directly east of Hue on the coast. We had moved our operations here from Phu Bai to avoid the nightly 122 rocket attacks." DAN KEIRSEY

THE EXPERIENCE. AH-1G. D Company, 227th Assault Helicopter Battalion. Phuoc Vinh, September 1969. A possible source of the name is The Jimi Hendrix Experience and its 1967 debut album *Are You Experienced*. TERRY MOON

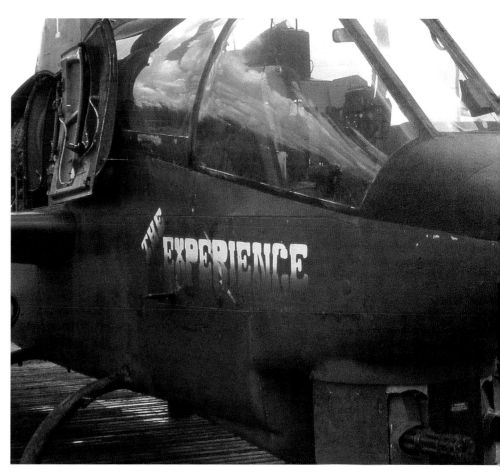

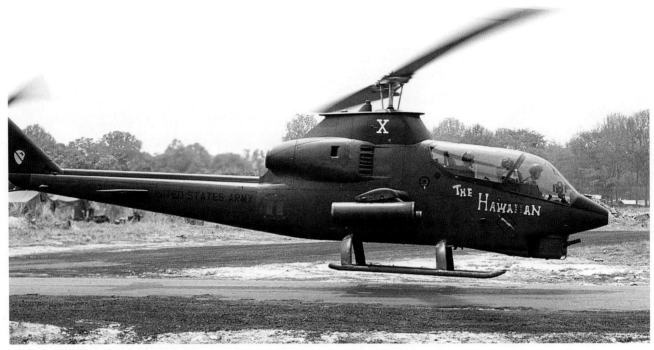

THE HAWAIIAN. AH-1G, 67-15803. D Company, 227th Assault Helicopter Battalion. Lai Khe, spring 1969. Survived Vietnam from January 1969 to August 1972, accumulating 2,560 flight hours, serving in D Company from January 1969 to June 1970. PAUL ANDERSON

CAJUN LADY. AH-1G. D Company, 229th Assault Helicopter Battalion. 1970. KEN CARLTON

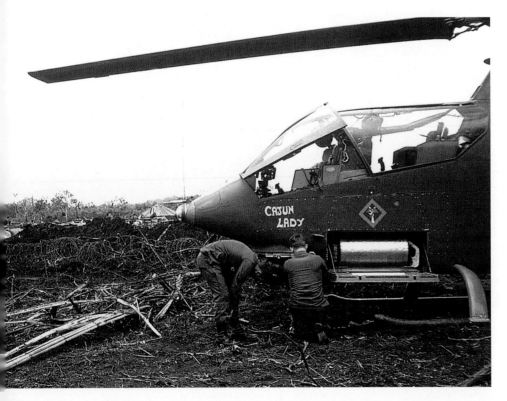

CH-21 SHAWNEE

Also known as the Flying Banana, the CH-21 Shawnee was a twin-engine heavy lifter manufactured by Piasecki Helicopter and Boeing-Vertol. Its crew included two pilots, a crew chief, and a door gunner, and it served primarily as a troop and cargo carrier. The Shawnee served in Vietnam from 1961 to 1964 and lost fourteen to combat and accidents. Fifty-three are known to have been named by their crews, such as *Jelly Belly* and *Rebel Rouser*.

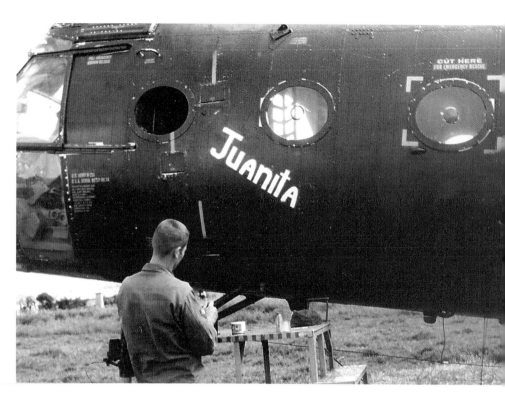

JUANITA. CH-21C, 52-08638. 81st Transportation Company. Ban Me Thuot, 1962. Al Doucette remembers: "I was a CE in Korea who was 'volunteered' to go to Vietnam along with three other CEs and eight pilots, equal numbers from the 6th Transportation Company and 13th Transportation Company in Korea. When we got to the 81st, we were used as fillers for three months to begin the rotation of the crew members back to the states, and we CEs ended up as door gunners." The 81st was redesignated the 119th Aviation Company in July 1963 and had its fleet of Flying Bananas replaced with brand-new UH-1Bs. AL DOUCETTE

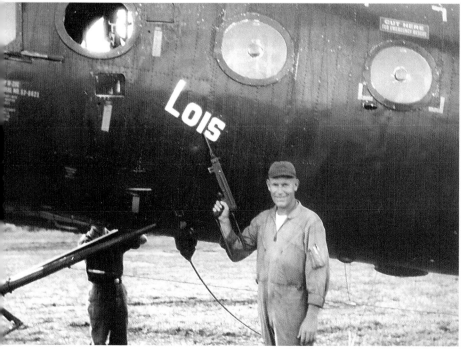

LOIS. CH-21C, 52-08621. 81st Transportation Company. Ban Me Thuot, 1962. AL DOUCETTE

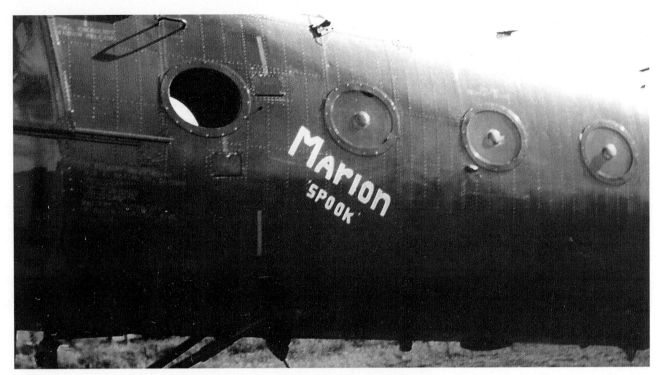

MARION SPOOK. CH-21C, 51-15889. 81st Transportation Company. Ban Me Thuot, 1962. Stricken from the army's inventory after a fatal accident on December 23, 1962. AL DOUCETTE

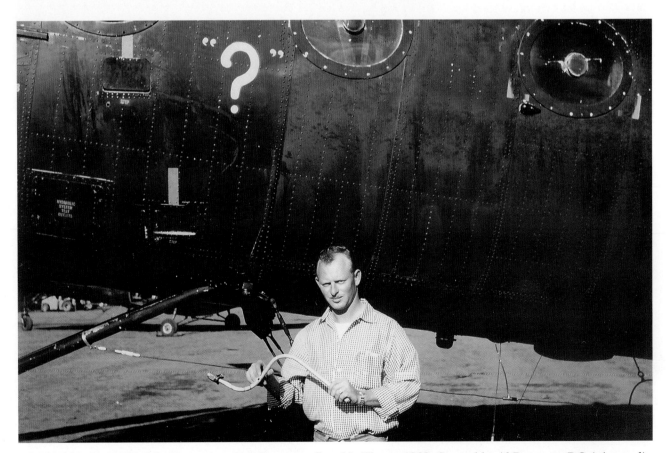

"?" CH-21C, 51-15898. 81st Transportation Company. Ban Me Thuot, 1962. Crewed by Al Doucette DG (pictured), who said the question mark meant that the pilot had "neither a wife or a girlfriend" for whom to name the aircraft. Loss to inventory after an accident on June 18, 1963. AL DOUCETTE

CH-47 CHINOOK

The CH-47 Chinook, which had A, B, and C variants, was a twin-engine heavy lifter made by Boeing-Vertol. Utilized for cargo and troop transport, artillery emplacement, and aircraft recovery, it boasted a crew of two pilots, one flight engineer, one crew chief, and one door gunner. From 1965 to 1973, 170 Chinooks were lost in Vietnam. More than 400 were named by their crews, including *Gook Stomper* and *Big Tuffy*.

GALLOPIN' GOOSE. CH-47A, 66-19092. A Company, 228th Assault Support Helicopter Battalion. Bear Cat, 1969. Crewed by Russ Seelig FE and Mike Killarney CE. Fuselage art rendered by Jim Rowe. According to Seelig, "when Killarney was down in New Orleans before heading off to Vietnam, he saw a motorcycle gang called The Gallopin' Gooses. We stole their colors. Let 'em come over and talk to us about it." H.C. stands for Helicopter Club. Accumulated 1,889 flight hours from November 1967 to February 1972, serving with A Company from November 1967 to November 1969. Loss to inventory. TOM ELLIS

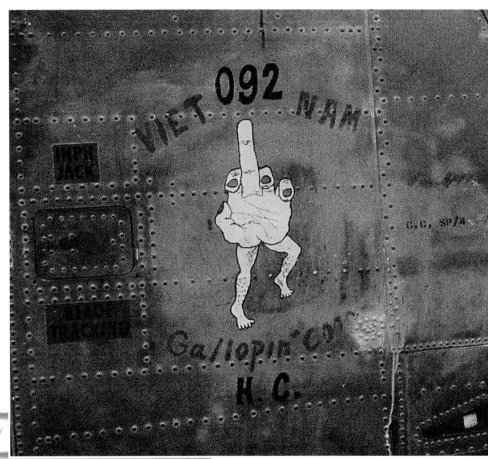

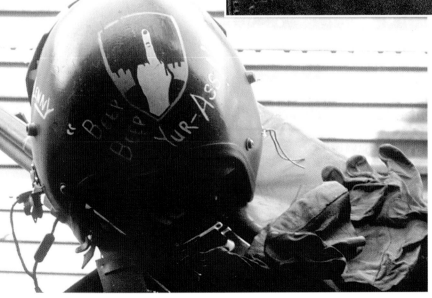

Door gunner Lenny Breeden's helmet, which sports a painted MACV insignia with a middle finger in place of the sword. LENNY BREEDEN

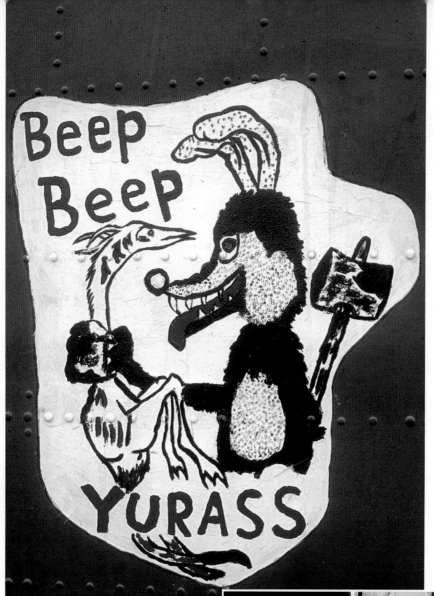

BEEP BEEP YUR ASS. CH-47A, 66-00100. 200th Assault Support Helicopter Company. Bear Cat, 1968. According to Joe Boxley, "We were in a gift shop looking for gifts to send home. I spotted a card that had a drawing of Wile E. Coyote holding a hammer in one hand and the Road Runner in the other, with the caption 'Beep Beep Yur Ass.' We decided that would be a great name for 66-00100." Accumulated 1,689 flight hours from June 1967 to June 1971, serving in the 200th from June 1967 to October 1968.
LENNY BREEDEN

The rear of BEEP BEEP YUR ASS.
LENNY BREEDEN

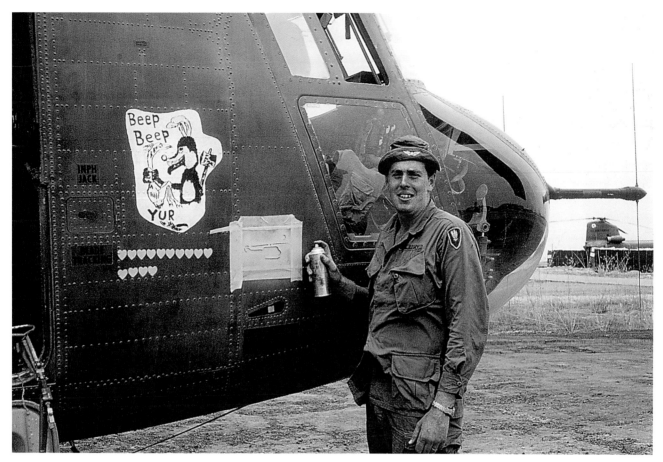

Adding a Huey with a moon to BEEP BEEP YUR, indicating that the aircraft recovered a downed Huey at night. The hearts represented bullet holes that were patched. Lenny Breeden is pictured. LENNY BREEDEN

Says Boxley: "When the 200th moved from Bear Cat to Hue-Phu Bai in I Corps, we became part of the 101st Airborne and were renamed A Company, 159th Assault Support Helicopter Battalion. The new company commander made some changes to nose art." LENNY BREEDEN

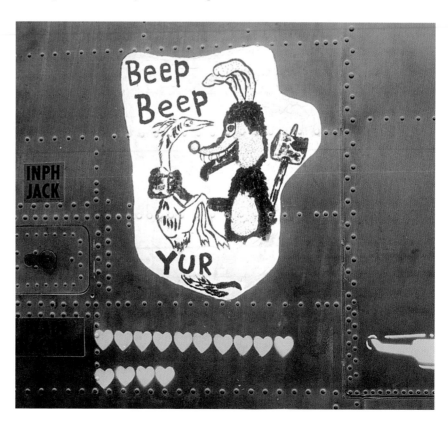

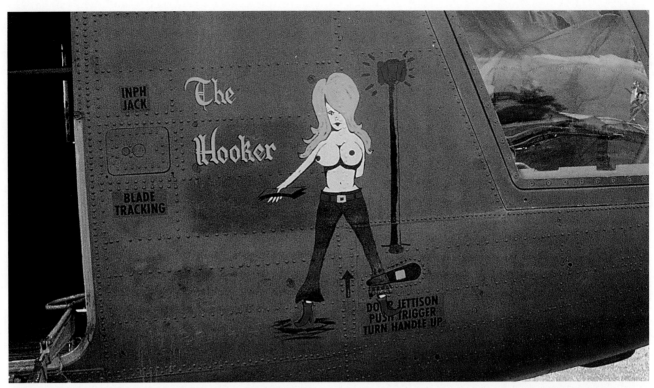

THE HOOKER. CH-47A, 66-00095. 200th Assault Support Helicopter Company. Bear Cat, spring 1968. Named for the large hook used by Chinooks for sling loads, according to Joe Boxley. Accrued 1,290 flight hours from August 1968 to September 1970, serving in the 200th from August 1968 to October 1968. Fuselage artwork painted by unit artist Larry Dumford. 200TH ASHC ASSOCIATION

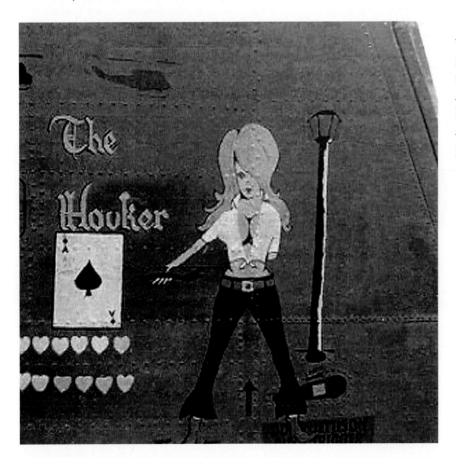

When the 200th Assault Support Helicopter Company was redesignated A Company, 159th Assault Support Helicopter Battalion, and joined the 101st Airborne Division, THE HOOKER put on a shirt. LENNY BREEDEN

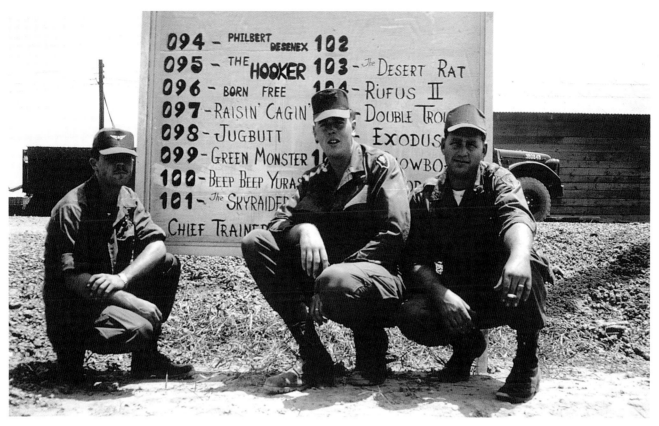

A sign in the 200th Assault Support Helicopter Company, Bear Cat, 1968. Pictured is the crew of BEEP BEEP YUR ASS. Left to right: Joe Boxley CE, Lenny Breeden DG, Lee Richardson FE. Visible on the large board containing the named aircraft of the 200th is RUFUS II (CH-47A, 66-00104), named in honor of Phil Roscoe's dog. LENNY BREEDEN

PEACE. CH-47A. B Company, 228th Assault Support Helicopter Battalion. Bear Cat, 1969. Pictured is SP5 Edwin Blum. Says Jim Ketcham: "I had to study this for a while. At first, I thought it was something with a sack over its head with one eye hole. I finally could see that it is a woman with long hair sitting with her back to us. What I thought was an eye is just a defect in the photo." JIM KETCHAM

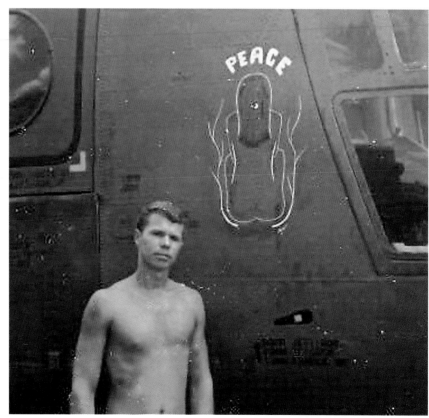

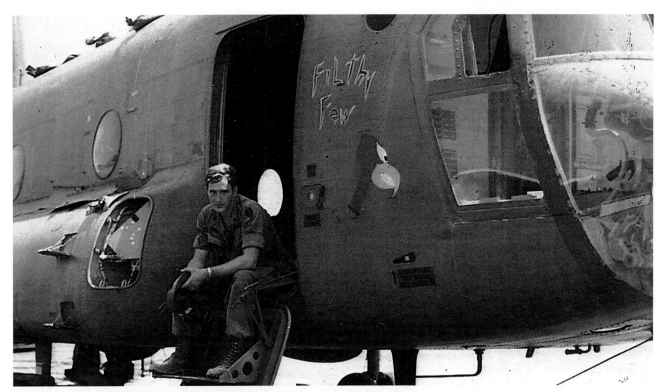

FILTHY FEW. CH-47B, 67-18438, 132nd Assault Support Helicopter Company. Chu Lai, 1969. Pictured is Dave Nichols. Name refers to a notorious American motorcycle club. Survived Vietnam from May 1968 to September 1971, with 2,132 flight hours, all while assigned to the 132nd. DAVE NICHOLS

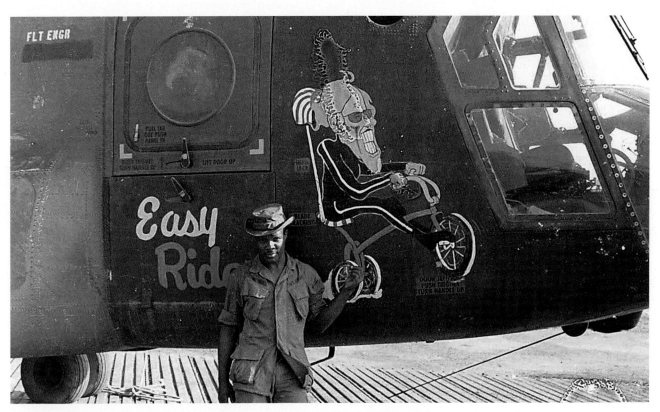

EASY RIDER. CH-47B, 67-18456. 132nd Assault Support Helicopter Company. Chu Lai, 1970. Artwork depicts Peter Fonda as he appeared in the film *Easy Rider*. Survived Vietnam from May 1968 to November 1971, with 2,193 flight hours credited entirely to the 132nd. CLARKE DAVIS

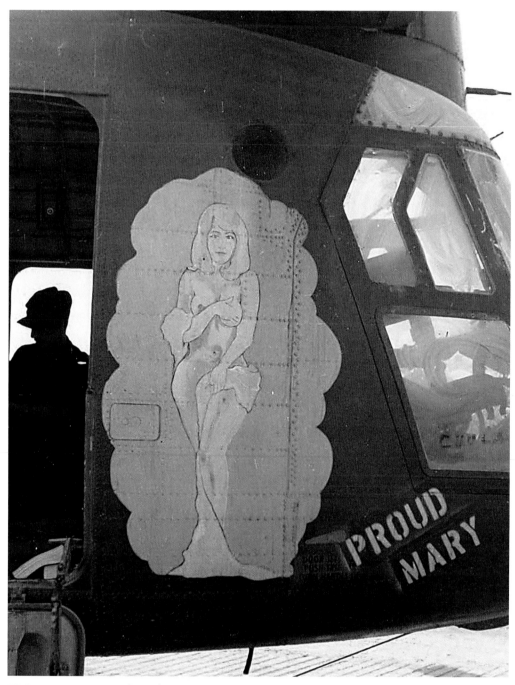

PROUD MARY. CH-47B, 67-18451. 132nd Assault Support Helicopter Company. Chu Lai, 1970. Artwork pays homage to the 1969 song by Creedence Clearwater Revival. Crewed by Monte McDonald FE. Survived Vietnam from May 1968 to November 1971, with 1,923 flight hours, serving in the 132nd from May 1968 to September 1971. CLARKE DAVIS

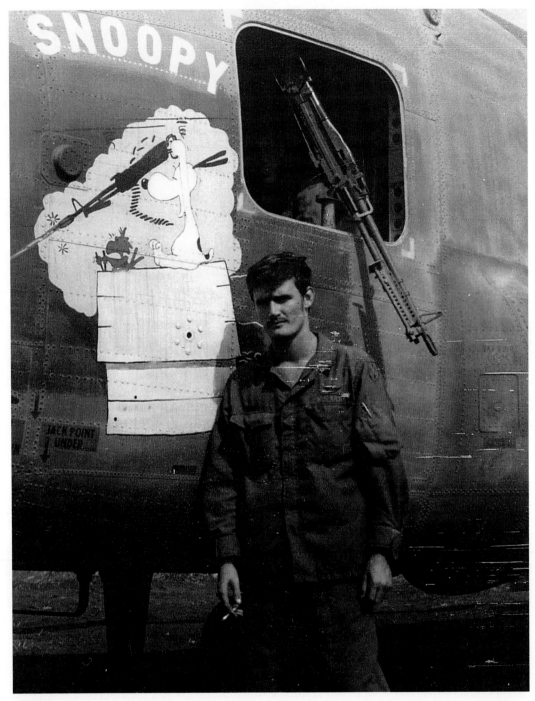

SNOOPY. CH-47B, 67-18453. 132nd Assault Support Helicopter Company. Chu Lai, 1970.
Survived Vietnam from May 1968 to August 1971, with 2,198 flight hours, all with the 132nd.
In 1987, it was issued a new serial number, 87-00085, and remade into a CH-47D. LARRY SEEGER

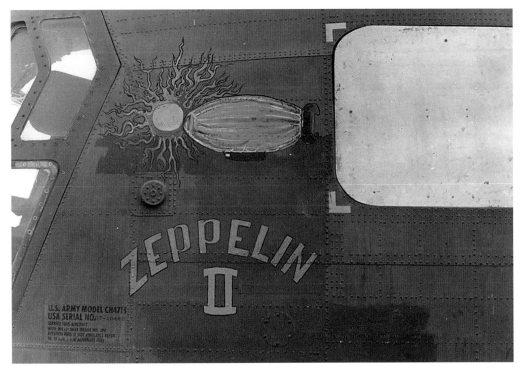

ZEPPELIN II. CH-47B, 67-18448. 132nd Assault Support Helicopter Company. Chu Lai, 1970. Survived Vietnam from May 1968 to September 1971, accumulating 2,080 flight hours, all with the 132nd. CLARKE DAVIS

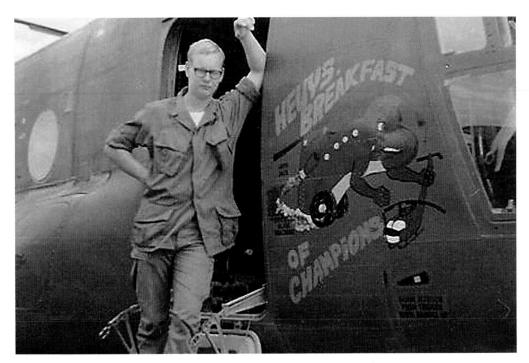

HEUY'S BREAKFAST OF CHAMPIONS. CH-47A, 66-00123. 147th Assault Support Helicopter Company. Vung Tau, 1969. Crewed by Larry Smith FE (pictured) and Paul Michelson CE. Parody of Wheaties cereal slogan. Smith says: "As for 'Heuy,' I don't recall anyone really noticing the spelling. It is supposed to refer to the Huey helicopter. I have a feeling that it might have been the French influence on the Vietnamese hired to paint it." Survived Vietnam from September 1968 to August 1969, with 636 flight hours, including a short stint with the 147th from December 1968 to March 1969. LARRY SMITH

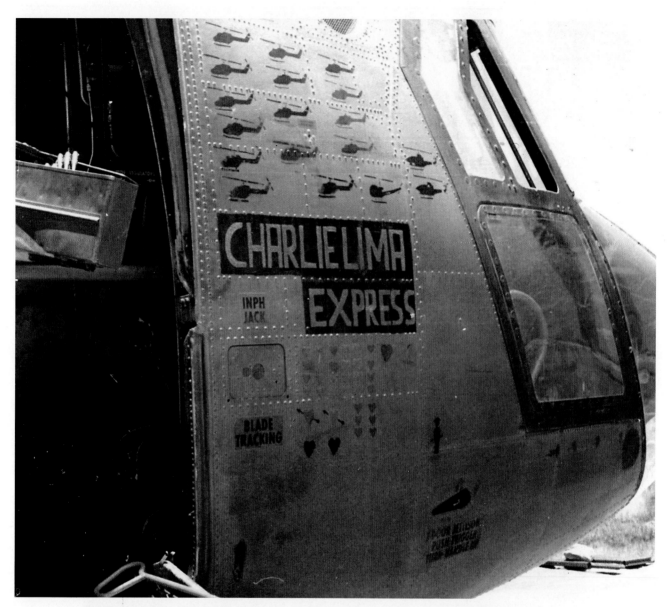

CHARLIE LIMA EXPRESS. CH-47B, 67-18459. 178th Assault Support Helicopter
Company. Chu Lai, 1971. Crewed by Mark Baird FE. Also known as CHU LAI EXPRESS.
Survived Vietnam from March 1968 to June 1971, accumulating 2,316 flight hours, all of
them with the 178th. STEVE WOLAK

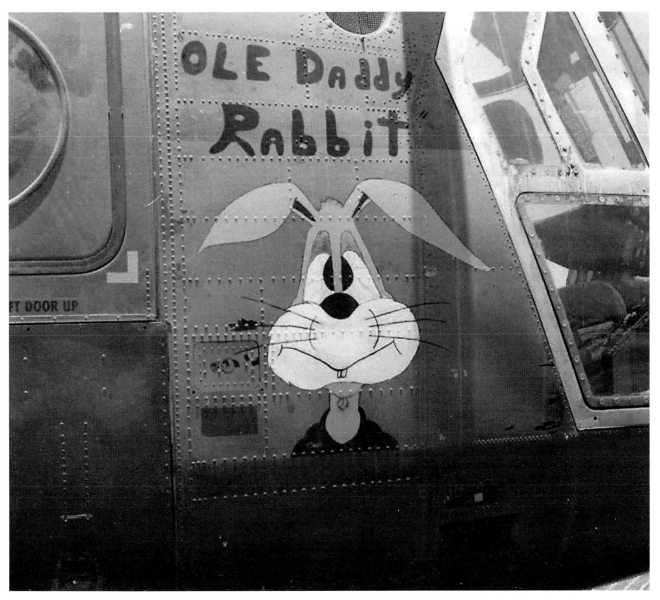

OLE DADDY RABBIT. CH-47B, 67-18436. 178th Assault Support Helicopter Company. Lai Khe, 1971. Survived Vietnam from August 1968 to November 1971, accruing 1,579 flight hours, serving in the 178th from June 1969 to November 1971. STEVE WOLAK

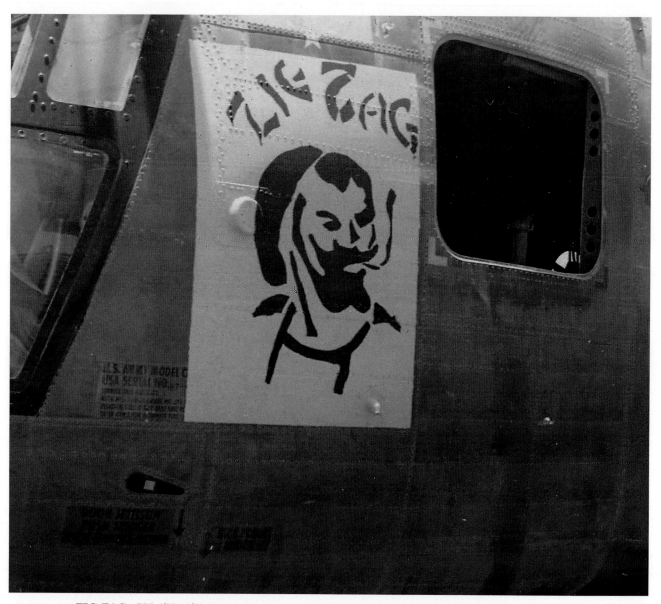

ZIG ZAG. CH-47B. 178th Assault Support Helicopter Company. Chu Lai, 1971. Art features the Zig-Zag man from the popular rolling paper brand. STEVE WOLAK

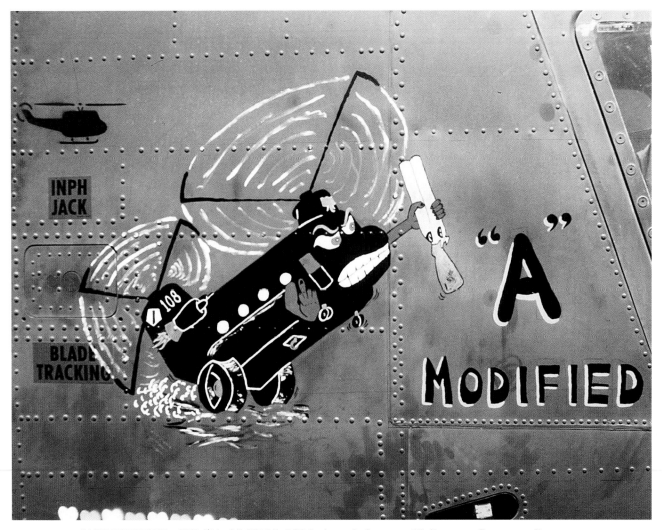

"A" MODIFIED. CH-47A, 66-00108. 200th Assault Support Helicopter Company. Bear Cat, 1968. Crewed by Darryl Garrett FE, Bob Grusheski CE, and Bill Bray DG. Artwork by unit artist Larry Dumford. Says Bray: "The history behind the name was that it was an 'A' model Chinook that had the tail ramp blown off. We replaced it with a 'B' model ramp." Survived Vietnam from August 1968 to September 1969, with 650 flight hours, serving in the 200th from April to October 1968. LENNY BREEDEN

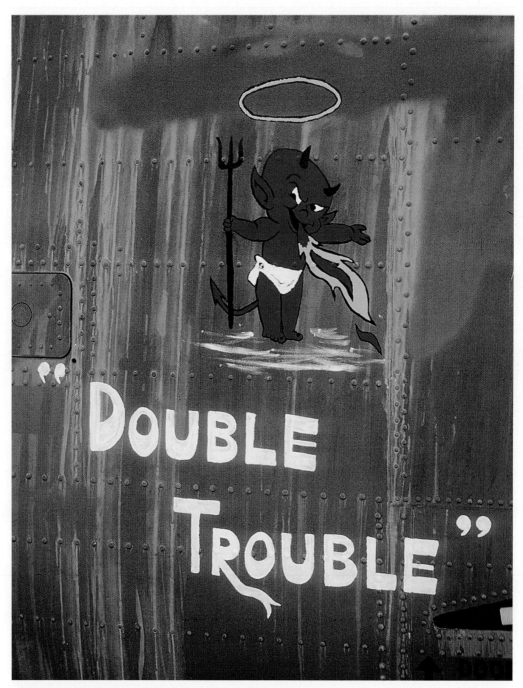

"DOUBLE TROUBLE." CH-47A, 66-00105. 200th Assault Support Helicopter Company. Bear Cat, 1968. Unit artist Larry Dumford painted the little devil. Served from August 1968 to January 1971, accumulating 1,434 flight hours, spending most of 1968 with the 200th. LENNY BREEDEN

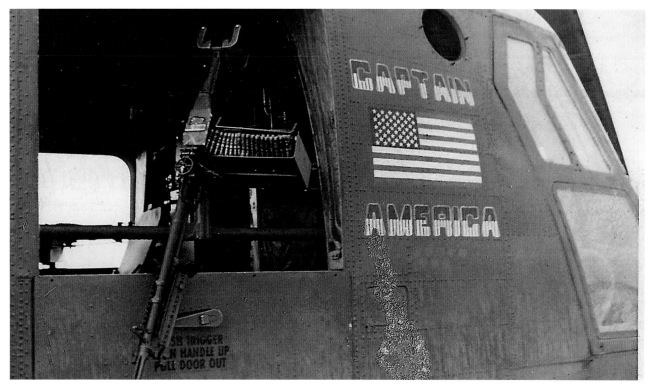

CAPTAIN AMERICA. CH-47B, 67-18462. 271st Assault Support Helicopter Company. Can Tho, 1970. Crewed by Craig Markovich FE. Name derived from the Marvel comics superhero. Artwork by Rick Ferrell. Served from March 1968 to June 1971, accumulating 2,042 flight hours, serving in the 271st from January 1969 to June 1971, when it crashed short of the runway and sustained serious structural damage. CRAIG MARKOVICH

CAPTAIN AMERICA. CH-47B, 67-18462. 271st Assault Support Helicopter Company. Can Tho, 1970. Craig Markovich FE (pictured) finishes up a paint job on the rear pylon of his assigned Chinook. Accumulated 2,043 flight hours from March 1968 to June 1971, serving in the 271st from January 1969 to June 1971. Loss to inventory on June 9th, 1971. CRAIG MARKOVICH

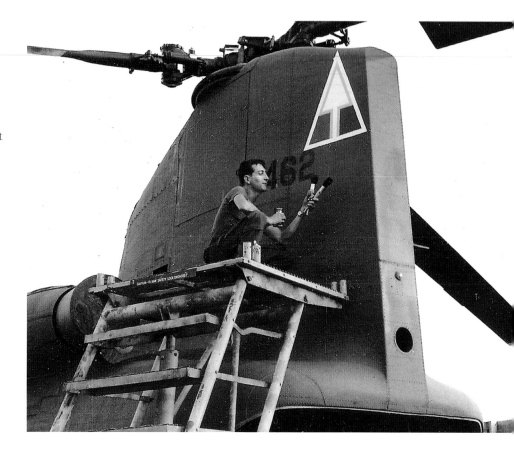

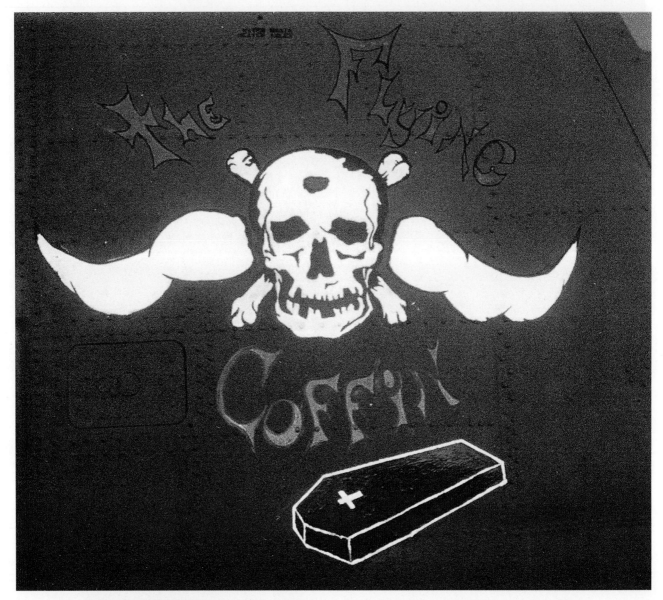

THE FLYING COFFIN. CH-47A. A Company, 228th Assault Support Helicopter Battalion. Bear Cat, 1969. TOM ELLIS

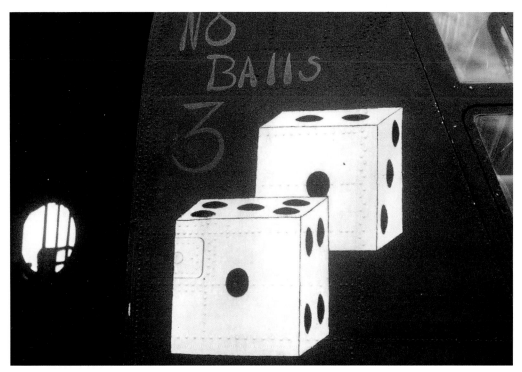

NO BALLS 3. CH-47A, 65-08003. A Company, 228th Assault Support Helicopter Battalion. Bear Cat, 1969. Piloted by Paul Getz AC and crewed by DeWayne Miller FE. Name reflects the serial number sequence of the last three digits. Survived Vietnam from March 1966 to March 1971, amassing 2,926 flight hours and serving in A Company from August 1969 to February 1970. TOM ELLIS

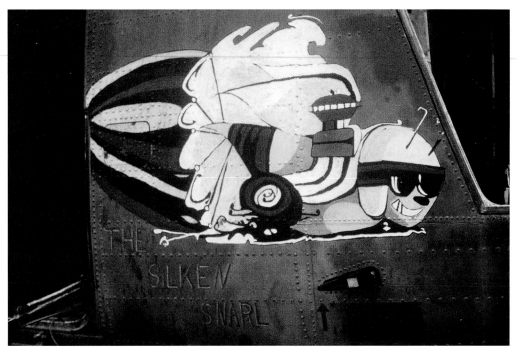

THE SILKEN SNARL. CH-47A, 66-00086. A Company, 228th Assault Support Helicopter Battalion. Bear Cat, 1968. Name derived from the factory nickname given to the 1968 Dodge Coronet. The fuselage artist was Larry Dumford of the 200th Assault Support Helicopter Company. The 200th and A Company, 228th, both based at Bear Cat, lay claim to this aircraft. TOM ELLIS

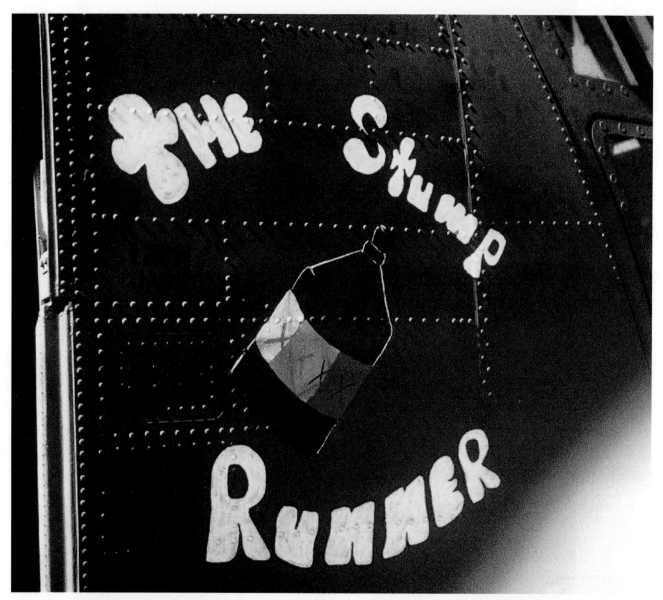

THE STUMP RUNNER. CH-47A. A Company, 228th Assault Support Helicopter Battalion. Bear Cat, 1969. Name refers to hillbillies. TOM ELLIS

CH-54 FLYING CRANE

Manufactured by Sikorsky, the CH-54 Flying Crane was a twin-engine heavy lifter with a crew of two pilots and a crew chief. It served in Vietnam from 1965 to 1972, providing transport and downed-aircraft recovery. Nine aircraft were lost, and more than fourteen were named by their crews—for example, *The Hulk* and *Load Runner.*

BIG MOTHER. CH-54A, 67-18418. 478th Aviation Company (Headquarters and Headquarters Company). Da Nang, 1968. According to pilot James Oden, this was "the first and only helicopter bomber in the army inventory. . . . It carried a 10,000-pound bomb that was used to create instant landing zones." Survived Vietnam from November 1968 to September 1971, with 1,502 flight hours, all with the 478th. JAMES ODEN

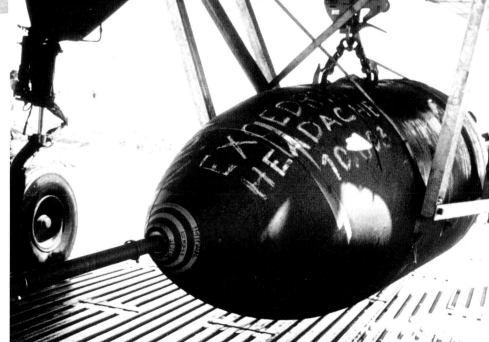

A bomb casing on BIG MOTHER inscribed "Excedrin Headache 10,003." JAMES ODEN

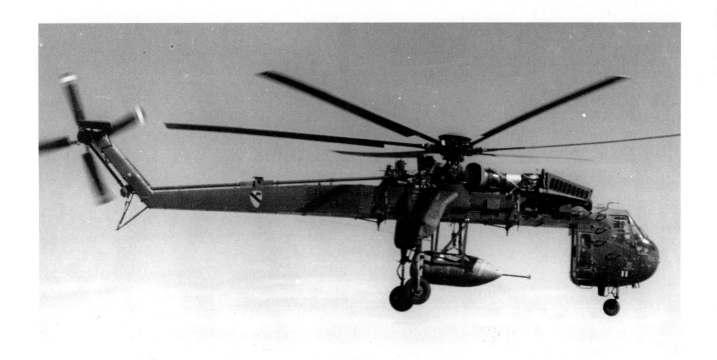

BIG MOTHER seen minutes away from another instant landing zone. JAMES ODEN

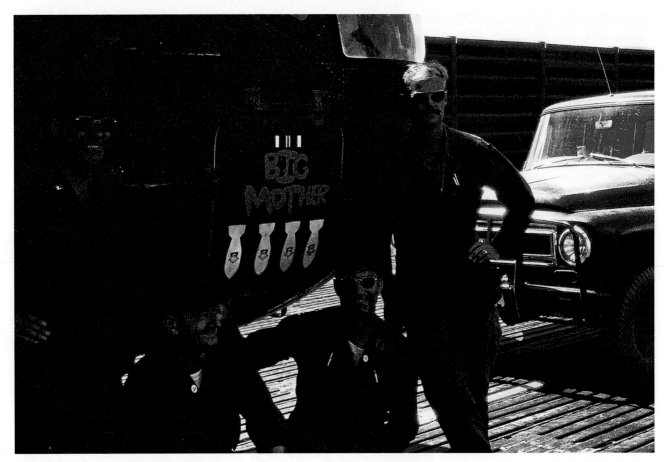

A closer look at the art on BIG MOTHER. The four painted bombs on the fuselage represent bomb drops.
JAMES ODEN

OH-6 LOACH

A single-engine multipurpose aircraft, the OH-6A Loach was made by Hughes Aircraft. Its crew consisted of a pilot, an observer, and a gunner, and it flew aeroscout missions such as observation and escort and attack. This aircraft served in Vietnam from 1967 to 1973, during which time 842 were lost. Crews gave names to more than 194 of this helicopter, including *Love Bug* and *Electrical Egg*.

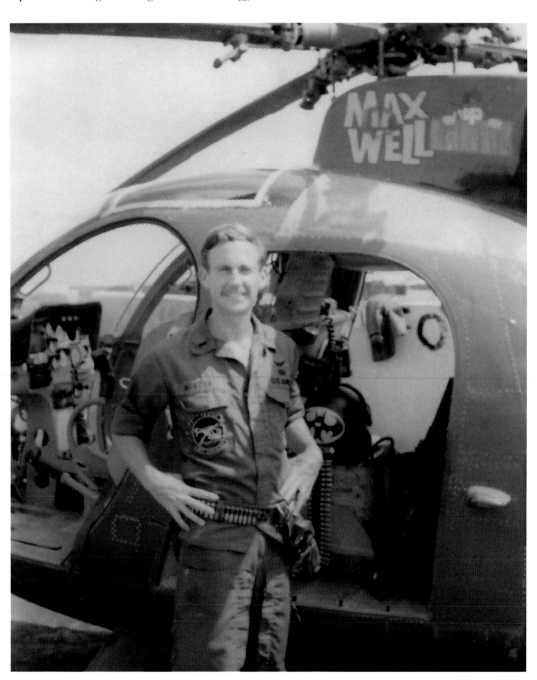

MAXWELL. OH-6A. H Troop, 16th Cavalry. FSB Mace, III Corps, fall 1971. Piloted by Paul Murtha AC (pictured). Named for "Maxwell's Silver Hammer" by The Beatles. Says Murtha: "If you look at the picture [artwork] closely, you'll see that the center of the logo is discolored where it had to be repainted after a well-meaning Viet Cong put a bullet through the dog house [rotor housing]." PAUL MURTHA

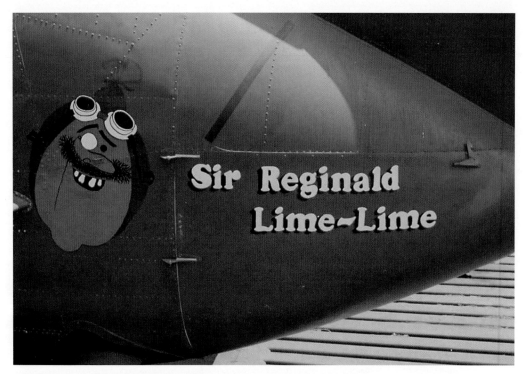

SIR REGINALD LIME-LIME. OH-6A. 11th Armored Cavalry Regiment. Xuan Loc, III Corps, 1968. Like his cohorts Crash Orange and Baron Von Lemon, Sir Reginald Lime-Lime was a character invented by Pillsbury in 1967 to promote a new powdered drink to compete with Kool-Aid. GRADY STOGNER

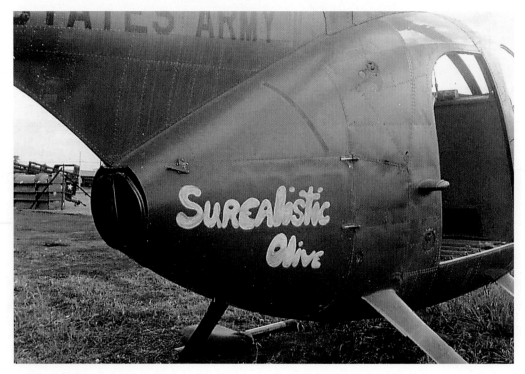

SUREALISTIC OLIVE. OH-6A. 11th Armored Cavalry Regiment. Xuan Loc, III Corps, November 1968. Name is a parody (and misspelling) of Jefferson Airplane's 1967 album *Surrealistic Pillow.* GRADY STOGNER

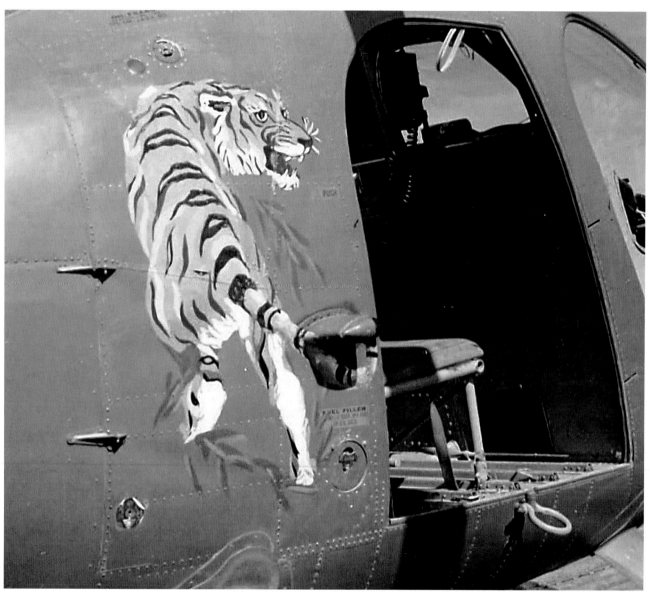

A tiger painted on an OH-6A in the 11th Armored Cavalry Regiment, Xuan Loc, III Corps, October 1968. GRADY STOGNER

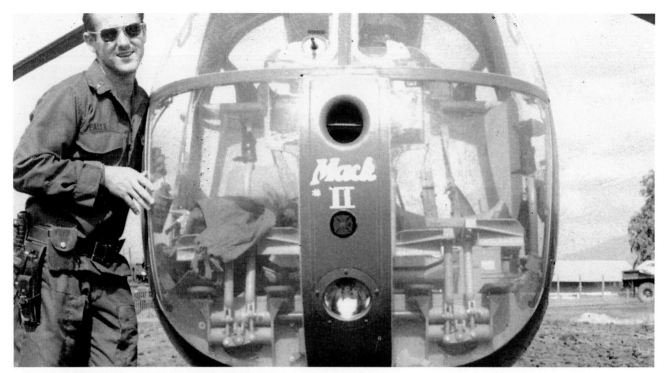

MACK II. OH-6A, 67-16062. Headquarters and Headquarters Company, 1st Brigade, 1st Cavalry. Tay Ninh, February 1969. Piloted by Mike Paitz (pictured) and crewed by Cleveland Grant CE, who named the aircraft after the Mack truck. Accrued 469 flight hours from August 1968 to January 1969, all with the 1st Brigade. Destroyed in a river accident on January 3, 1969, resulting in two killed (Paitz and Grant were elsewhere). CLEVELAND GRANT

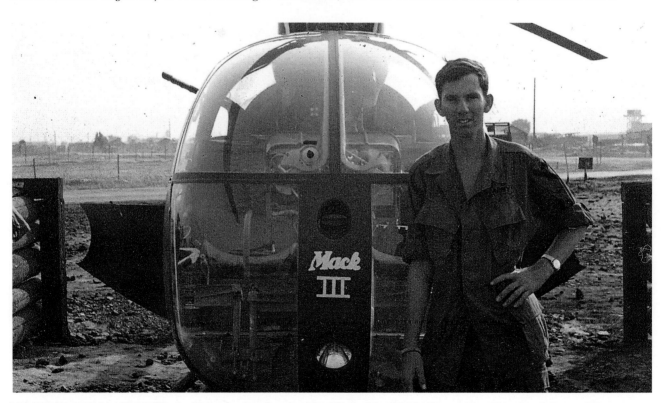

MACK III. OH-6A, 67-16578. 1st Brigade, 1st Cavalry. Tay Ninh, May 1969. Crewed by Cleveland Grant CE (pictured). Accrued 610 flight hours from March 1969 to August 1970, serving in the 1st Brigade from March to August 1969. Loss to inventory on August 9, 1970. CLEVELAND GRANT

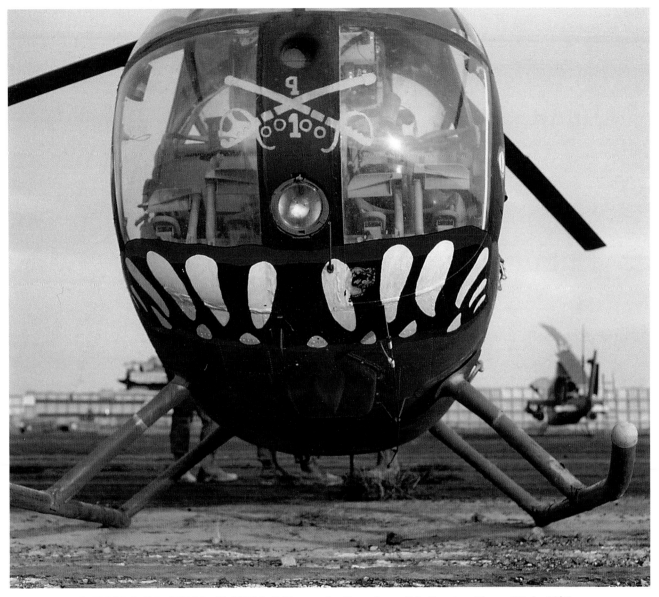

GIVE BLOOD. OH-6A, 68-17220. C Troop, 1st Squadron, 9th Cavalry. Phuoc Vinh, 1971. Piloted by Bruce Campbell AC. Accumulated 611 flight hours from July 1969 to March 1971, serving in C troop from September 1970 to March 1971. Loss to inventory, March 17, 1971. BRUCE CAMPBELL

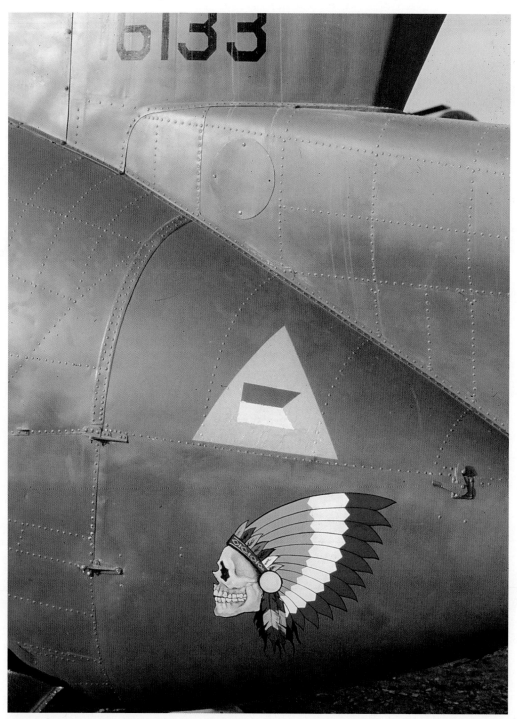

Comanche headdress on OH-6A 67-16133 in C Troop, 7th Squadron, 1st Cavalry, Vinh
Long, 1970. Crewed by Rick O'Connell CE. Comanche represented C Troop, and the two-
color guidon in a yellow triangle represented the 7th Squadron. Survived Vietnam from
August 1968 to March 1971, amassing 1,558 flight hours, serving in C Troop from July
1970 to February 1971. RICK O'CONNELL

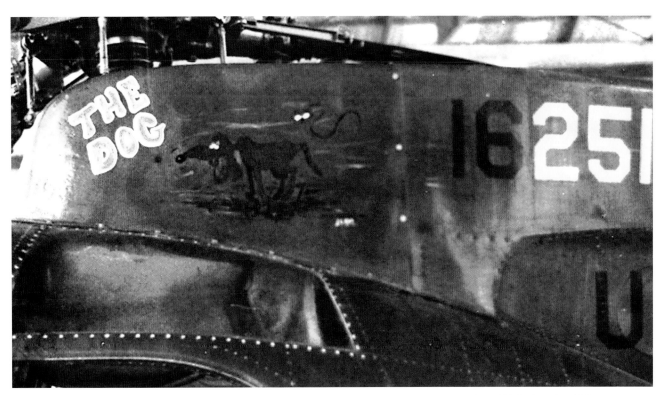

THE DOG. OH-6A, 67-16251. D Troop, 1st Squadron, 1st Cavalry. Chu Lai, November 1970. Survived Vietnam from November 1968 to February 1971, netting 1,518 flight hours, serving in D Troop from September to December 1970. BILL TUCKER

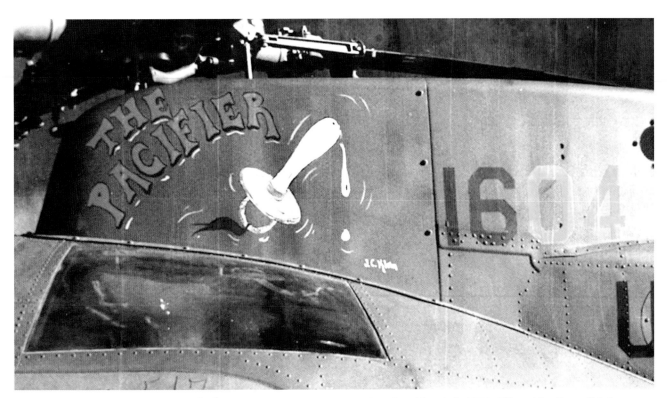

THE PACIFIER. OH-6A, 69-16047. D Troop, 1st Squadron, 1st Cavalry. Chu Lai, 1971. Piloted by Russell Johnson AC. Survived Vietnam from August 1970 to May 1971, accumulating 523 flight hours and serving in D Troop from December 1970 to May 1971. Artwork by Jay Klein. Shot down and destroyed on May 22, 1971; the crew survived. BILL TUCKER

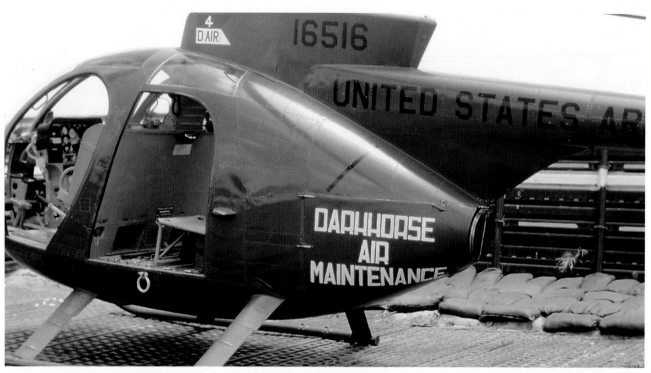

DARKHORSE AIR MAINTENANCE. OH-6A, 67-16516. D Troop, 1st Squadron, 4th Cavalry. Tay Ninh, 1969. This highly polished Loach accumulated 1,953 flight hours before succumbing to mechanical failure and loss to inventory on September 7, 1971. Served in Vietnam from December 1968 to September 1971, including its maintenance role with D Troop from February 1969 to January 1970. TOM MIKULSKI

LITTLEST LOBO. OH-6A, 67-16326. D Company, 227th Assault Helicopter Battalion. Lai Khe, spring 1969. The Roman numeral on the main rotor housing and the Lobo name indicate that this Loach belonged to Headquarters and Headquarters Company of the 227th, attached to D Company ("El Lobo"). Survived Vietnam from November 1968 to January 1973, with 2,942 flight hours, serving in Headquarters and Headquarters Company from November 1968 to May 1969. PAUL ANDERSON

UH-1 GUNSHIPS

The UH-1, manufactured by Bell Helicopter in B, C, and M models, was a single-engine aircraft with two pilots, a crew chief, and a door gunner. It served in Vietnam from 1962 to 1972, providing aerial fire support with rockets, grenades, miniguns, and M60 machine guns. More than 700 were named by their crews—*Elusive Butterfly* and *Sadistic Revenge*, for example—and 722 were lost (357 B models and 365 C/M models).

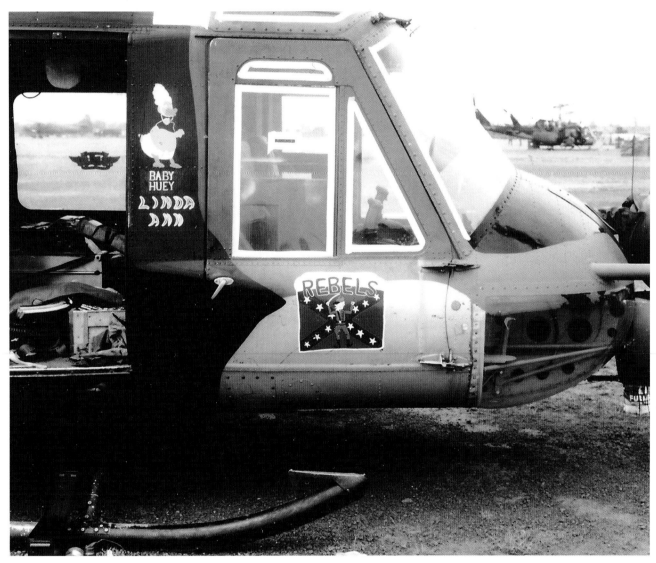

BABY HUEY. UH-1B. A Company, 1st Aviation Battalion, 1st Infantry Division. Phu Loi, 1966. Also known as LINDA ANN as shown on the doorpost below the artwork. ROD PATRICK

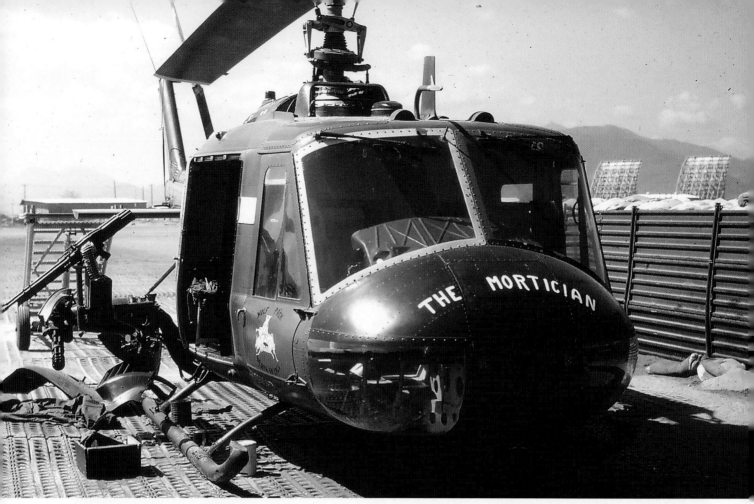

THE MORTICIAN. UH-1C, 65-09553. 281st Assault Helicopter Company. Nha Trang, 1967. Crewed by Trubee Krothe CE. TRUBEE KROTHE

Another look at THE MORTICIAN, specifically the gun set-up. According to Krothe, it was "two M60s mounted together using solid tracer rounds. In the end, it was not flexible enough, so I went back to the single M60 hung on a bungee cord from the ceiling." The labeled minigun cover is visible below the twin 60s. TRUBEE KROTHE

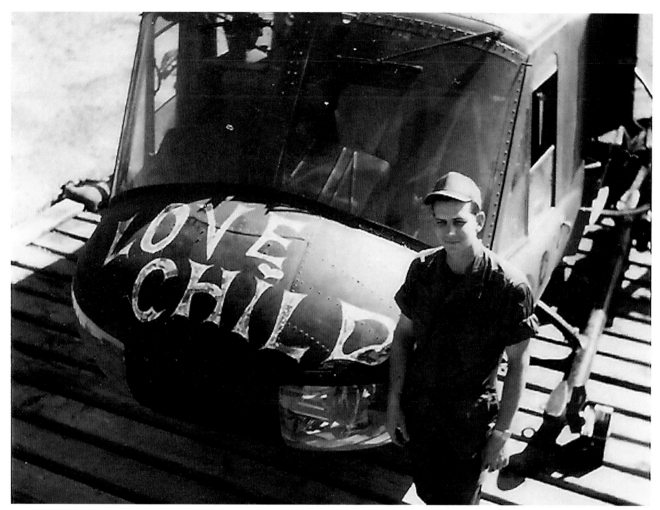

LOVE CHILD. UH-1C. 281st Assault Helicopter Company. Nha Trang, 1969. Crewed by Daryl Evangelho CE and John Gachich DG (pictured), who painted the name. Named after the popular 1968 song by Diana Ross and The Supremes. According to Gachich, the name "did not go over too well due to its 'political implications' with some 'lifer' types, and I was ordered to remove it. I refused, and they had someone else do it." JOHN GACHICH

FUCK IT JUST FUCK IT. UH-1M, 66-00618. 176th Assault Helicopter Company. Chu Lai, 1971. Crewed by Garry Roberts CE, who says this "belly message really got a lot of attention from the guys on the ground. Seems it was one of those statements that everyone could relate to." Also had "1%" painted on the nose, which represented the percentage of combat helicopter crews in Vietnam compared to the general population. Survived Vietnam from November 1968 to February 1972, with 1,267 flight hours, serving in the 176th from March to October 1971. GARRY ROBERTS

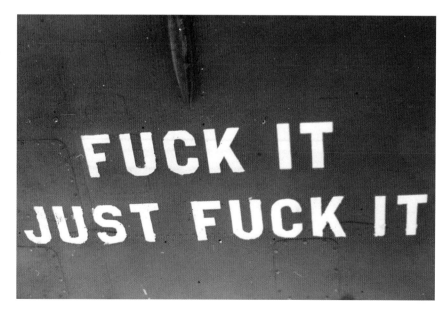

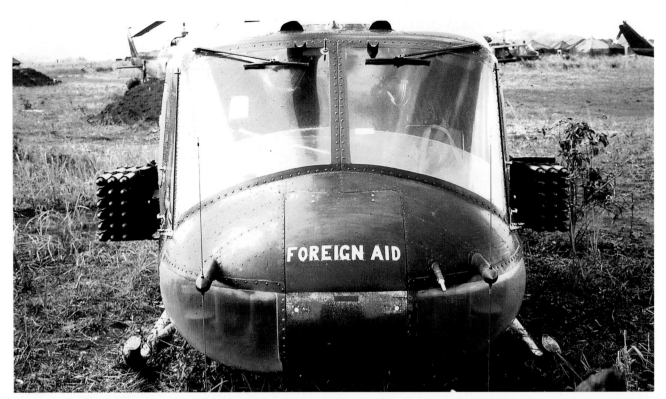

FOREIGN AID. UH-1B. 117th Aviation Company. June 1966. Piloted by Ron Hudak AC. RON HUDAK

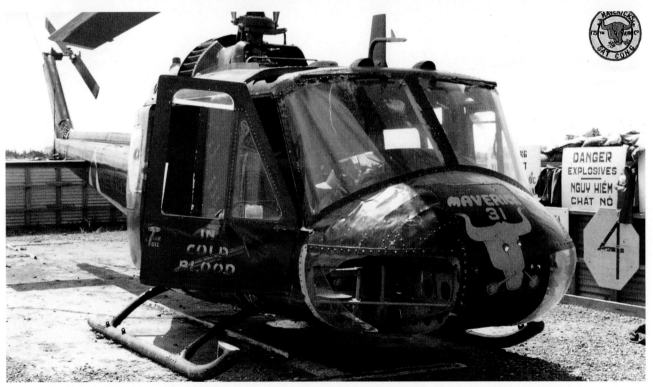

IN COLD BLOOD. UH-1C, 66-15044. 175th Assault Helicopter Company. Crewed by Ed Thayer DG. This is the second incarnation (1970–71) of the name—possibly influenced by the book by Truman Capote—which, according to Thayer, had been changed to THE MORNING AFTER in late 1966 or early 1967 because the higher-ups decided it was too brutal. Also known as MAVERICK 31. Accumulated 1,229 flight hours from September 1966 to September 1968, all with the 175th. Loss to inventory followed a mechanical failure on September 12, 1968.
FRANK EFFENBERGER

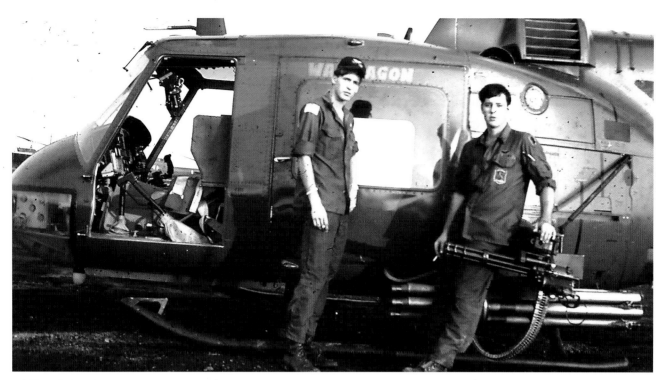

WARWAGON. UH-1M, 65-09554. 117th Assault Helicopter Company. III Corps, 1971. Crewed by Vance Cowart CE (right) and Jim Barrie DG (left). Named after the 1967 John Wayne movie. Accumulated 1,227 flight hours from March 1968 to December 1971, serving in the 117th from December 1970 to December 1971. Loss to inventory on December 21, 1971. LEE BRADLEY

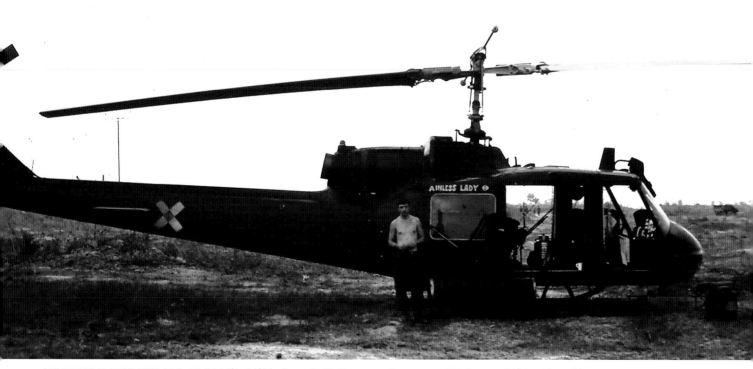

AIMLESS LADY. UH-1M, 66-00667. 117th Assault Helicopter Company. III Corps, 1971. Piloted by Dennis Lemons AC and crewed by Lee Bradley CE (pictured). Also known as SIDEWINDER 1, this gunship acquired its name from a 1970 Grand Funk Railroad song, which Lemons chose because he wanted "a name with class," according to Bradley. Survived Vietnam from March 1967 to February 1972, with 3,540 flight hours, serving in the 117th from November 1970 to February 1972. LEE BRADLEY

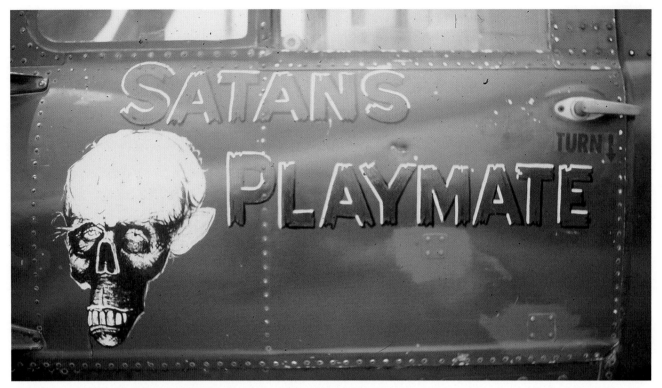

SATANS PLAYMATE. UH-1C, 66-15054. 175th Assault Helicopter Company. Vinh Long, 1967. Piloted by Jim Spiers AC and crewed by Tom Kennedy CE and Eddie Adair DG. Survived Vietnam from April 1967 to February 1971, amassing 2,875 flight hours, serving in the 175th from April 1967 to June 1969. DICK KOENIG

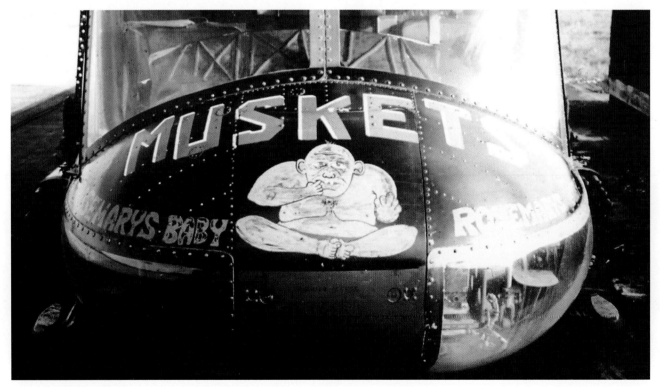

ROSEMARYS BABY. UH-1C, 66-15089. 176th Assault Helicopter Company. Chu Lai, 1970. Crewed by Butch Brant CE. Named after the 1968 horror film. Survived Vietnam from August 1968 to November 1971, with 1,664 flight hours, serving in the 176th from April 1969 to February 1971. BUTCH BRANT

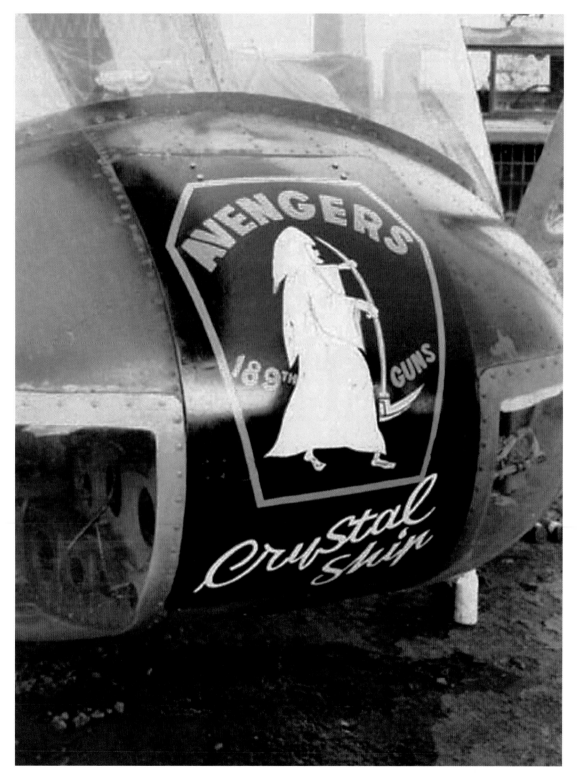

CRYSTAL SHIP. UH-1C, 65-09552. 189th Assault Helicopter Company. Pleiku, 1970. Piloted by
Gordon Cockrell AC and crewed by Tom Freis CE and Jack Lokin DG. Name inspired by the 1967
song by The Doors, whose song titles would eventually adorn twenty-two other helicopters in
Vietnam. Says Cockrell: "About a month after I got the ship, I was told to remove the name—drug-
related innuendo." Also known as AVENGER IX. Survived Vietnam from June 1966 to February
1971, with 1,158 flight hours, serving in the 189th from April 1969 to November 1970.
GORDON COCKRELL

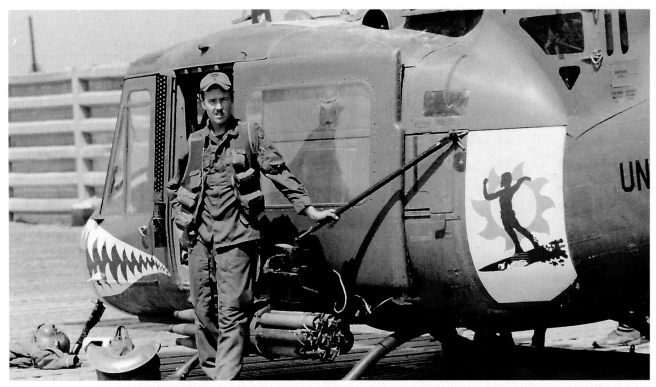

SURFER. UH-1C, 66-15161. 174th Assault Helicopter Company. Duc Pho, 1971. Artwork painted by Bud Vann, inspired by the classic 1966 surfing movie *The Endless Summer*. Fred Thompson (pictured) had been a serious surfer before the war. FRED THOMPSON

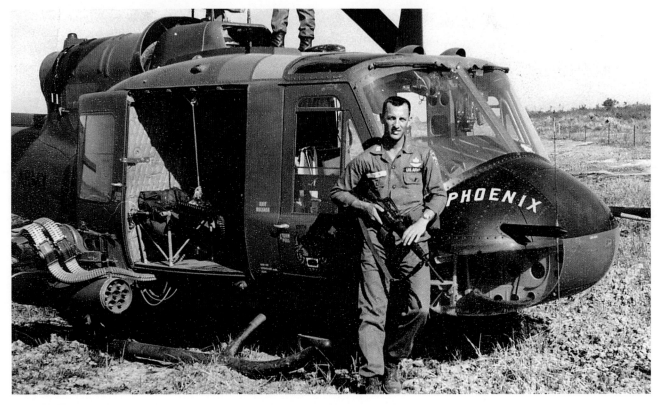

PHOENIX. UH-1B. 68th Aviation Company. III Corps, 1966. Piloted by Dan Telfair AC (pictured). Named after the mythical creature and the 1966 Jimmy Stewart movie *The Flight of the Phoenix*. Note the early Tiger painted on the pilot's door (Andrew Platacis, artist). DAN TELFAIR

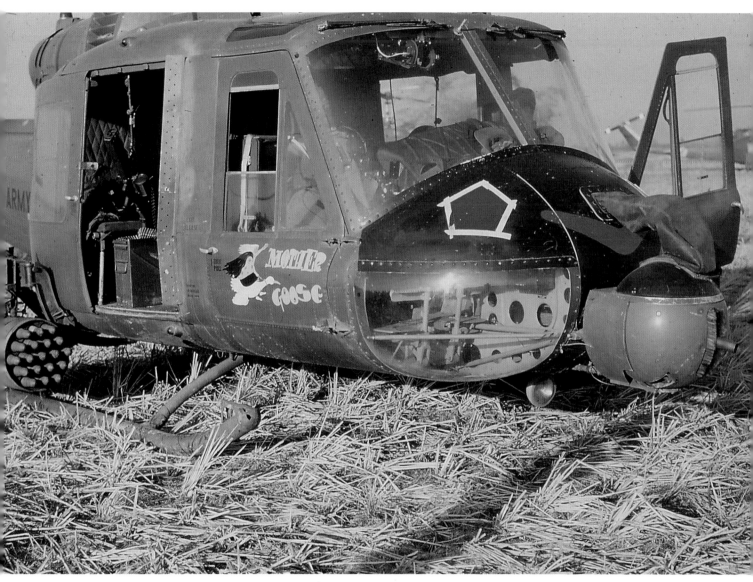

MOTHER GOOSE. UH-1C, 66-15107. 191st Assault Helicopter Company. Rach Kien, III Corps, late 1967. Piloted by Stan Cherrie AC and crewed by Skip Waugh CE and Rich Fleming DG. Artwork on pilot door painted by Richard Weske. Survived Vietnam from November 1967 to February 1973, amassing 2,922 flight hours, serving in the 191st from November 1967 to July 1970. HAROLD STITT

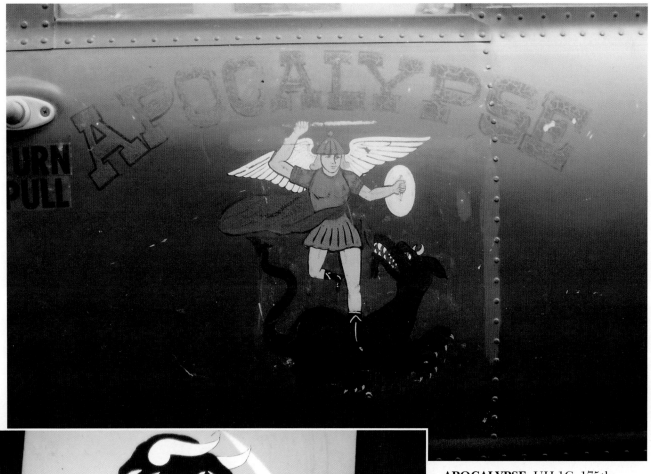

APOCALYPSE. UH-1C. 175th Assault Helicopter Company. Vinh Long, 1967–68. Piloted by Dick Koenig AC. This was Maverick Lead's (MAV 35) gunship. DAN ALDRIDGE

BATTLIN' BITCH. UH-1C, 65-09507. 174th Assault Helicopter Company. Also known as LADY MADONNA. No lettering was painted: this was a verbal name relating to the artwork itself. All gunships in the Shark platoon utilized the rear access doors to display a colorful and extensive collection of personalized artwork. (See page 168 for a photo of artist Gary Harter.) FRED THOMPSON

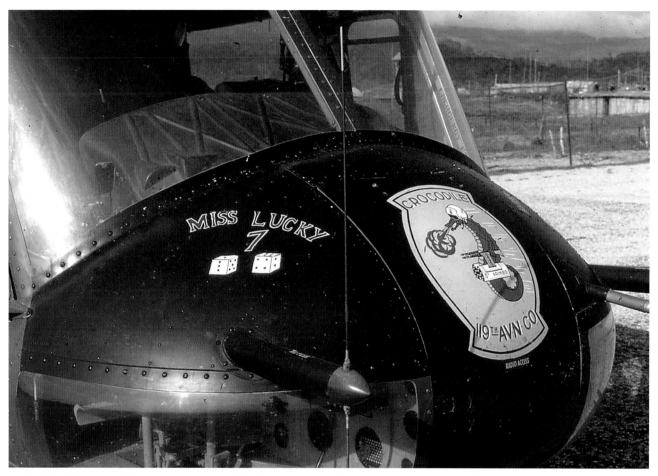

MISS LUCKY 7. UH-1B gunship, 64-13939. 119th Assault Helicopter Company. Pleiku, 1966. Piloted by Ed Coombs AC and crewed by Jimmy Roberts CE. Also known as CROCODILE 7. ED COOMBS

CROCODILE 8. UH-1B gunship. 119th Assault Helicopter Company. Pleiku, 1966. Exquisite detailed art work on pilot's door. ED COOMBS

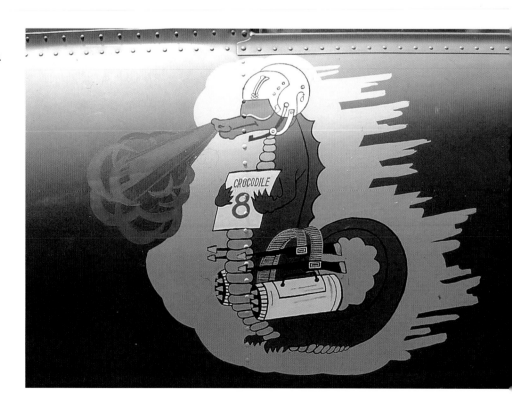

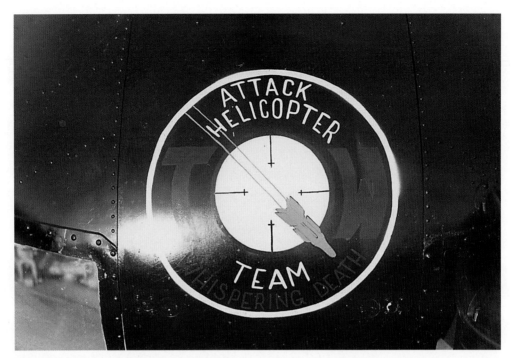

WHISPERING DEATH. UH-1B, 62-12553. 1st TOW Team Detachment. Camp Holloway, 1972. Piloted by Terry Gannon AC, who says: "One of our Hughes aircraft engineers and I designed the circular patch, which had TOW, a missile in flight, and the words 'Whispering Death' around the edge. It was also painted on the nose of both of the B models. In addition, we had symbols of tanks, trucks, and other kills painted on the side of the aircraft." Survived Vietnam from July 1972 to January 1973, accruing 197 flight hours. (TOW stands for tube-launched, optically tracked, wire-guided antitank missile.) TERRY GANNON

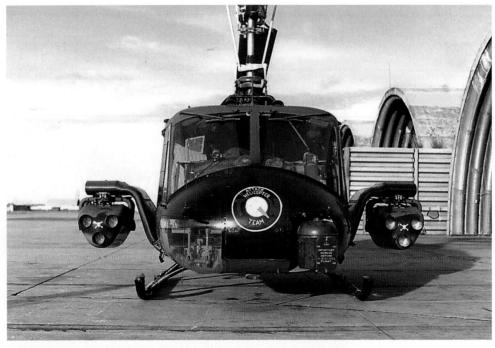

A head-on shot of WHISPERING DEATH. The telescopic sight unit is visible on the nose. Most prominent are the two side-mounted, three-round missile launchers.
TERRY GANNON

This side view of WHISPERING DEATH nicely depicts its camouflage scheme.
TERRY GANNON

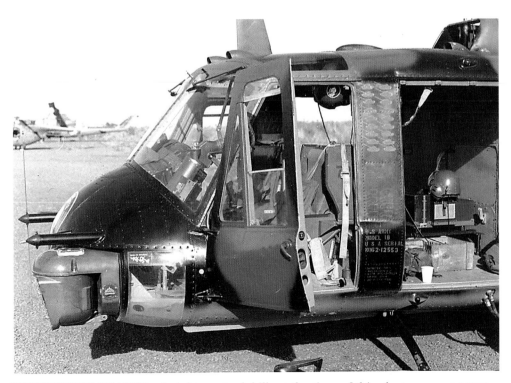

WHISPERING DEATH had eighteen tank kills at the time of this photo. TERRY GANNON

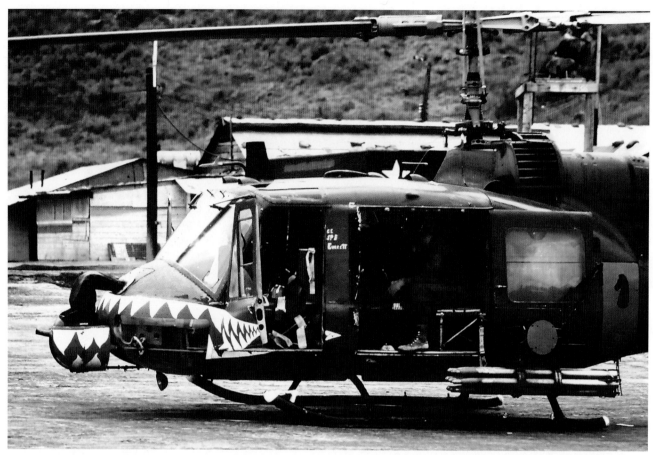

HAVE GUN WILL TRAVEL. UH-1C, 65-09507. 174th Assault Helicopter Company. Duc Pho, 1970. Crewed by Everett CE. Also known as PALADIN. Named after a TV Western series in which the character named Paladin acted like the James Bond of the Old West. Survived Vietnam, amassing 3,326 flight hours, serving in the 174th from August 1970 to February 1971. FRED THOMPSON

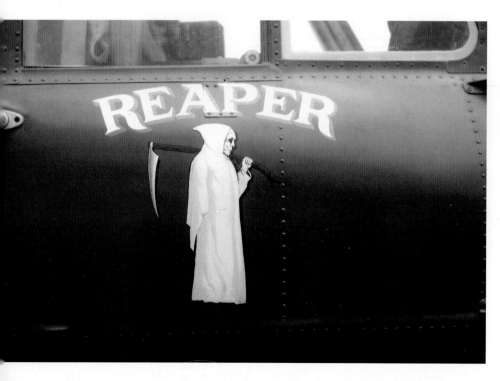

REAPER. UH-1C, 66-15045. 175th Assault Helicopter Company. Vinh Long, 1967. Crewed by Roger Anderson CE. Accrued 2,530 flight hours from April 1967 to November 1970, serving in the 175th from April 1967 to February 1969. Loss to inventory on November 23, 1970. DAN ALDRIDGE

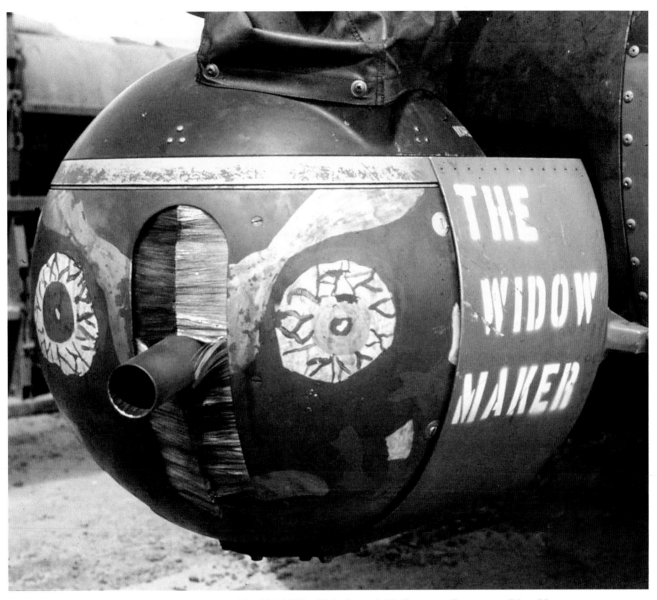

THE WIDOW MAKER. UH-1C, 66-00688. 68th Assault Helicopter Company. Bien Hoa, 1968. Survived Vietnam from 1967 to April 1971, accruing 1,569 flight hours, serving in the 68th in 1967–68. KENT HUFFORD

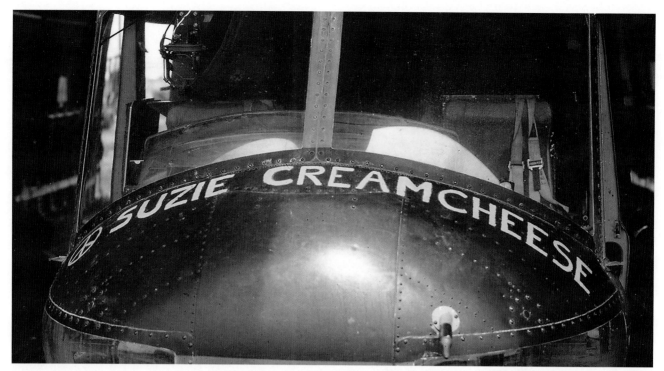

SUZIE CREAMCHEESE. UH-1B, 63-12916. A Troop, 1st Squadron, 9th Cavalry. Cu Chi, 1968. Crewed by Chris Gray CE. Name and peace symbol painted by Chris Gray (later killed in an OH-6A). Named for the fictional female musical character, Suzy Creamcheese, featured on Frank Zappa records. Survived Vietnam from October 1964 to August 1970, compiling 2,872 flight hours, serving in A Troop from April 1969 to April 1970. GEORGE SULLIVAN

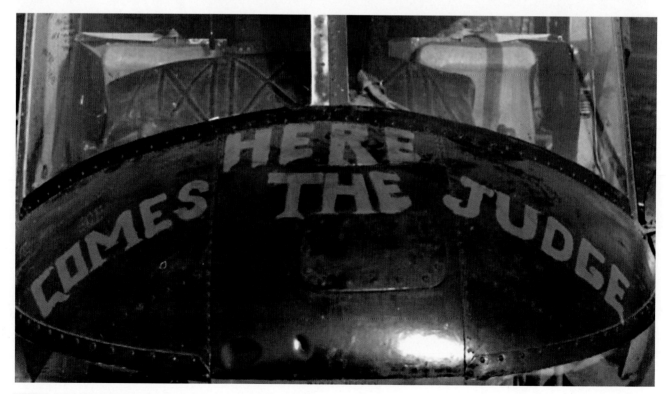

HERE COMES THE JUDGE. UH-1C, 66-15005. 116th Assault Helicopter Company. Cu Chi, 1969. Crewed by Joe Skarda DG. Name can be traced to the emphatic punch line—"Here comes da judge!"—heard weekly on *Laugh-In*. Survived Vietnam from October 1967 to October 1971, with 1,812 flight hours, serving with the 116th from July 1968 to March 1969. JOE SKARDA

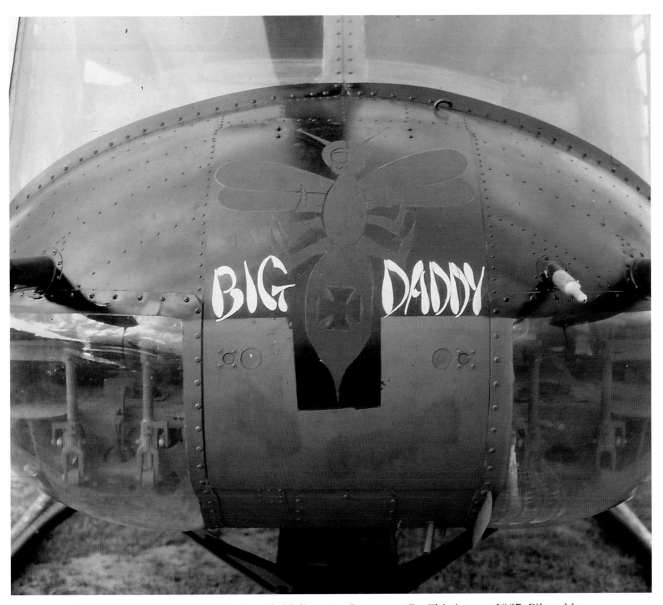

BIG DADDY. UH-1D. 116th Assault Helicopter Company. Cu Chi, August 1967. Piloted by Mike Cheney AC and crewed by John Holman DG and George Cathey DG. Aptly named gunship that was outfitted with an M39 20mm cannon from a U.S. Air Force A-1 Skyraider, a fixed-wing attack bomber. The cannon was slung under the Huey's belly between the skids and belt-fed out the open left cargo door. JIM JOHNSON

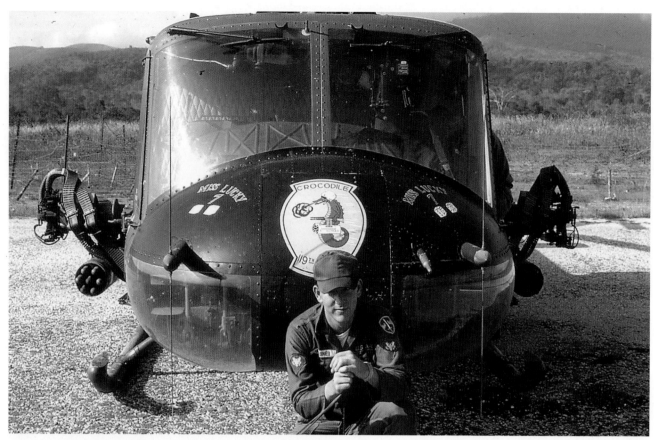

MISS LUCKY 7. UH-1B, 64-13939. 119th Assault Helicopter Company. Pleiku, 1966. Piloted by Ed Coombs AC and crewed by Jimmy Roberts CE (pictured). Name inspired by Coombs's four unscheduled landings—"shoot downs"—in other gunships and the aircraft's designation as CROC 7 within the 3rd Platoon. Survived Vietnam, leaving in May 1971 with 2,981 total hours. ED COOMBS

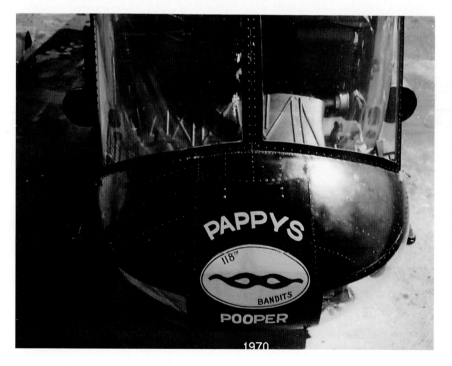

PAPPYS POOPER. UH-1C, 66-00558. 118th Assault Helicopter Company. Bien Hoa, 1970. Piloted by Darrell Burkhalter AC and crewed by J. Rizzo CE and J. Cushing DG. Named after the M-5 grenade launcher (no longer attached to the copter nose). Survived Vietnam from August 1966 to February 1971, accruing 2,581 flight hours, serving in the 118th from July 1969 to January 1971.
DARRELL BURKHALTER

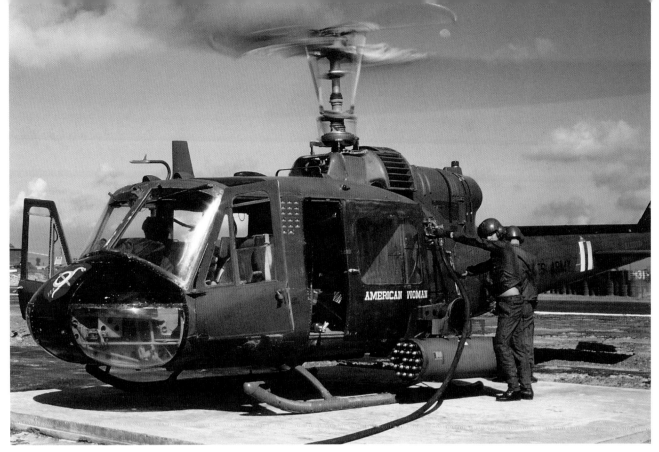

AMERICAN WOMAN. UH-1M, 65-09438. 135th Assault Helicopter Company. Bear Cat, 1971. Piloted by Bob Bratkovic AC and crewed by Larry Ritchie CE and Mike Peterson DG. Named after the 1970 song by The Guess Who. According to Bratkovic, "Ritchie had his mom in Detroit send us actual black lacquer paint from GM's Cadillac division to paint the nose. We put about five coats on her so she had this really deep shine to her." Photo shows a hot refuel. Survived Vietnam from November 1967 to December 1971, with 1,756 flight hours, serving in the 135th from April 1970 to December 1971. PETER OLESKO

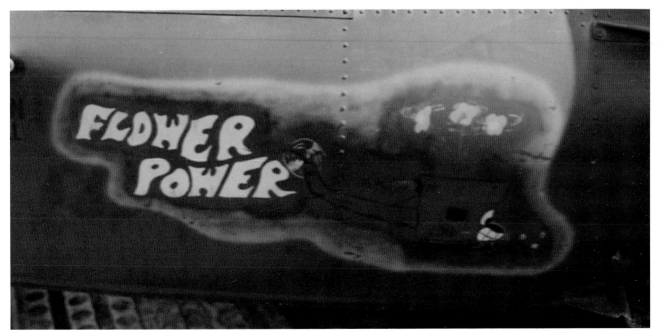

FLOWER POWER. UH-1C, 66-15169. 173rd Assault Helicopter Company. Lai Khe, 1969. Crewed by Richie Wolk CE. Name drawn from the American counterculture. Artwork on pilot's door depicts a flowerpot minigun firing flowers. Accumulated 2,321 flight hours from July 1967 to March 1971, serving in the 173rd from April 1968 to September 1969. Loss to inventory on March 5, 1971, during Lam Son 719 with the 174th Assault Helicopter Company. RICHIE WOLK

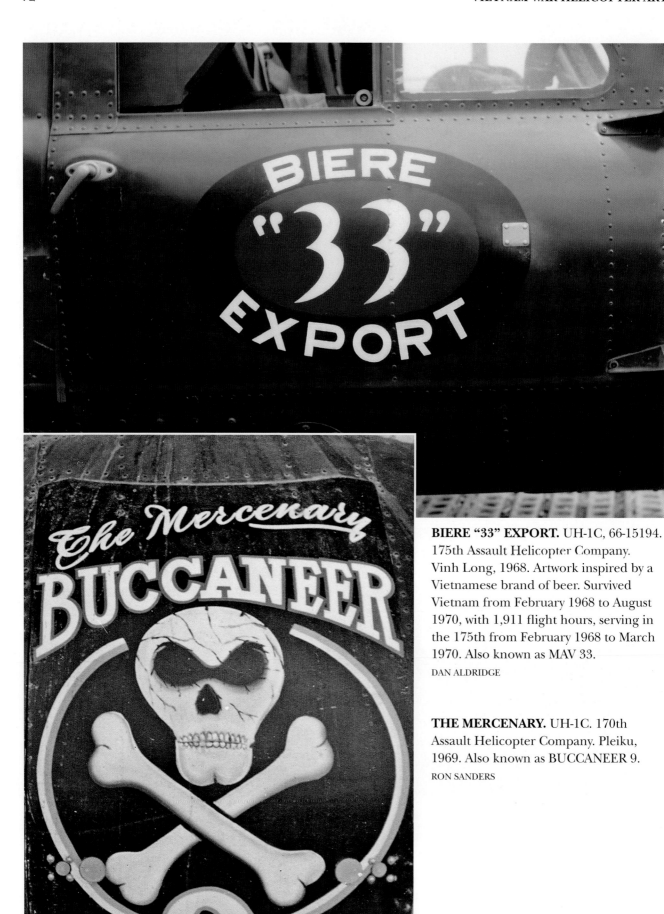

BIERE "33" EXPORT. UH-1C, 66-15194. 175th Assault Helicopter Company. Vinh Long, 1968. Artwork inspired by a Vietnamese brand of beer. Survived Vietnam from February 1968 to August 1970, with 1,911 flight hours, serving in the 175th from February 1968 to March 1970. Also known as MAV 33.
DAN ALDRIDGE

THE MERCENARY. UH-1C. 170th Assault Helicopter Company. Pleiku, 1969. Also known as BUCCANEER 9.
RON SANDERS

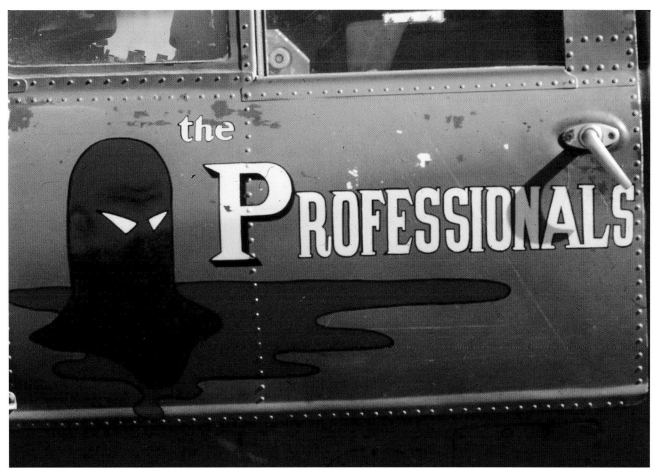

THE PROFESSIONALS. UH-1C. 175th Assault Helicopter Company. Vinh Long, 1968. Crewed by Virgil Wright CE and Dale Senatore DG. Name possibly influenced by the 1966 Hollywood film starring Burt Lancaster. Artwork possibly influenced by vintage pulp paperback covers. Also known as MAV 34. DICK KOENIG

TOP GUNS WILL TRAVEL. UH-1C, 65-09417. 173rd Assault Helicopter Company. Lai Khe, 1967. Crewed by Tony Zanfardino CE. Amassed 2,269 flight hours from December 1965 to April 1970, serving in the 173rd from 1966 until February 1968. Loss to inventory on April 11, 1970. MIKE WILTON

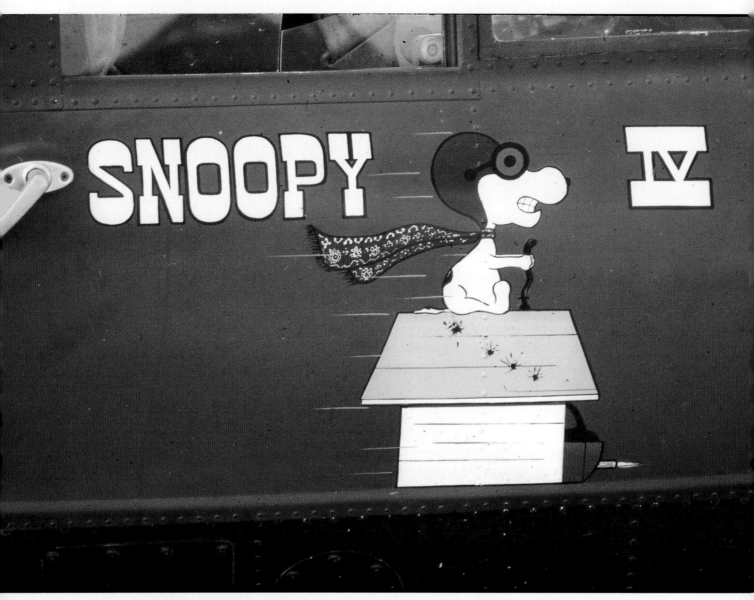

SNOOPY IV. UH-1C. 175th Assault Helicopter Company. Vinh Long, 1968. A local civilian named Oscar performed all Maverick and Outlaw commissioned art. Not seen in the photo is the "Curse You Red Baron" slogan painted on the XM-159 rocket pod. The aircraft's weapons configuration also included an M-5 grenade launcher on the nose, turning this flying doghouse into a heavy hog. Also known as MAV 38. DICK KOENIG

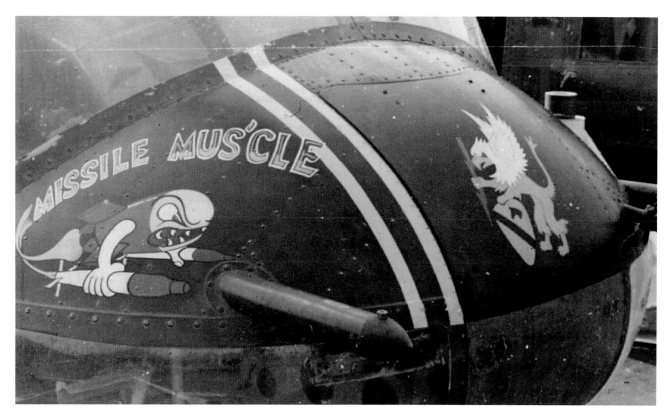

MISSILE MUSCLE. UH-1B, 62-12518. B Battery, 2nd Battalion, 20th Aerial Rocket Artillery. Tan Son Nhut, 1967. This aircraft was armed with both SS-11s (wire-guided, antiarmor) and 2.75-inch rockets. Accumulated 2,656 flight hours from October 1963 to March 1969, serving in B Battery from October 1966 to September 1967. Destroyed on March 26, 1969, in an ammo dump explosion at Dong Tam while serving with the U.S. Navy's HAL-3 gunship detachment. BOB CHENOWETH

THE EXECUTIONER. UH-1C, 66-00597. 192nd Assault Helicopter Company. Phan Thiet, 1971. Piloted by Bruce Whitney AC and Bobby Goolsby CP and crewed by John Arthur CE. Artwork features the iconic figure from the Zig-Zag brand of cigarette rolling papers. Painted on the doorpost—illegible at the right of the photo—is "Happiness Is a Warm Gun," from the 1968 song by The Beatles. Began tour with the 114th Assault Helicopter Company, where it was known as KING COBRA. Amassed 2,749 flight hours from November 1966 to June 10, 1971, when the aircraft crashed, with two killed, including Arthur. BRUCE WHITNEY

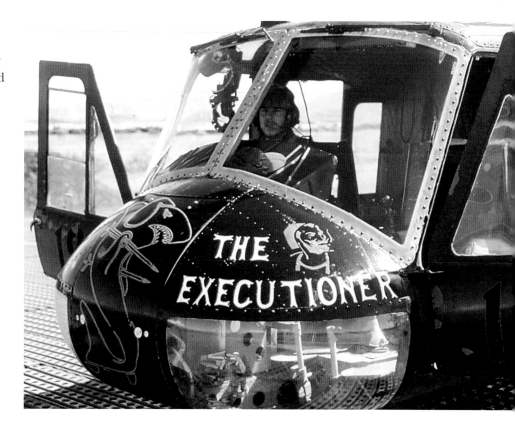

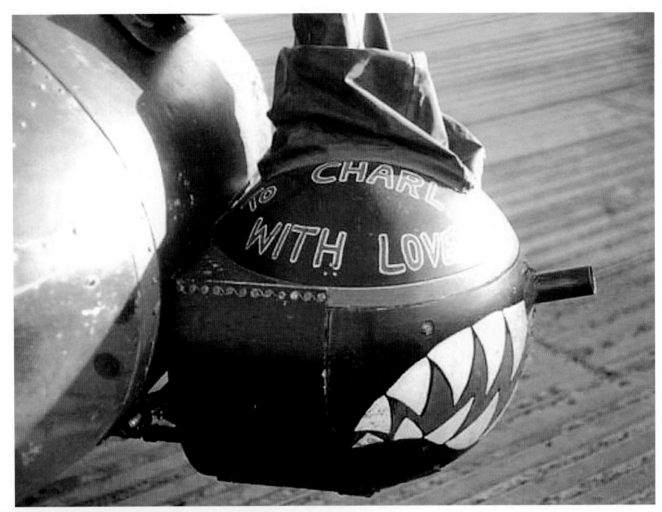

TO CHARLIE WITH LOVE.
UH-1C. 192nd Assault Helicopter
Company. Phan Thiet, 1969.
This endearing message for
Victor Charlie accompanied the
exploding bite from the M-5
grenade launcher attached to
this gunship. ROBERT DAVIS

PSYCHODELIC DEATH. UH-1C.
155th Assault Helicopter Company.
Ban Me Thuot, 1968. Intentional
misspelling of "psychedelic."
AL BOLLENS

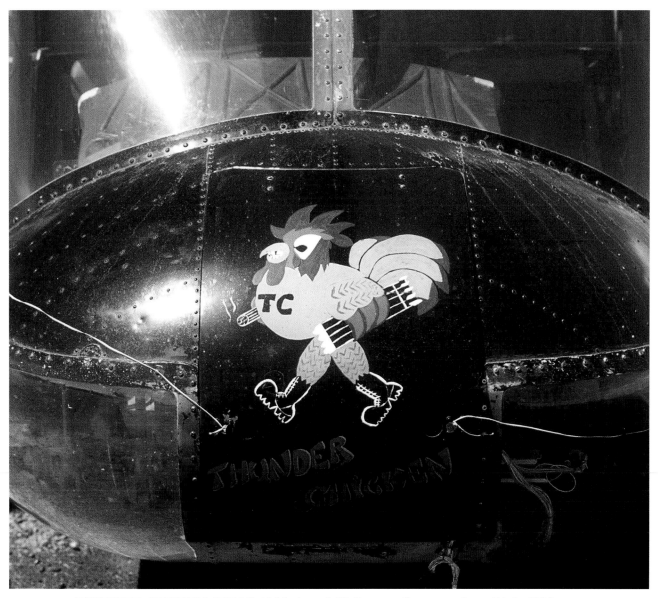

THUNDER CHICKEN. UH-1C. 195th Assault Helicopter Company. Long Binh, 1969.
This name was the gunship platoon's call sign. GRANT CURTIS

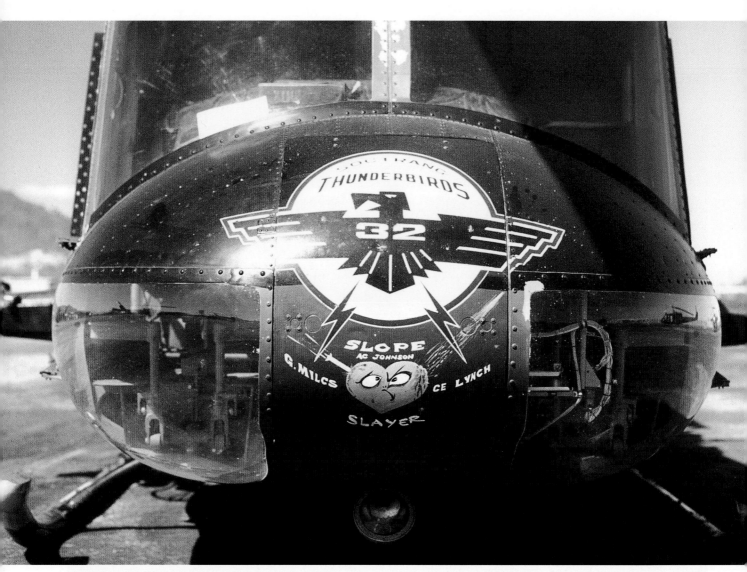

SLOPE SLAYER. UH-1C. 336th Assault Helicopter Company. Soc Trang, 1969. Piloted by Jim Beddingfield. GRANT CURTIS

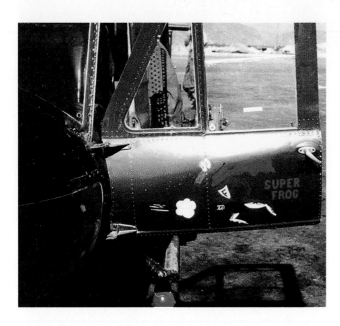

SUPER FROG. UH-1C, 66-00713. 188th Assault Helicopter Company. LZ Sally, 1968. Crewed by Cabigon CE. Accumulated 486 flight hours from August 1968 to February 1970, serving in the 188th from August 1968 to December 1968. Loss to inventory on February 28th, 1970. JOHN SOARES VIA DICK DETRA

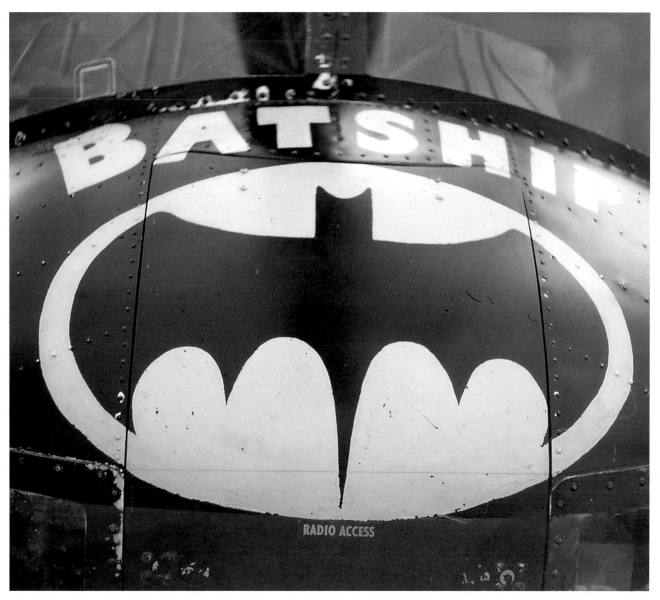

BATSHIP. UH-1C, 65-09435. B Company, 25th Aviation Battalion. Cu Chi, July 1967. This aircraft was the unit's smoke ship. JIM JOHNSON

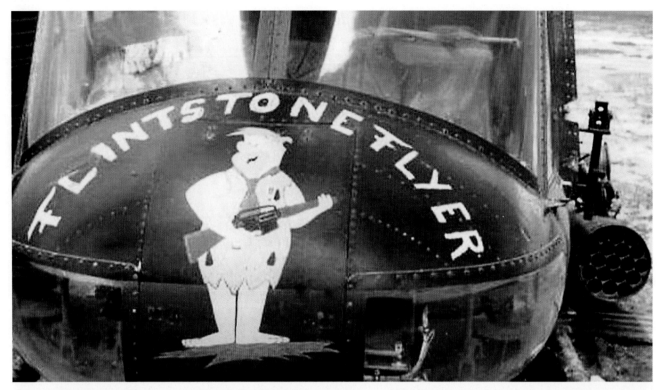

FLINTSTONE FLYER. UH-1C, 66-15174. B Company, 25th Aviation Battalion. Cu Chi, 1968. Crewed by Ed Lyons CE. The iconic star of the animated series holds an M16. ED LYONS

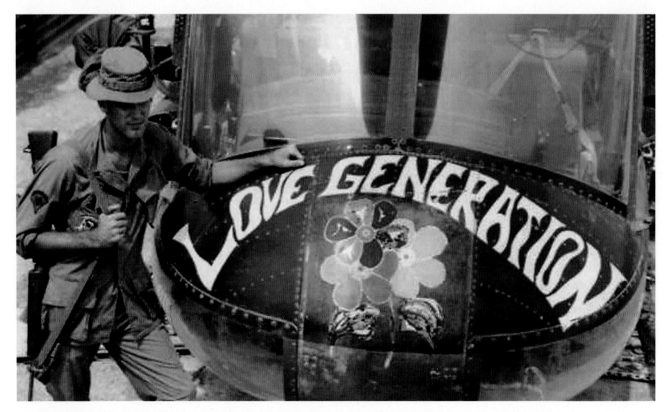

LOVE GENERATION. UH-1C, 66-15170. B Company, 25th Aviation Battalion. Cu Chi, 1969. Piloted by Joe Footer AC. Survived Vietnam from November 1968 to October 1971, with 2,993 flight hours, serving in B Company from November 1968 to December 1969. ED LYONS

UH-1 HUEY

Manufactured by Bell Helicopter in A, B, D, and H models, the UH-1 was a single-engine multipurpose aircraft with two pilots, one crew chief, and one door gunner who flew primarily troop-carrier operations. The Huey served in Vietnam from 1962 to 1973, losing 2,689 aircraft. More than 2,200 are known to have been named by their crews, including *Honey Mama* and *Unlimited Hell*.

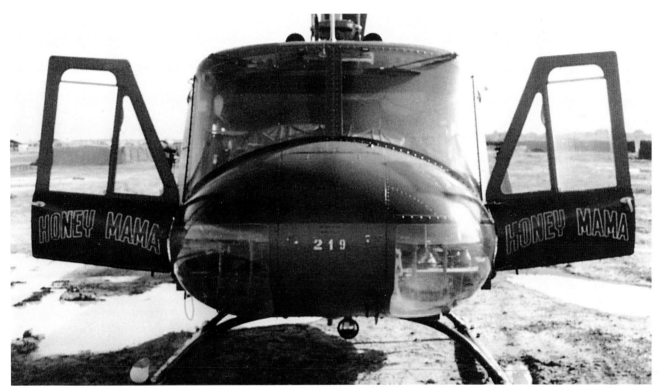

HONEY MAMA. UH-1H, 67-17219. 187th Assault Helicopter Company. Tay Ninh, 1968. Piloted by Russell Welch AC and crewed by Bill Newman CE and Keith Stowell DG. Survived Vietnam from March 1968 to December 1970, with 2,363 flight hours, serving in the 187th from March 1968 to September 1969.
KEITH STOWELL

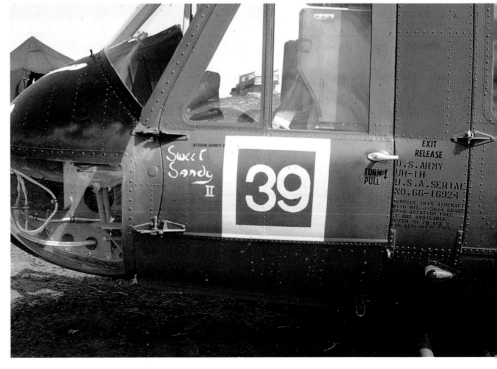

SWEET SANDY II. UH-1H, 66-16924. B Troop, 1st Squadron, 9th Cavalry. LZ Porrazzo, II Corps, November 1967. Piloted by Jim Pratt AC. Named after Pratt's girlfriend. Served its entire tour with B Troop, accumulating 781 flight hours from November 1967 to October 69. Loss to inventory on October 10, 1969.
JIM PRATT

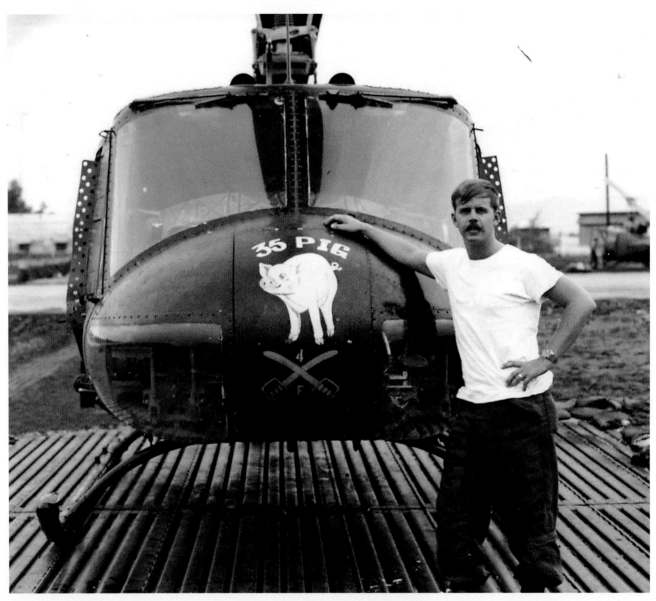

35 PIG. UH-1H, 68-16358. F Troop, 4th Cavalry. Tan My Island, fall 1972. Piloted by Dan Keirsey AC (pictured). Name emphasizes the aircraft's weak engine and corresponds to the last three digits of the serial number, replacing "8" with "pig" because of its suggestive shape. Survived Vietnam from November 1969 to January 1973, with 2,925 flight hours, serving in F Troop from August 1972 to January 1973. DAN KEIRSEY

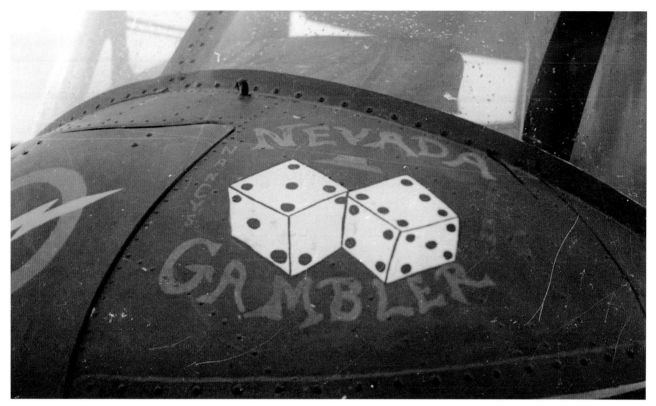

NEVADA GAMBLER. UH-1H, 66-16642. C Company, 227th Assault Helicopter Battalion. Phuoc Vinh, 1969. Crewed by Howie Belkin DG, who painted the nose art. Also known as NANCY'S DREAM. Survived Vietnam from August 1967 to February 1972, amassing 3,890 flight hours and serving in C Company from September 1969 to September 1971. HOWIE BELKIN

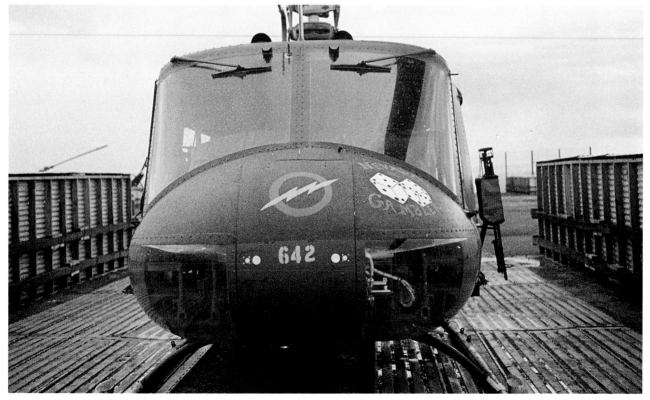

A head-on shot of NEVADA GAMBLER. HOWIE BELKIN

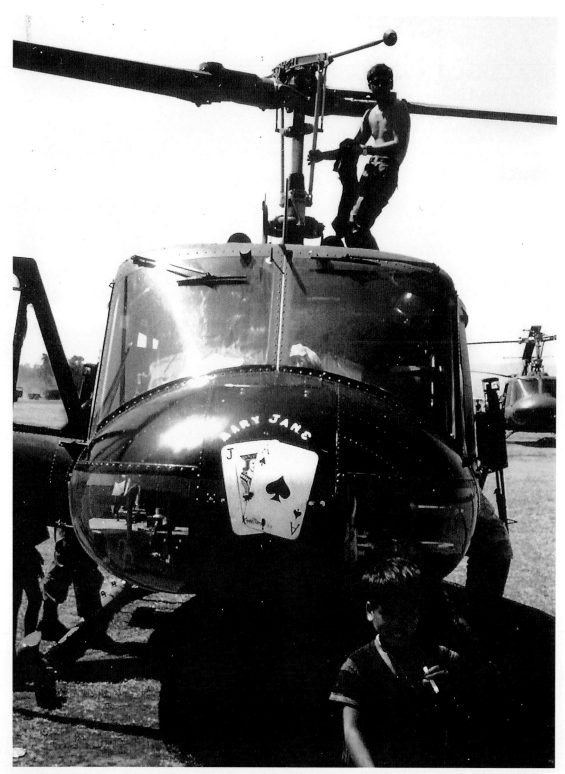

MARY JANE. UH-1H, 66-16598. A Company, 4th Aviation Battalion. Camp Enari, Pleiku, 1969.
Piloted by Beck Gipson and crewed by Frank Morrison CE. Says Gipson: "I can tell you that this
country boy was so naïve as to not understand why troops always waved a peace sign at me when
we landed for resupply. After some embarrassing moments, my crew chief set me straight that
'Mary Jane' was code for marijuana." Compiled 295 flight hours from November 1968 to February
1969, all with A Company. Suffered serious combat damage on February 17, 1969. BECK GIPSON

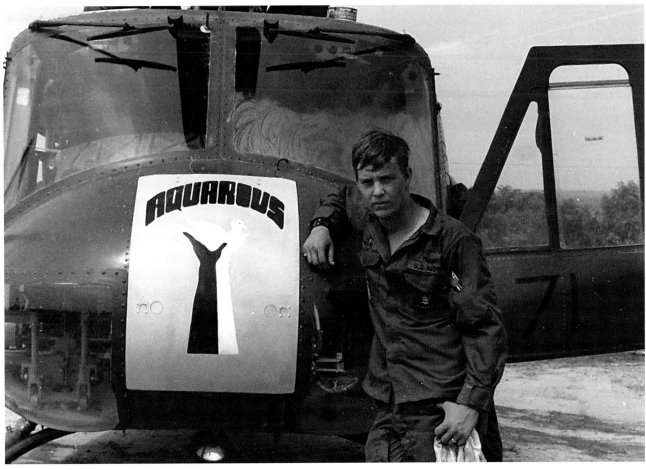

AQUARIUS. UH-1H, 69-15762. 71st Assault Helicopter Company. 1971. Crewed by Ron Taylor CE (pictured). Named after the hit song "Aquarius/Let the Sunshine In" by The 5th Dimension. According to Taylor, "Captain Frazer called me a hippie and wanted to know why I painted a peace sign on the ship. He never forgot that aircraft." Survived Vietnam from November 1970 to June 1971, with 675 flight hours, all with the 71st. RON TAYLOR

CHRISTINE. UH-1H, 69-15763. 174th Assault Helicopter Company. Chu Lai, October 1971. Piloted by Don Peterson AC and crewed by Randy Godbold CE. Named for Peterson's daughter, whose portrait is painted on the avionics door. Accumulated 1,197 flight hours from November 1970 to October 1971, all with the 174th. Loss to inventory on October 23, 1971. ABE GOMES

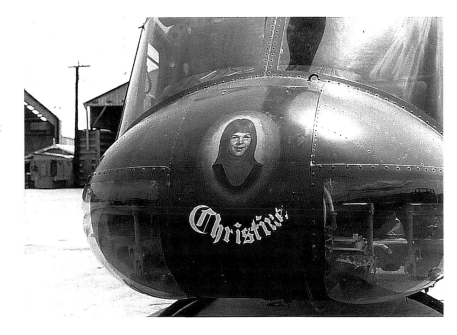

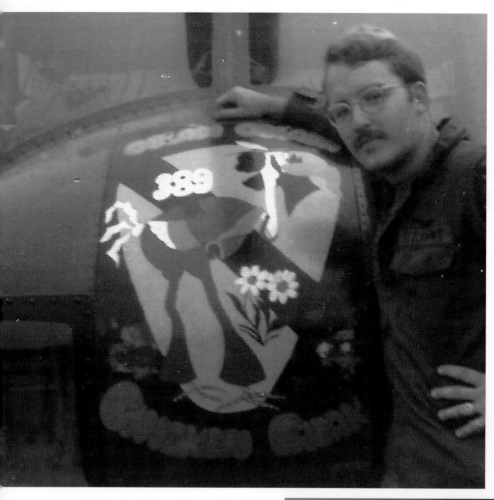

CHICKEN FREAK. UH-1H, 67-17389. A Company, 227th Assault Helicopter Battalion. Lai Khe, 1970. Piloted by John Culhane AC and crewed by Craig Tonjes CE (pictured) and Mark Olmstead DG. Also known as OBLADI OBLADA, from The Beatles song "Ob-La-Di, Ob-La-Da," which appears at the top of the painting. Says Tonjes: "We were the hippie chicken." Survived Vietnam from August 1968 to December 1970, with 2,301 flight hours, serving in A Company from June to November 1970.

DON WYROSDICK VIA P. J. TOBIAS

CHICKENMAN 6. UH-1H, 68-16510. A Company, 227th Assault Helicopter Battalion. Camp Holloway, 1971. According to Terry Moore, "This was Major Adams's aircraft—his regular aircraft, not the one he died in. We stole the cover when Major Adams's replacement arrived since we didn't think he deserved to fly that cover. It was later returned since we didn't know what else to do with it as we sobered up the next day." TERRY MOORE

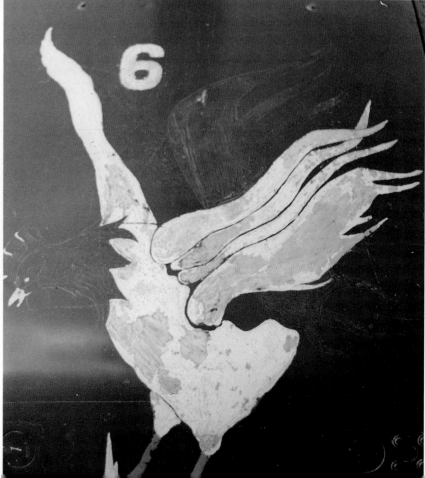

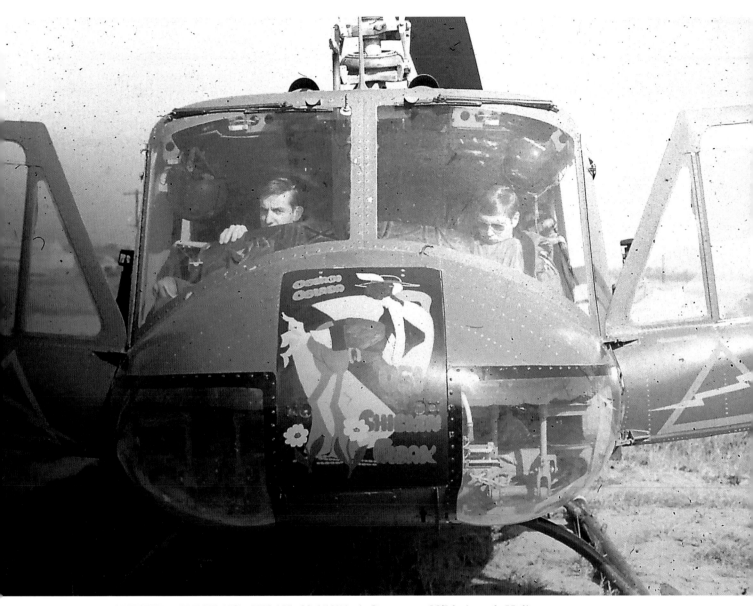

CHICKEN FREAK (#2). UH-1H, 69-15051, A Company, 227th Assault Helicopter Battalion. Lai Khe, 1970. Piloted by John Culhane AC (right) and crewed by Craig Tonjes CE and Mark Olmstead DG. Survived Vietnam from February 1970 to February 1972, with a total of 1,971 flight hours, serving in A Company from December 1970 to September 1971. CRAIG TONJES

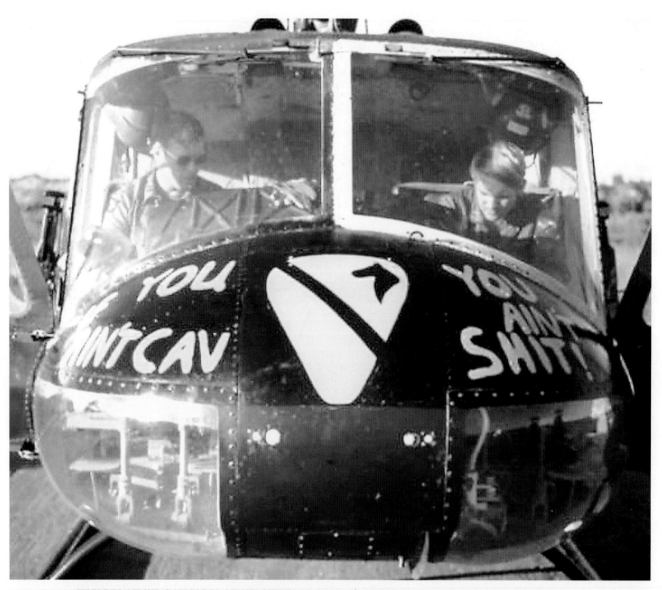

IF YOU AIN'T CAV YOU AIN'T SHIT! UH-1H, 67-19495. A Company, 229th Assault
Helicopter Battalion. Bien Hoa, fall 1971. Piloted by Doug Jorgenson AC (right), who says
the name caused "some controversy amongst senior officers, especially from other units,
and I was ordered to take it off but never did." Survived Vietnam from December 1968 to
January 1972, amassing 2,956 flight hours. DOUG JORGENSON

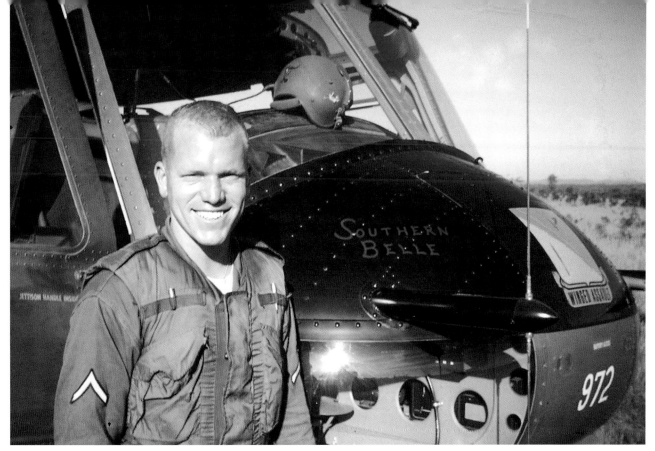

SOUTHERN BELLE. UH-1D, 63-12972. B Company, 229th Assault Helicopter Battalion. An Khe, December 1965. Crewed by Bill Weber CE (pictured), who remembers, "I hung a small Confederate flag in the headliner, and the troops loved to see it when they got on board. SOUTHERN BELLE was a play on words: 'Southern' because we trained with the 11th Air Assault at Fort Benning, Georgia, and 'Belle' because of Bell Helicopter." Survived Vietnam from August 1965 to July 1969, amassing 2,842 flight hours and serving in B Company from August 1965 to July 1967. BILL WEBER

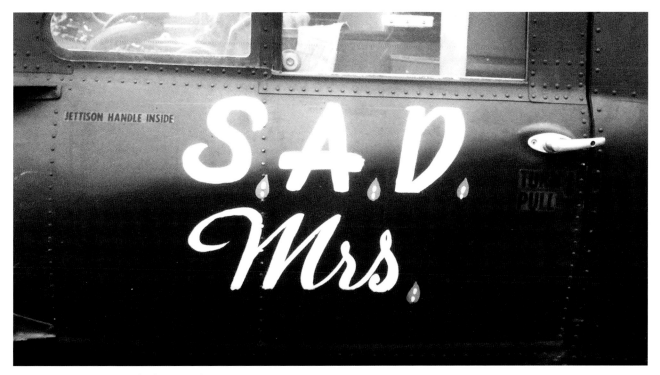

S.A.D. MRS. UH-1H, 67-17558. 187th Assault Helicopter Company. Tay Ninh, 1968. Piloted by Pat Dougan AC, who named the aircraft with his wife's initials. Survived Vietnam from July 1968 to February 1971, with 1,667 flight hours, serving in the 187th from July 1968 to June 1969. PAT DOUGAN

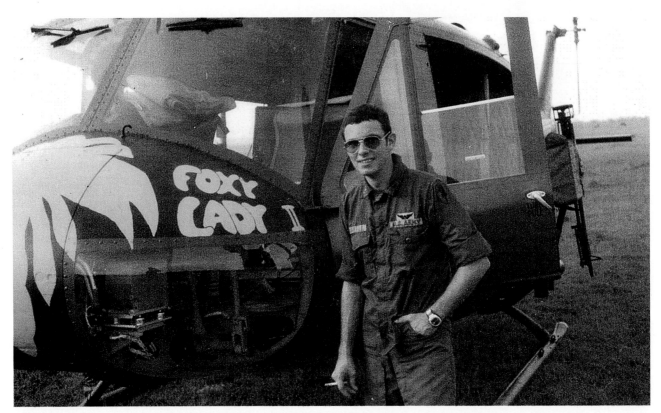

FOXY LADY II. UH-1D. 116th Assault Helicopter Company. 1970. Piloted by Kirk Farrell (pictured) and crewed by Greg Fox CE. Named after the 1967 song by Jimi Hendrix. KIRK FARRELL

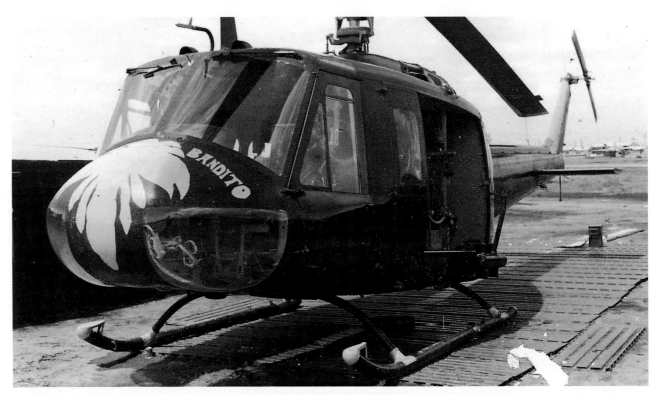

FRITO BANDITO. UH-1D, 66-01021, 116th Assault Helicopter Company. Cu Chi, 1970. Piloted by Larry Pickett AC and Richard Salamond CP and crewed by Juan Garcia CE and K. W. Murphy DG. Named after the mascot of Fritos Corn Chips. Accrued 1,418 flight hours from March 1968 to August 1970, with a stint in the 116th from April to August 1970. Loss to inventory on August 7, 1970. JUAN GARCIA

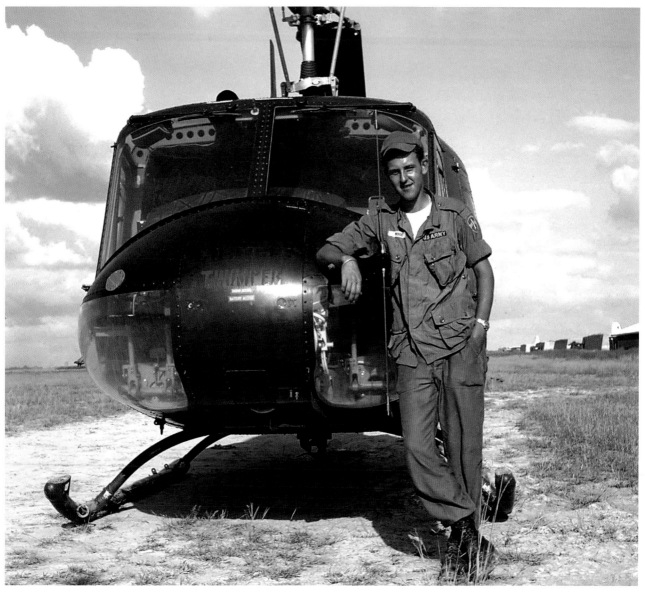

THUMPER. UH-1D, 64-13583. 117th Assault Helicopter Company. III Corps, 1966.
Crewed by Dennis Wood CE (pictured). Named after Wood's girlfriend and future wife.
Accrued 2,268 flight hours from 1965 through November 1967 before it was loss to
inventory on December 3, 1967. DENNIS WOOD

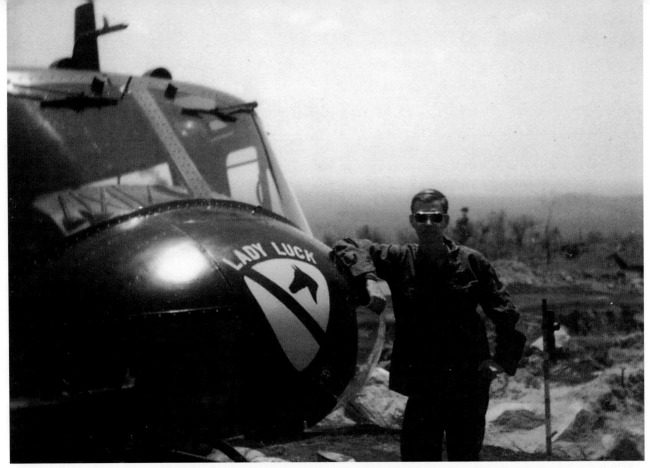

LADY LUCK. UH-1H, 67-17812. Headquarters and Headquarters Company, 1st Air Cavalry Division. 1969. Piloted by Mick Molish AC (pictured). Racked up 3,115 flight hours from November 1968 to December 1971, serving with Headquarters and Headquarters Company from November 1968 to July 1969. MICK MOLISH

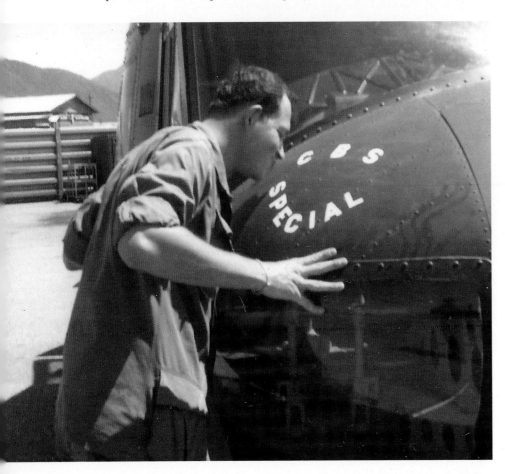

CBS SPECIAL. UH-1H. 21st Signal Group Aviation Detachment. Nha Trang, 1969. Tom Crews CE plants a wet one on CBS. According to Crews, "CBS stands for the first letter of the following last names: Crews, Brown, and Stringham . We had a shortage of qualified crew chiefs, so the three of us NCOs, in theory, took turns crewing this ship while we also did our other duties. But I was outranked and, in practice, ended up taking most of the flights." TOM CREWS

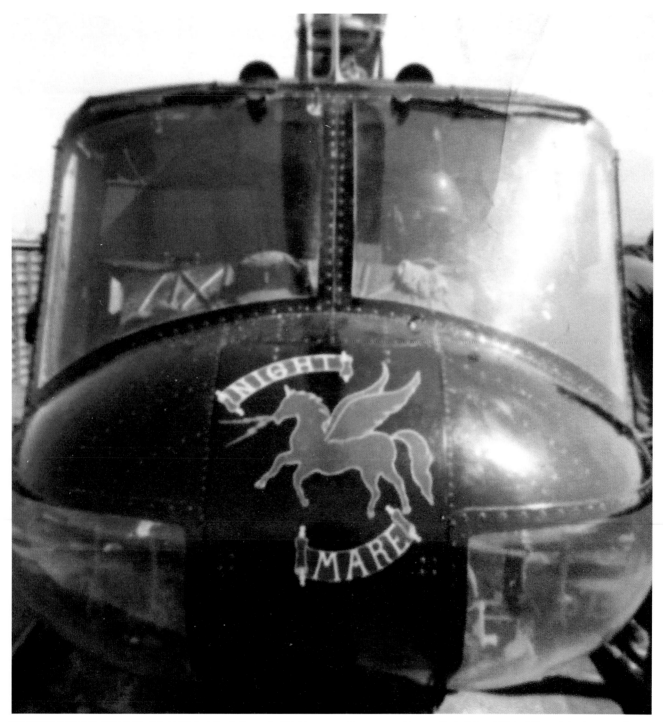

NIGHT MARE. UH-1H, 66-17038. 92nd Assault Helicopter Company. Dong Ba Thin, 1971. Piloted by Stan Edburg AC and crewed by Morris Lambert CE. Specifically utilized for Nighthawk missions patrolling the Cam Ranh Bay perimeter. Survived Vietnam from December 1967 to September 1971, with 3,120 flight hours, serving in the 92nd from May 1970 to September 1971. MORRIS LAMBERT

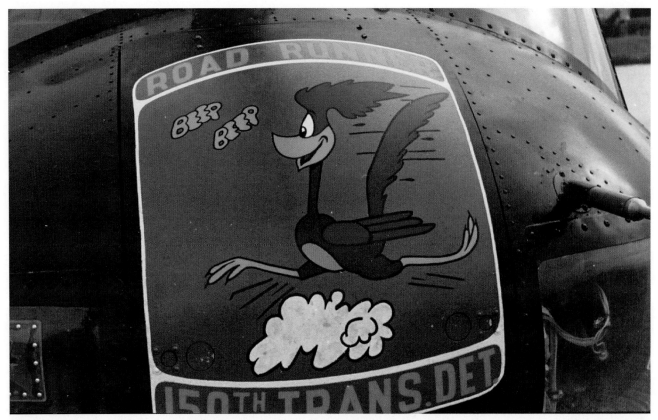

ROAD RUNNER. UH-1D. 150th Transportation Detachment. Vinh Long, 1967. Unit maintenance ship for the 175th Assault Helicopter Company. Nose art designed by Bob Koonce. BOB CHENOWETH

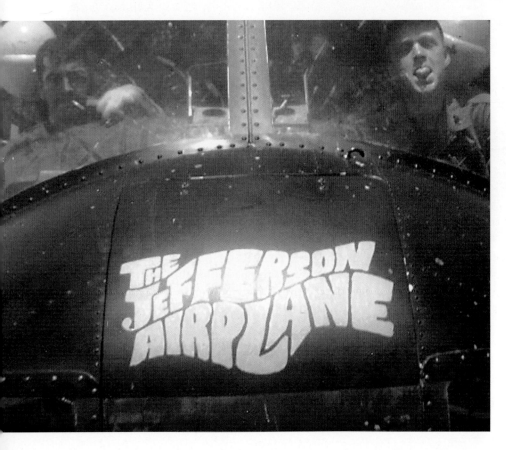

THE JEFFERSON AIRPLANE. UH-1H, 66-16460. 92nd Assault Helicopter Company. Dong Ba Thin, 1968. Piloted by WO Cecchin (left) and WO Coombs (right). Named after the San Francisco–based rock band. Survived Vietnam from November 1967 to February 1970, with 1,857 flight hours, serving in the 92nd from November 1967 to June 1968. BOB HERNDON

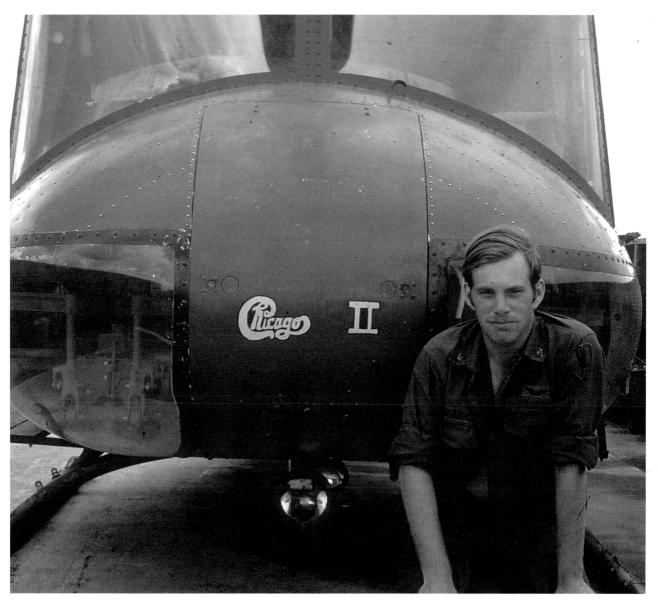

CHICAGO II. UH-1H, 68-16563. 117th Assault Helicopter Company. Long Binh, 1971.
Crewed by Paul Goodwin CE (pictured), who came from a suburb of Chicago and also
liked the band Chicago. Survived Vietnam from January 1970 to February 1972, with
1,886 flight hours, serving in the 117th from July 1971 to February 1972. PAUL GOODWIN

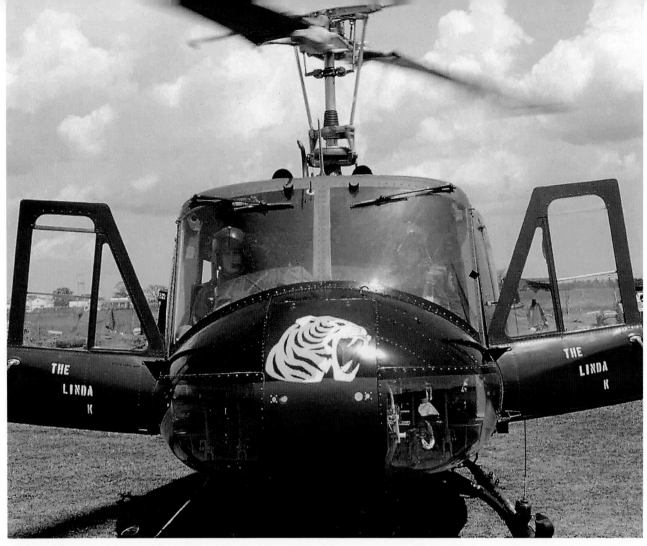

THE LINDA K. UH-1D, 66-16860. 68th Assault Helicopter Company. Bien Hoa, March 1968. Named after the wife of Paul Hill AC, Linda K. Hill. Destroyed by a rocket-propelled grenade on August 18, 1968, only twenty days after former crew chief David Green returned stateside. DAVID GREEN

Paul Hill in THE LINDA K. Hill was killed on May 12, 1968, while piloting UH-1D 65-09680.
DAVID GREEN

WEE LUCK. UH-1B, 63-08711. 2nd Signal Group. Tan Son Nhut, 1966. Piloted by Lester Heath AC and crewed by Bob Callaghan CE and Oliver Ridgway DG. Cargo door artwork by Callaghan. Survived Vietnam from August 1964 to May 1970, amassing 3,086 flight hours, serving in the 2nd Signal Group from May 1966 to August 1967.
BOB CALLAGHAN

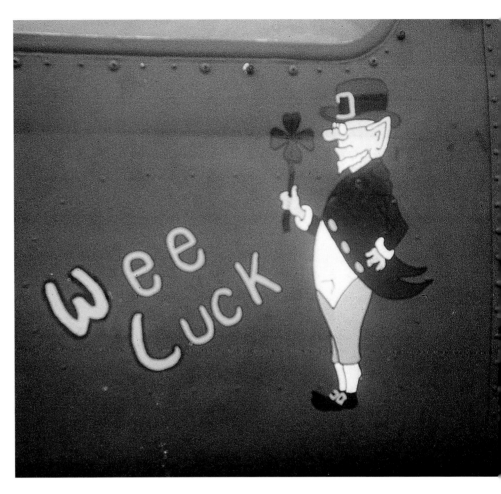

Another view of WEE LUCK, with crew chief Bob Callaghan.
BOB CALLAGHAN

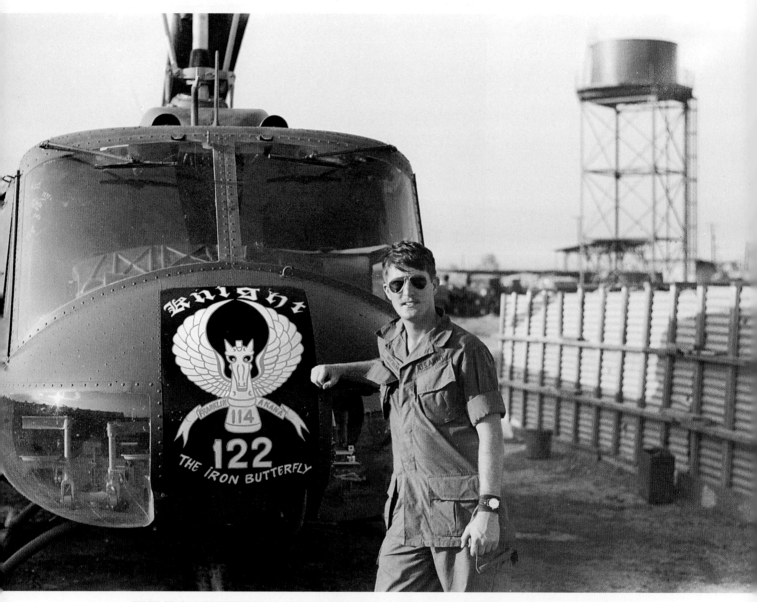

THE IRON BUTTERFLY. UH-1H, 69-15122. 114th Assault Helicopter Company. Vinh
Long, 1970. Named after the rock band. Inscribed in the 2nd Platoon insignia are the
names of Frank Akana CE (KIA November 20, 1970) and Terry Franklin DG. Pictured is
John Brennan. Survived Vietnam from March 1970 to July 1972, accumulating 2,389 flight
hours, serving in the 114th from March 1970 to February 1972. JOHN BRENNAN

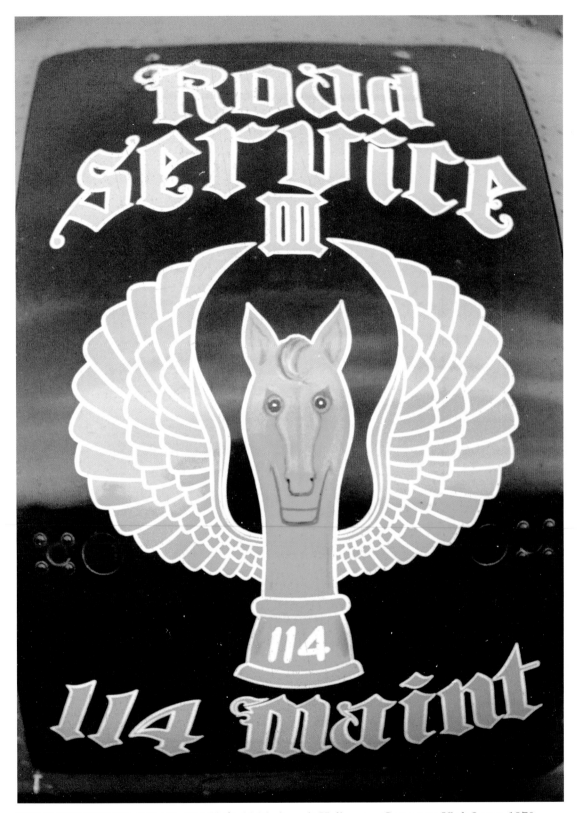

ROAD SERVICE III. UH-1H, 69-15347. 114th Assault Helicopter Company. Vinh Long, 1970. Crewed by Philip Vanderwedge CE. Large white "RS" was also painted on the fin (vertical stabilizer). Survived Vietnam from June 1970 to May 1971, with 811 flight hours, serving all its time in the 114th. JOHN BRENNAN

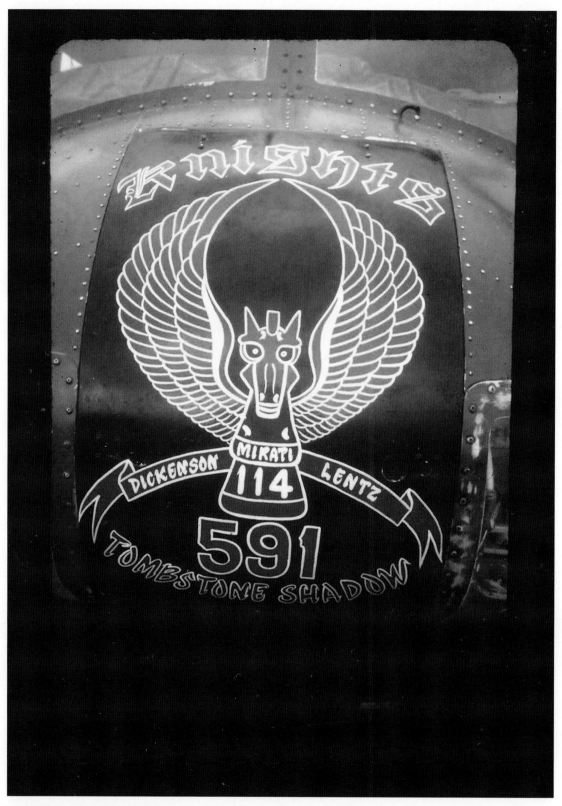

TOMBSTONE SHADOW. UH-1H, 68-16591. 114th Assault Helicopter Company. Vinh Long, 1971. Piloted by Albert Mirati AC and crewed by Glenn Dickenson CE and Lonnie Lentz DG. Name taken from the 1969 song by Creedence Clearwater Revival. Survived Vietnam from January 1970 to January 1972, accumulating 1,983 flight hours, serving in the 114th from December 1970 to January 1972. AL MIRATI

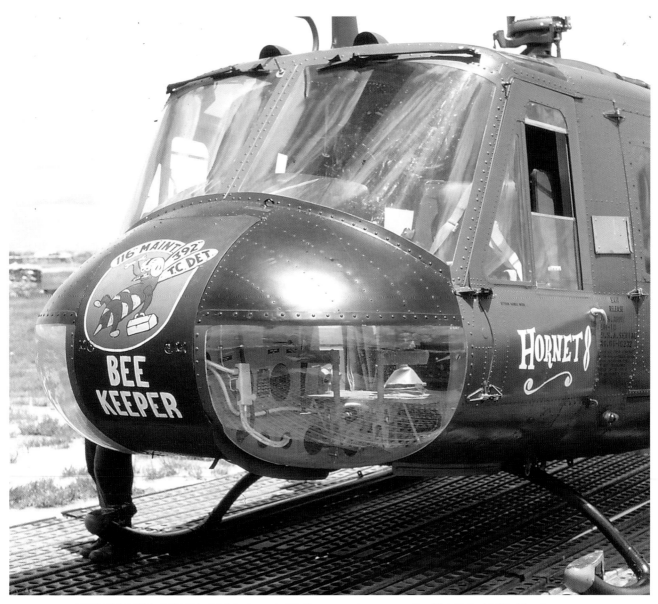

BEE KEEPER. UH-1D. 116th Assault Helicopter Company. Cu Chi, July 1967. Also known as HORNET 8. JIM JOHNSON

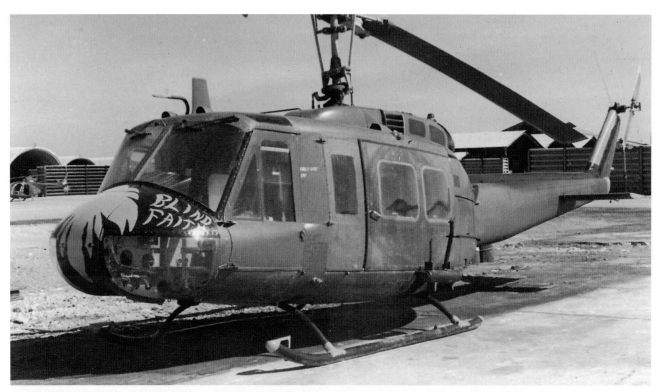

BLIND FAITH. UH-1H, 68-16178. 116th Assault Helicopter Company. Chu Lai, 1970. Crewed by Tommy Kyle CE. Name possibly influenced by the British rock band of the same name. Survived Vietnam from September 1969 to January 1972, exclusively with the 116th, accumulating 2,174 flight hours. JOHN BARRERA

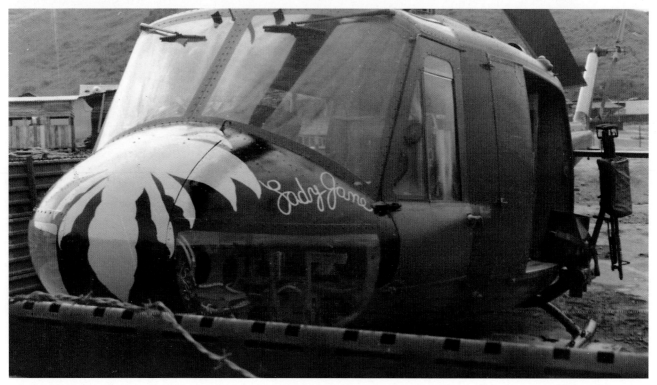

LADY JANE. UH-1H, 69-15527. 116th Assault Helicopter Company. Duc Pho, 1971. Piloted by Ed Hughes AC and crewed by John Barrera CE and R. Tabita DG. Name possibly refers to the 1966 Rolling Stones song. Cursive lettering is unique. Accrued 1,909 flight hours during a tour that spanned from August 1970 to September 1972, serving in the 116th from August 1970 to September 1971. JOHN BARRERA

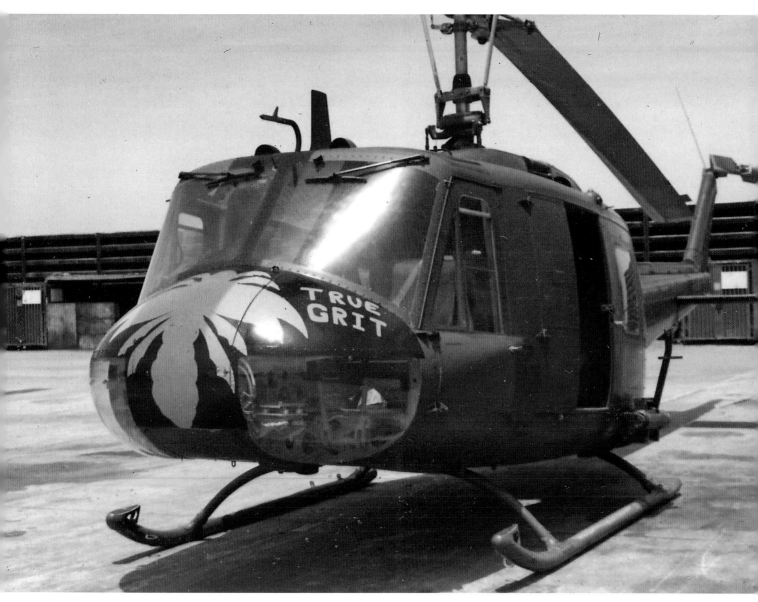

TRUE GRIT. UH-1H, 69-15698. 116th Assault Helicopter Company. Chu Lai, 1970.
Named for the 1969 John Wayne movie. Served in Vietnam from December 1970 to
January 1972, exclusively in the 116th, accumulating 1,174 flight hours. JOHN BARRERA

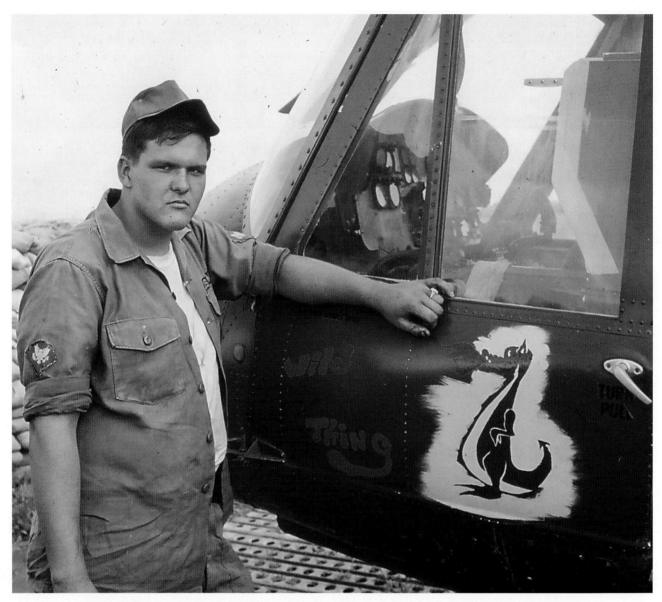

WILD THING. UH-1D, 66-00987. 116th Assault Helicopter Company. Chu Lai, March 1968. Crewed by Dan Johnson CE (pictured), who also painted the artwork. Named after the hit 1966 song by The Troggs. Survived Vietnam from March 1967 to December 1970, with 3,799 flight hours, serving in the 116th from March 1967 to September 1968.
JIM JOHNSON

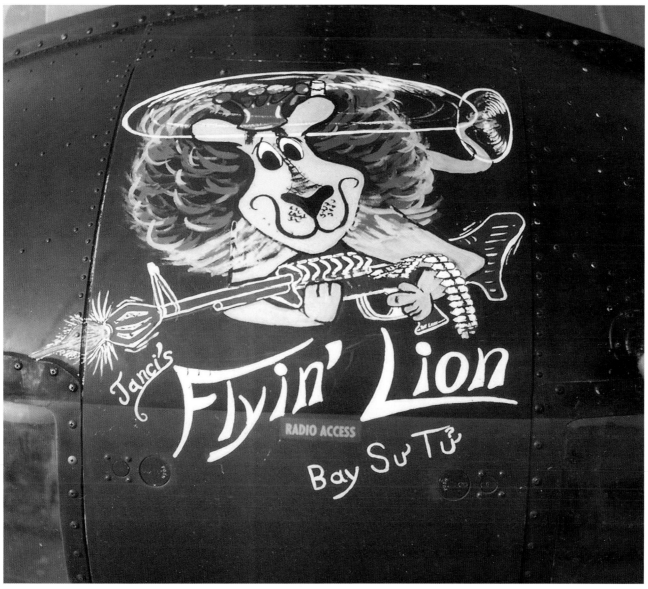

JANCI'S FLYIN' LION. UH-1B. 121st Aviation Company. Soc Trang, 1964. *Bay Su Tu* means "fly and shoot." When the 121st traded in its CH-21s for Hueys in 1964, this Bravo-model slick was among the first batch to arrive from the states. GEORGE MUCCIANTI

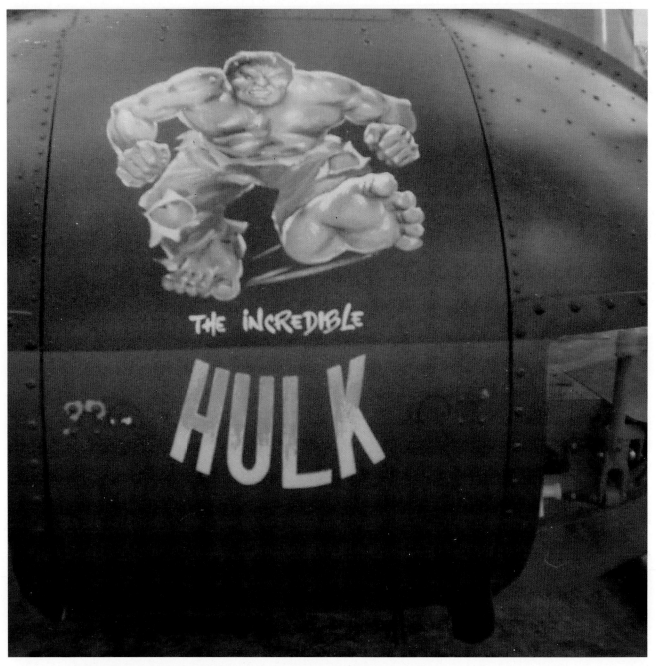

THE INCREDIBLE HULK. UH-1D. 121st Assault Helicopter Company. Soc Trang, 1967.

GARY DOWLER

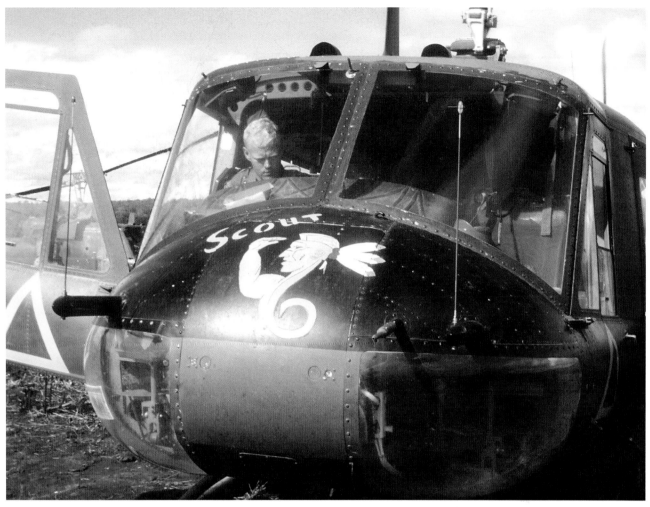

SCOUT. UH-1B, A Troop, 1st Squadron, 9th Cavalry. June 1966. Piloted by John Nielson AC and Thaddeus Cronen CP. Cronen was the commanding officer of A Troop. Notice how the number six on the nose is made part of the art work.
THADDEUS CRONEN VIA JEREMY HOGAN

MASTER PANTHER. UH-1H. 117th Assault Helicopter Company. Long Binh, 1970. Piloted by Dick Dutson (pictured). Name might have been the call sign of the aircraft commander. DICK DUTSON

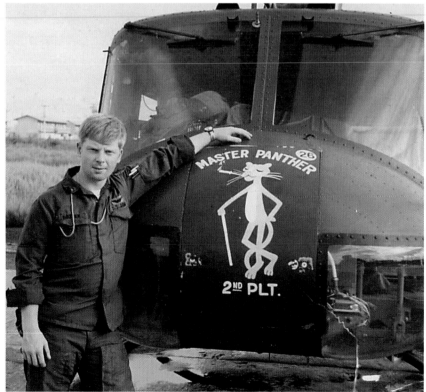

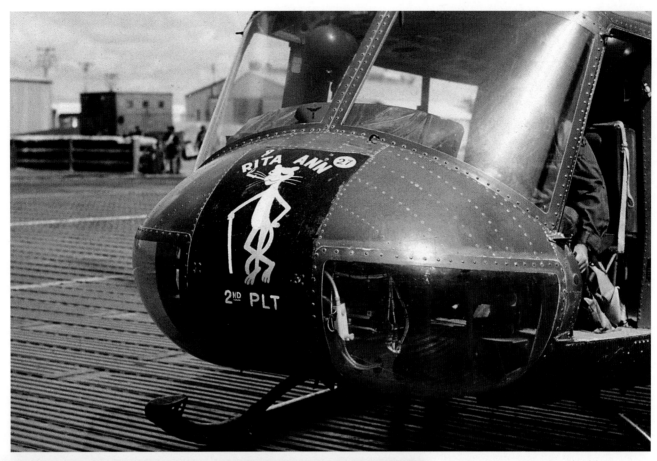

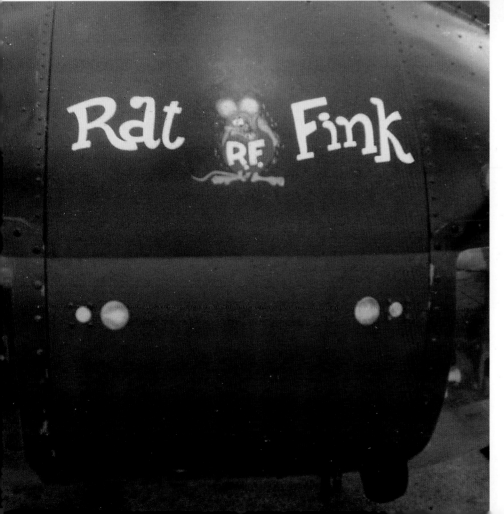

RITA ANN. UH-1H, 67-17725. 117th Assault Helicopter Company. Long Binh, 1969. Piloted by Mike Deady AC. Accrued 1,835 flight hours, serving all its time in the 117th. GRANT CURTIS

RAT FINK. UH-1D. 121st Assault Helicopter Company. Soc Trang, 1967. Crewed by Jerry McBee CE. Name and artwork inspired by the iconic logo by famous funny car artist Ed Roth. GARY DOWLER

STRANGE DAZE. UH-1H, 67-17304. C Company, 229th Assault Helicopter Battalion. Tay Ninh, 1970. Crewed by James Townsend CE. Name probably derived from a 1967 song title by The Doors. Survived Vietnam, accumulating 2,145 flight hours, all with C Company 229 AHB during November 1968 to January 1971. CRAIG THOMAS

The instrument panel of a UH-1B from the 2nd Lift Platoon (WK4-White Knight), 114th Aviation Company. Vinh Long, August 1965. Note "BELL" on the foot pedals. RILEY COOK

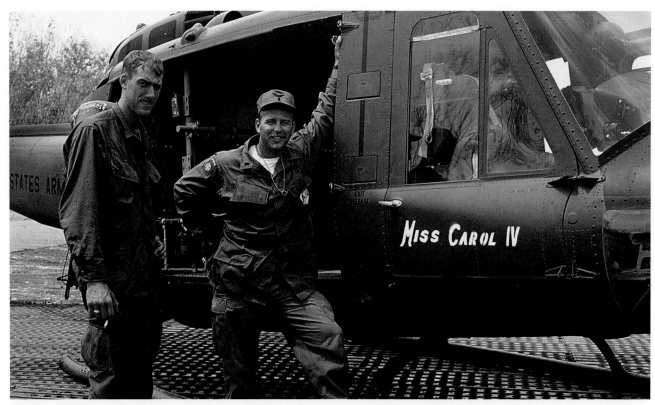

MISS CAROL IV. UH-1H. 173rd Assault Helicopter Company. Lai Khe, 1966. Piloted by Mike Wilton AC (right) and crewed by Jim Visel CE (left). Named after the crew chief's girlfriend. MIKE WILTON

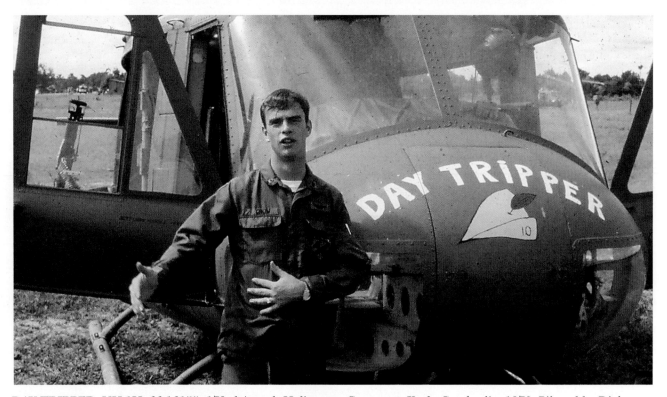

DAY TRIPPER. UH-1H, 66-16155. 173rd Assault Helicopter Company. Krek, Cambodia, 1970. Piloted by Dick Crow AC (pictured) and crewed by Tom Sutton CE. Named after the 1965 song by The Beatles. Survived Vietnam from June 1967 to March 1971, with 1,892 flight hours, serving in the 173rd from April 1970 to March 1971. DICK CROW

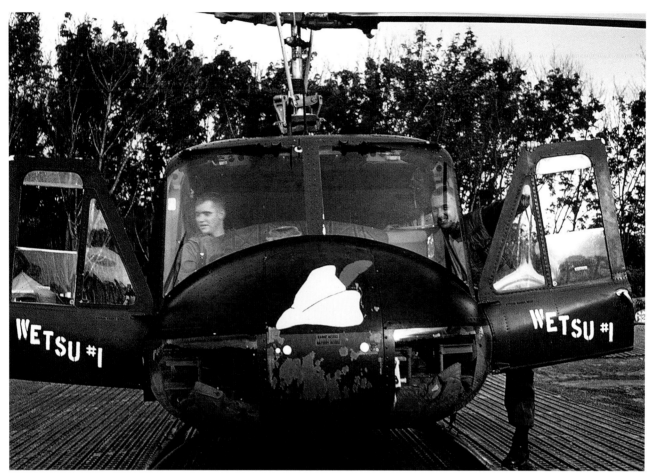

WETSU #1. UH-1D. 173rd Assault Helicopter Company. Lai Khe, 1966. Name stands for "We Eat This Shit Up."
Note the flak jackets in the chin bubbles: Plexiglas apparently wasn't all that bulletproof. MIKE WILTON

FRITO BANDITO. UH-1H, 69-15767. 174th Assault Helicopter Company. Chu Lai, 1971. Nose art by crew chief Keith Jarrett. Served in Vietnam from November 1970 to April 1971, accruing 515 flight hours. Crashed upside down through a forest of trees on April 27, 1971, when Jarrett moved the nose art to UH-1H 68-16573.
ABE GOMES

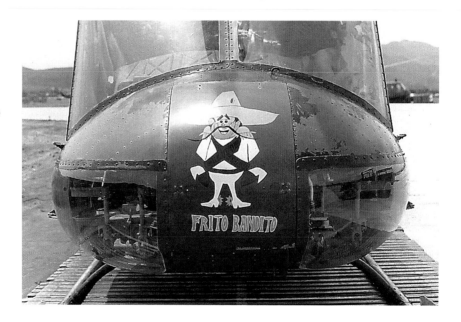

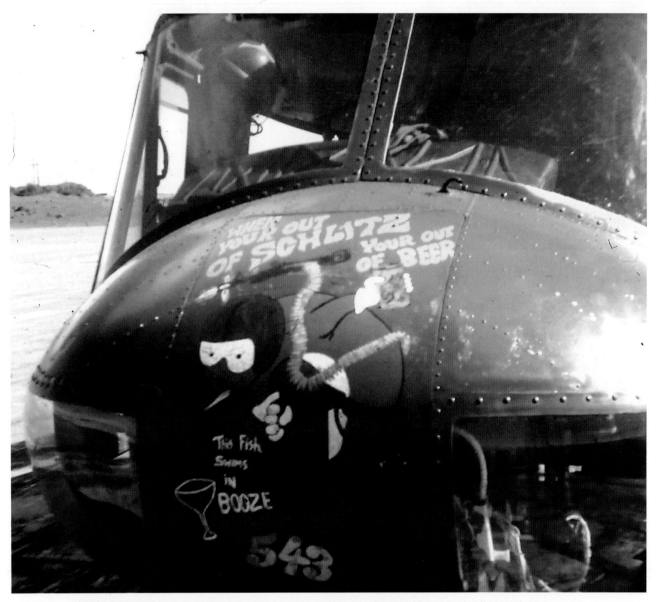

WHEN YOUR OUT OF SCHLITZ YOUR OUT OF BEER. UH-1H, 67-17543. 174th
Assault Helicopter Company. Duc Pho, 1970. Crewed by Harry Cooper CE. Artwork by
Ben Kennedy, inspired by the slogan of the Schlitz Brewing Company. Survived Vietnam
from June 1968 to January 1971, amassing 3,136 flight hours, serving in the 174th from
June 1968 to December 1970. FRED THOMPSON

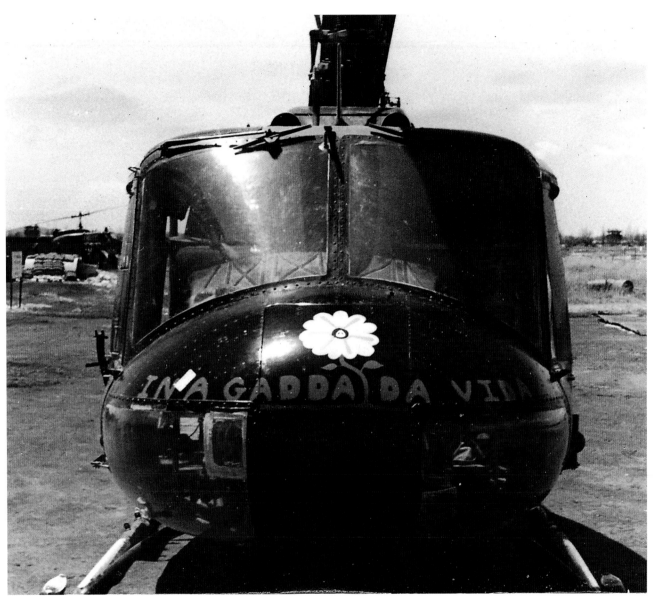

IN A GADDA DA VIDA (#2). UH-1H, 66-17120. 176th Assault Helicopter Company. Chu
Lai, 1970. Piloted by Joe Gross AC and crewed by Ed Doyle CE and Jay Wilbur DG. Named
for the 1968 song by Iron Butterfly. Accrued 1,768 flight hours from November 1968 to
September 1971, serving in the 176th from August 1970 to September 1971. JOE GROSS

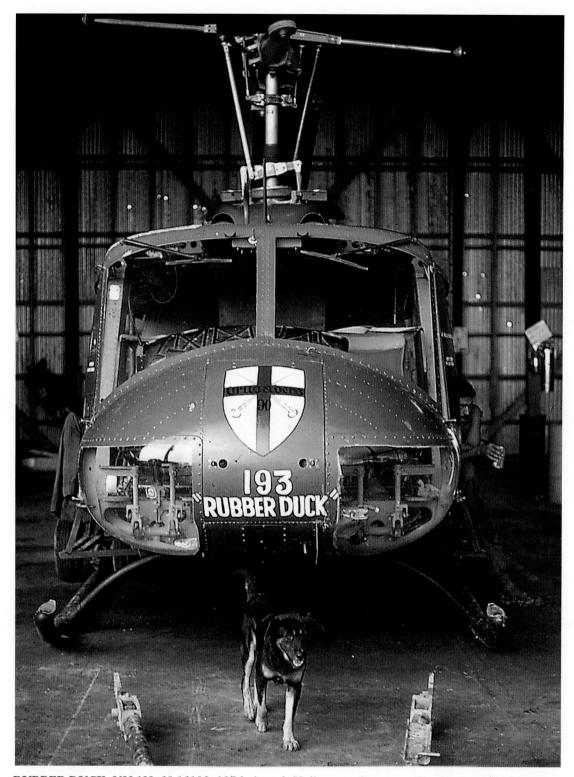

RUBBER DUCK. UH-1H, 68-16193. 187th Assault Helicopter Company. Tay Ninh, 1970. Survived Vietnam from September 1969 to March 1971, with 2,047 flight hours, all with the 187th.
DOUG WINDSAND

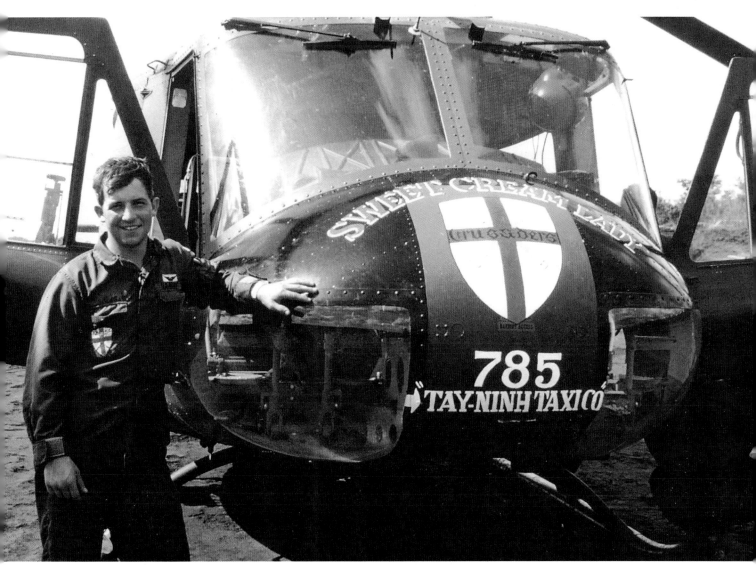

SWEET CREAM LADY. UH-1H, 69-15785. 187th Assault Helicopter Company. Tay Ninh, 1971. Crewed by Larry Pickett CE. Named after the 1969 song by The Box Tops. The bottom of the nose reads "Tay-Ninh Taxi Co"; the pilot's door, not pictured here, reads "NO FARE." Survived Vietnam from December 1970 to October 1971, accruing 735 flight hours, serving in the 187th from February 1971 to September 1971. BILL GREENHALGH

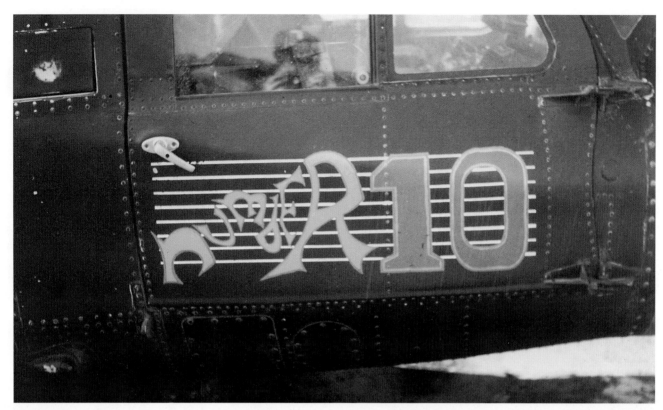

NUMBER 10. UH-1H. 188th Assault Helicopter Company. LZ Sally, 1968. Name was Vietnamese slang for "bad, the worst." DICK DETRA

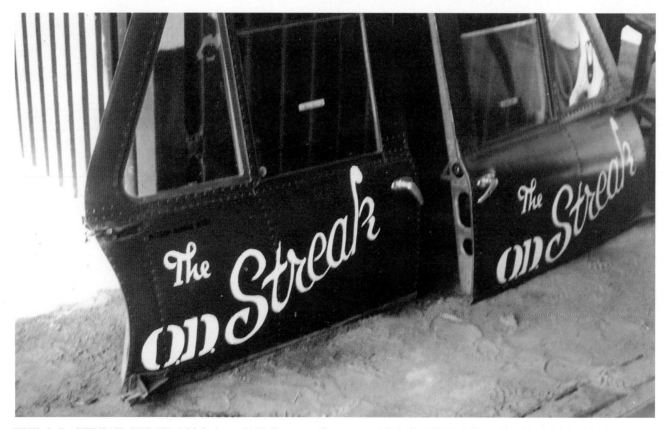

THE O.D. STREAK. UH-1H. 188th Assault Helicopter Company. LZ Sally, 1968. Piloted by Harold Smith AC. Name refers to olive drab, the military color of choice. DICK DETRA

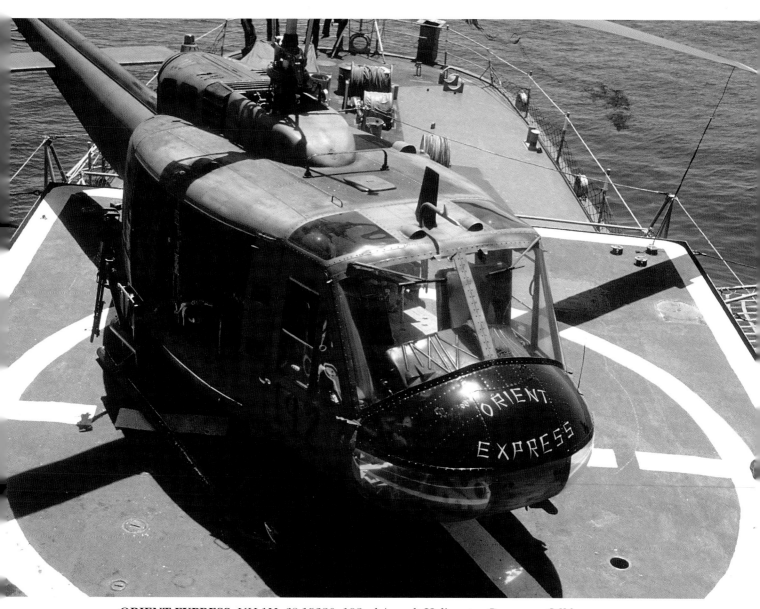

ORIENT EXPRESS. UH-1H, 68-15320. 192nd Assault Helicopter Company. Offshore from LZ Betty, 1970. Piloted by Roger Mitchell AC and crewed by Steve Fensky CE. Seen here on the deck of an unknown destroyer escort a few miles offshore between Phan Thiet and Phan Rang. According to Mitchell, he and the crew "spent a whole night painting this aircraft. It was a very amateurish job with what I now know was improperly thinned lacquer." Survived Vietnam, recording 2,954 flight hours from February 1969 to January 1972, all with the 192nd. ROGER "WOODY" MITCHELL

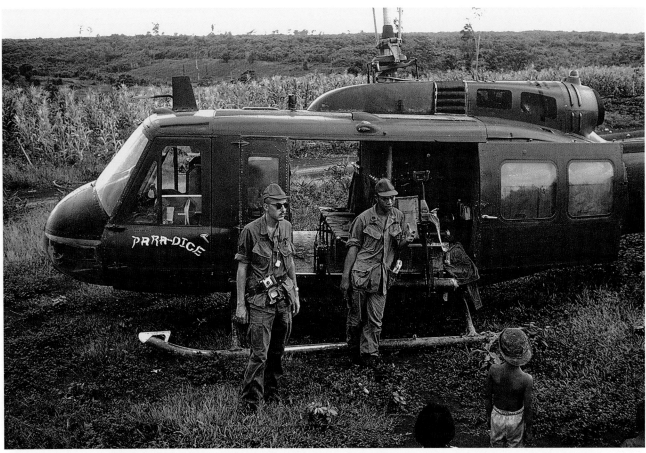

PARA-DICE. UH-1D, 66-00833. 191st Assault Helicopter Company. III Corps, 1968. Served exclusively in the 191st from June 1967 to September 1968, accruing 1,619 flight hours. Loss to inventory on September 6, 1968. JIM HONL

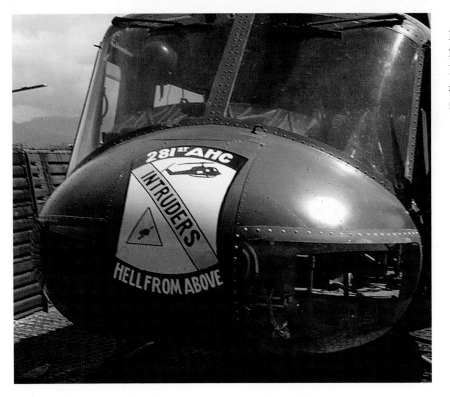

HELL FROM ABOVE. UH-1H. 281st Assault Helicopter Company. Nha Trang, 1970. Name and nose art replicate the official unit patch. RUDY SANGL

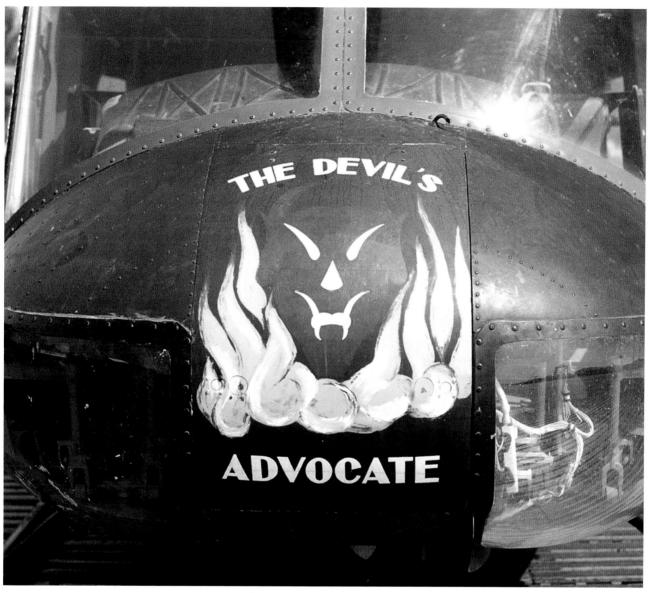

THE DEVIL'S ADVOCATE. UH-1H. 235th Assault Helicopter Company. Can Tho, 1969.
Utilized as a flare ship during night missions. GRANT CURTIS

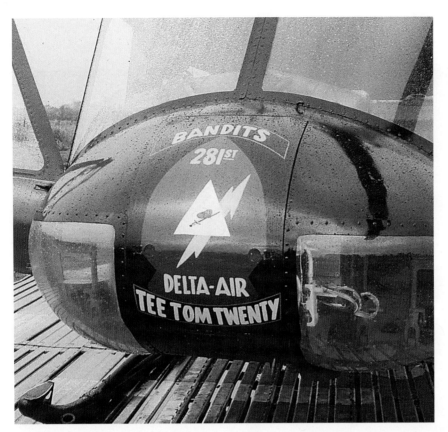

TEE TOM TWENTY. UH-1H. 281st Assault Helicopter Company. Nha Trang, 1970. Also known as BANDIT 20. "Delta-Air" and the triangle with the green beret signify Detachment B-52 Project Delta and the 5th Special Forces Group, respectively. In essence, the 281st was the U.S. Army's first Special Operations helicopter company, assigned the mission of providing support, copters, and crews for "over the fence" forays into Laos and Cambodia by Special Forces. RUDY SANGL

CAT DOCTOR. UH-1H, 67-17457. 282nd Assault Helicopter Company. Da Nang, 1969. Left to right: Ray Boyle CE, Lanny Orange DG, and unknown pilot. Helicopter maintenance platoons often adopted a name imitating the parent unit's call sign. Here the 484th Transportation Company has elected to continue the feline legacy with a red painted cat of its own to go along with the black cat carried on unit slicks and guns. Survived Vietnam from June 1968 to March 1972, accumulating 2,121 flight hours, serving with the 282nd from June 1968 to August 1971. RAY BOYLE

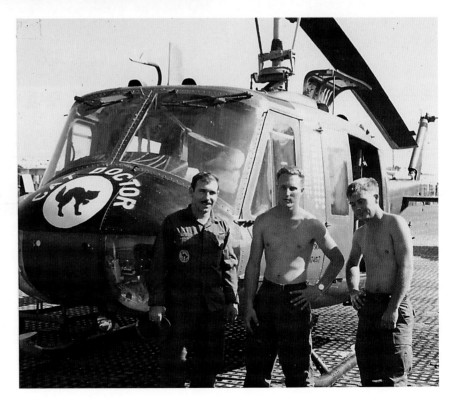

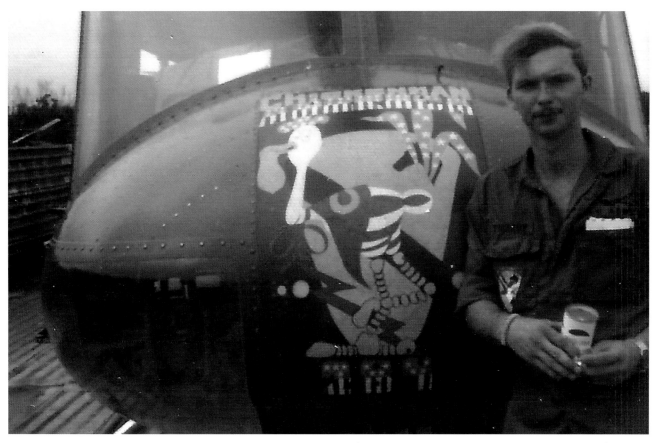

CHICKENMAN AMERICA. UH-1H, 68-15284. Λ Company, 227th Assault Helicopter Battalion. Lai Khe, 1970. Pictured is David Thibaut CE. Survived Vietnam from February 1969 to July 1972, with 2,640 flight hours, serving in A Company from May 1970 to September 1971. DON WYROSDICK VIA P. J. TOBIAS

LIL' ANNIE'S FANNIE. This was the second name applied to Jim Jester's aircraft 69-15715 (see page 124 for the first). Jester's wife was named Annie, but the name is also a play on the *Playboy* comic *Little Annie Fanny*. Pictured is Benjamin J. Bond CP. Loss to inventory on April 24, 1972. JIM JESTER

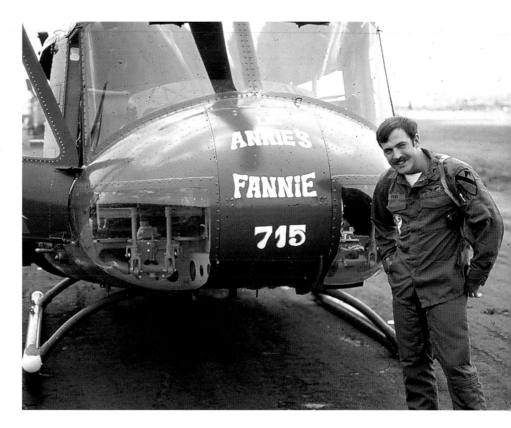

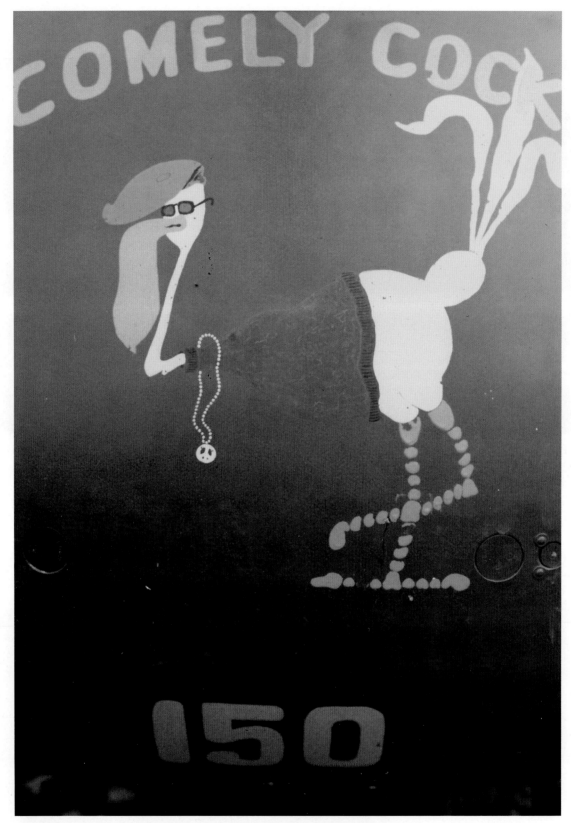

COMELY COCK. UH-1H, 66-16150. A Company, 227th Assault Helicopter Battalion. Camp Holloway, 1971. Artwork by Joe Paranal. Survived Vietnam from December 1967 to July 1972, with 2,250 flight hours, serving in A Company from September 1970 to September 1971. TERRY MOORE

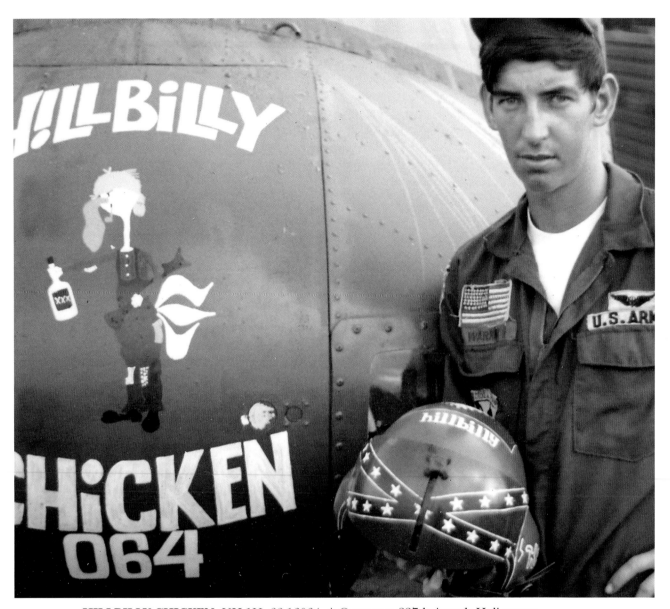

HILLBILLY CHICKEN. UH-1H, 66-16064. A Company, 227th Assault Helicopter Battalion. Camp Holloway, 1971. Crewed by Calvin Warren CE (pictured). Art by Joe Paranal. Accumulated 2,469 flight hours from May 1967 to January 1972, including a short assignment with A Company from May to September 1971. TERRY MOORE

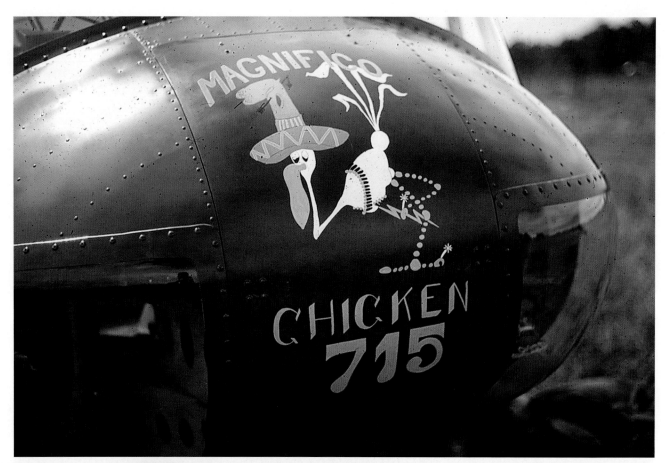

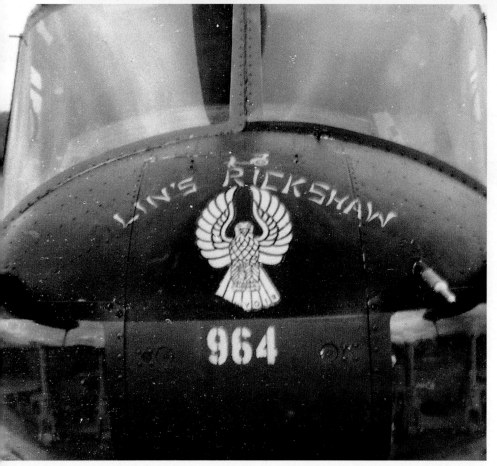

MAGNIFICO CHICKEN.
UH-1H, 69-15715. A Company,
227th Assault Helicopter Battalion.
Camp Holloway, 1971. Piloted by
Jim Jester AC. Nose art by Joe
Paranal. Amassed 1,482 flight hours
from September 1970 to April 1972,
serving in A Company from
October 1970 to September 1971.
JIM JESTER

LIN'S RICKSHAW. UH-1D, 63-
12964. A Company, 227th Assault
Helicopter Battalion. 1966, Phan
Thiet. Nose art painted by Richard
Mitchell. Lin was short for Linda,
the name of crew chief Mike
Schlaudraff's wife. Accumulated
1,341 flight hours from July 1965 to
July 1967 before a July 19, 1967,
accident while assigned to B
Company, 227th, ended its career.
MIKE SCHLAUDRAFF

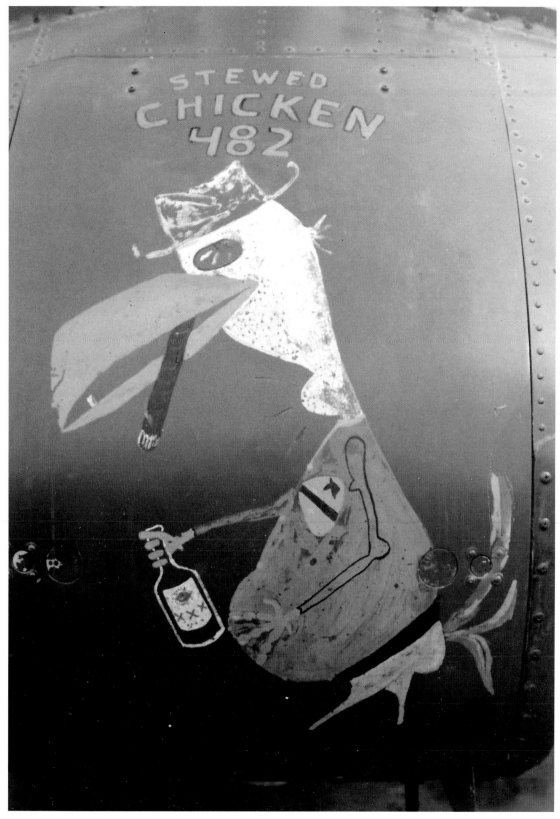

STEWED CHICKEN. UH-1H, 69-15482. A Company, 227th Assault Helicopter Battalion. Camp Holloway, 1971. Crewed by David Thibaut CE. Artwork by Joe Paranal. Survived Vietnam from July 1970 to February 1972, accumulating 1,648 flight hours, serving in A Company from July 1970 to September 1971. TERRY MOORE

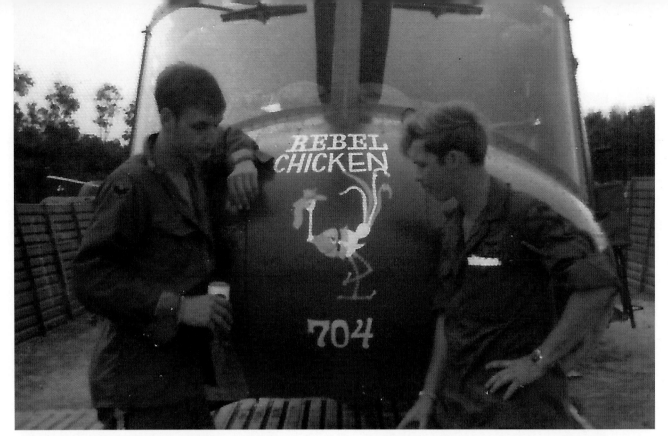

REBEL CHICKEN. UH-1H, 69-15704. A Company, 227th Assault Helicopter Battalion. Lai Khe, 1971. Pictured are David Thibaut (right) and Pete Fiory (left). Served exclusively in A Company, accruing 841 flight hours from October 1970 to June 1971. Utilized in a Medal of Honor mission in Kontum Province on May 25, 1971.

DON WYROSDICK VIA P. J. TOBIAS

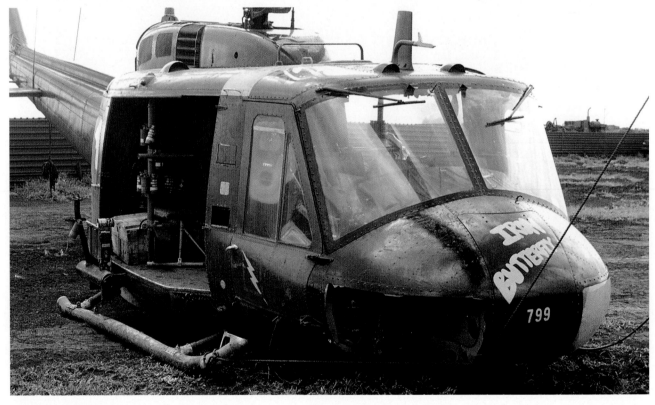

IRON BUTTERFLY. UH-1H, 67-17799. B Company, 227th Assault Helicopter Battalion. LZ Buttons, September–October 1969. This name appeared on more than fifty helicopters between 1968 and 1973. Note collapsed skids and broken chin bubble. Accrued 1,177 flight hours, all with B Company, from November 1968 until a revetment accident on October 18, 1969. PAUL ANDERSON

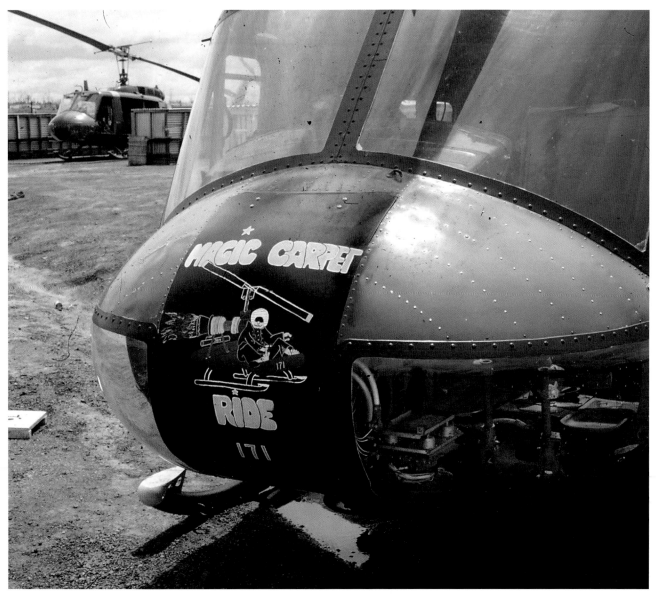

MAGIC CARPET RIDE. UH-1H, 68-16171. B Company, 227th Assault Helicopter Battalion. Phuoc Vinh, 1970–71. Name possibly influenced by the 1968 song by Steppenwolf. Survived Vietnam from September 1969 to December 1971, with 2,803 flight hours, serving in B Company from September 1969 to September 1971. BEN LIPFORD

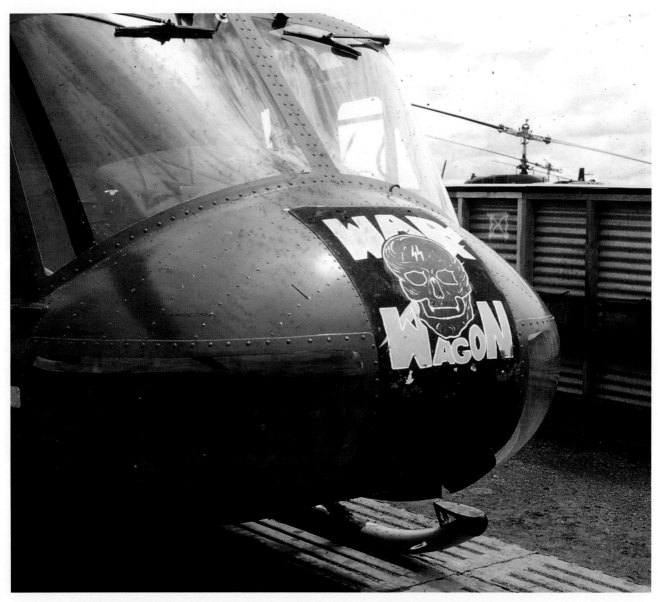

WAR WAGON. UH-1H. B Company, 227th Assault Helicopter Battalion. Phuoc Vinh,
1970. Name is similar to a 1967 Hollywood Western starring John Wayne. BEN LIPFORD

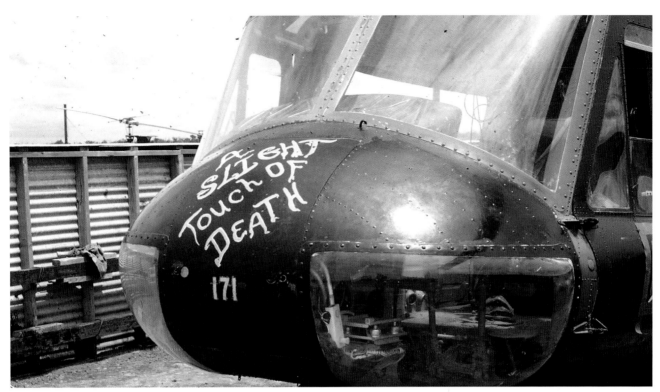

A SLIGHT TOUCH OF DEATH. UH-1H, 68-16171. B Company, 227th Assault Helicopter Battalion. Phuoc Vinh, 1970. Used principally as a Nighthawk ship. Survived Vietnam from September 1969 to December 1971, with 2,803 flight hours, serving in B Company from September 1969 to September 1971. BEN LIPFORD

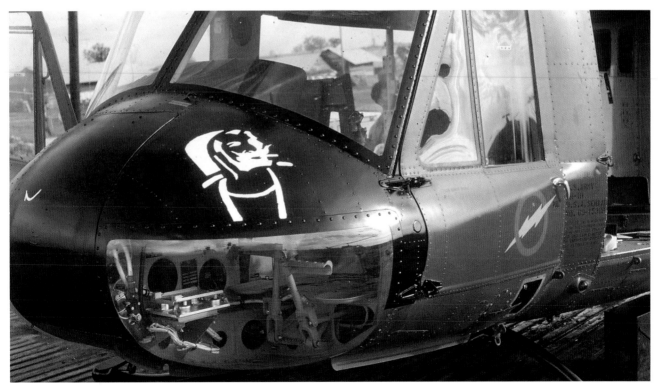

ZIG ZAG. UH-1H, 69-15368. C Company, 227th Assault Helicopter Battalion. Phuoc Vinh, 1970. Artwork by Ben Lipford features the Zig-Zag man logo from the popular rolling paper brand. Accumulated 1,731 flight hours from June 1970 to April 1972, serving in C Company from June 1970 to September 1971. Destroyed on April 18, 1972, with six killed when it hit a cloud-covered mountain. BEN LIPFORD

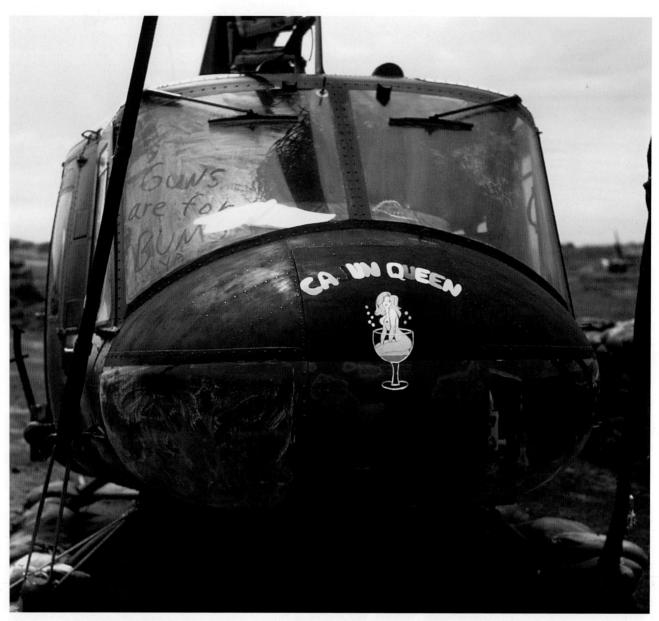

CAJUN QUEEN. UH-1H. C Company, 227th Assault Helicopter Battalion. Camp Evans, 1968. Piloted by Milton Lesemann CP. Crew chief who named it was from Louisiana. Someone has scrawled "Guns are for bums" on the windshield. BOB GRIFFIN

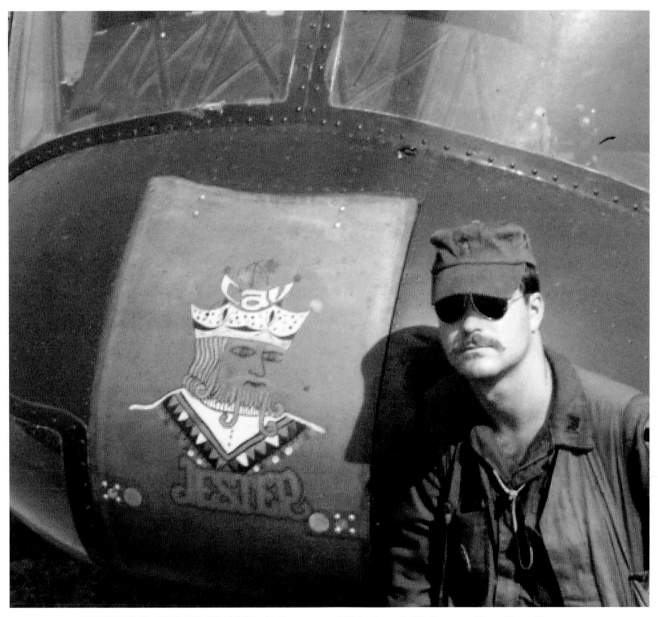

CAV JESTER. UH-1H, 67-17779. C Company, 229th Assault Helicopter Battalion. Tay Ninh, 1970. Piloted by Lawrence Shemley AC (pictured). Survived Vietnam from October 1968 to April 1971, with 2,910 flight hours, serving in C Company from September 1969 to April 1971. CRAIG THOMAS

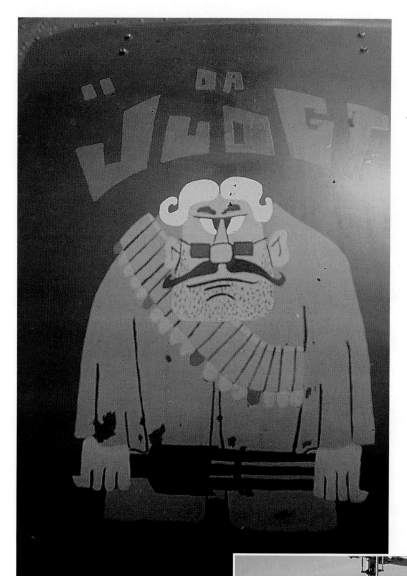

DA JUDGE. UH-1H, 68-16082. C Company, 229th Assault Helicopter Battalion. Tay Ninh, 1970. Nose art by Roger Baker, a pilot in C Company. Name can be traced to the emphatic punch line "Here comes da judge!" heard weekly on the TV comedy show *Laugh-In*. Initially used as the battalion commander's ship, later assigned to Dayhawk duties defending the airfield. Accumulated 2,988 hours from September 1969 to June 1972, flying exclusively with C Company. LARRY SHEMLEY

SHORT STOMPER. UH-1H, 67-17173. C Company, 229th Assault Helicopter Battalion. Tay Ninh, 1969. Visible in the background is Black Virgin Mountain (Nui Ba Den). Survived Vietnam from March 1968 to December 1971, amassing 3,221 flight hours, serving in C Company from May 1969 to January 1970. LARRY SHEMLEY

DUSTOFF and MEDEVAC

Dustoff and Medevac were the radio call signs of aero-medical evacuation ambulances (UH-1A, B, D, and H). These aircraft—with crews consisting of two pilots, one crew chief, and one medic—flew a total of 500,000 missions in Vietnam from 1962 to 1973. Dustoff helicopters (non-Cav) were unarmed; Medevac aircraft (1st Air Cav) carried M60 door guns. During the war, 211 pilots and crew were killed while flying Dustoffs and Medevacs, and 199 air ambulances were shot down. More than 200 air ambulances were named by their crews, such as *Iron Lung* and *Soul Inspiration*.

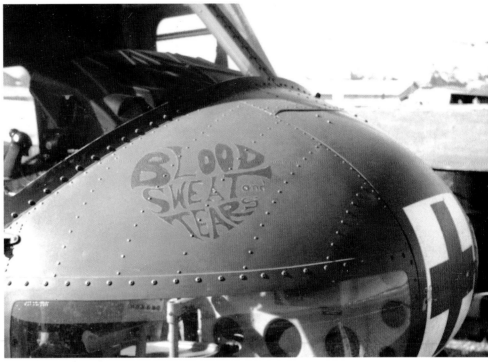

BLOOD SWEAT AND TEARS. UH-1H, 69-15015. 254th Medical Detachment. Nha Trang, 1970. Crewed by Jack Wolfe CE, who also painted this design, probably inspired by the band. "This ship has seen them all," said Wolfe. Survived Vietnam from February 1970 to April 1972, with 1,506 flight hours, serving in the 254th from February to September 1970. DALE LACHER

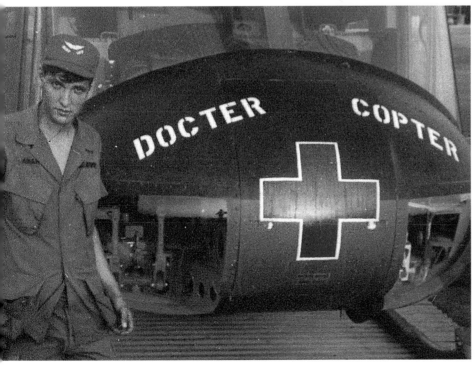

DOCTER COPTER. UH-1H, 66-17101. 45th Medical Company. Long Binh, March 1968. Crewed by Clif Adams CE (pictured), who said, "I decided to spell it incorrectly to give it a little 'character.' Our maintenance officer walked by right after I finished the painting and said, 'You see, Adams, that's why I'm an officer and you're an enlisted man—you don't know how to spell.'" Survived Vietnam, serving all of its in-country time (January 1968 to November 1970) with the 45th while amassing 1,952 flight hours. Renamed FOXY LADY in 1970 by a different crew. CLIF ADAMS

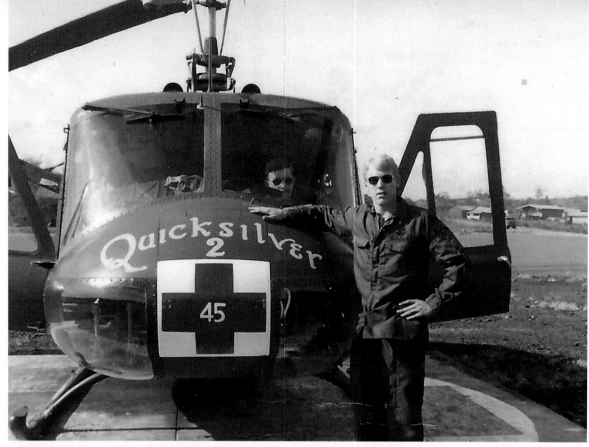

QUICKSILVER 2. UH-1H, 68-16463. 45th Medical Company. Long Binh, 1970. Crewed by Mike O'Brien CE (pictured). According to O'Brien, "Most of us were into rock and roll and really dug the name on one 4th Platoon ship, IRON BUTTERLY. I was into the Quicksilver Messenger Service's *Happy Trails* album and figured QUICKSILVER was good, meaning quick and messenger of the gods." Accumulated 1,980 flight hours during a tour from January 1970 to January 1973, serving in the 45th from January 1970 to March 1971. MIKE O'BRIEN

ELECTRIC BANANA. UH-1H, 66-17007. 498th Medical Company. LZ English, 1970. Crewed by Paul Coleman CE and medic Tim Coogan. According to Coogan, an RPG shredded the aircraft's tail boom, which was replaced but still painted with yellow primer when they had to go into the field. The color grew on them. Survived Vietnam from December 1967 to May 1970, tallying 1,150 flight hours, all with the 498th. TIM COOGAN

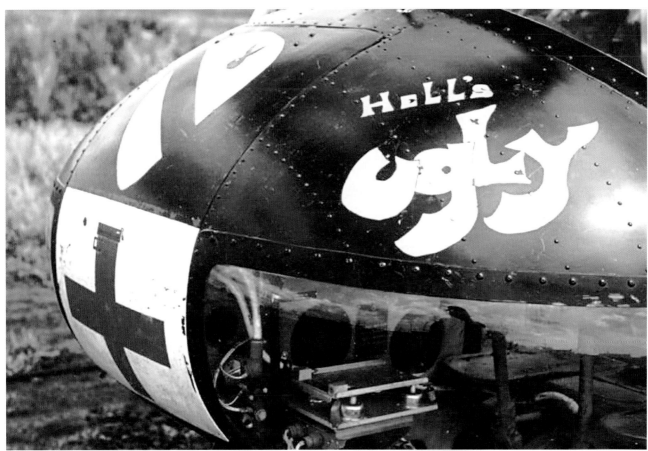

HELL'S UGLY. UH-1H, 69-15183. 215th Composite Service Battalion. Phuoc Vinh, 1972. Crewed by Doug Campbell CE and medic Patrick Cardinal. The 215th inherited this aircraft after the 15th Medical Battalion stood down on April 15, 1971. Accrued 1,588 flight hours from May 1970 to August 1972. PATRICK CARDINAL

NIXON'S WITHDRAWAL. UH-1H. 571st Medical Detachment. Khe Sanh, March 1971. PAUL SIMCOE

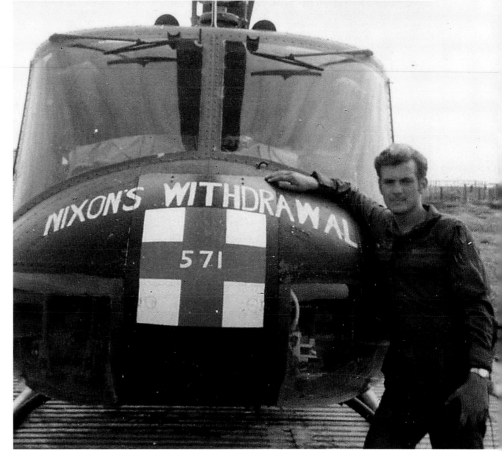

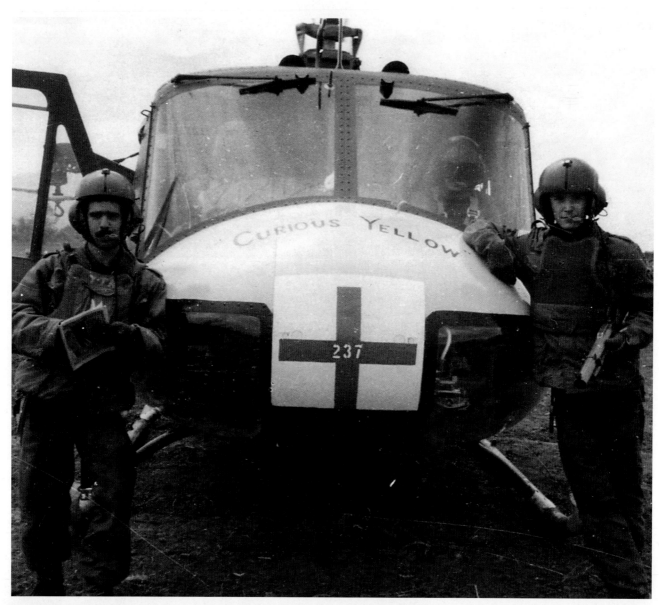

CURIOUS YELLOW. UH-1H, 69-16656. 237th Medical Detachment. 1971. Piloted by Dave Hansen AC and Milton Kreger CP and crewed by Ed Hopper CE (right), medic Ed Iacobacci (left), and George Shaughnessy. The name has two possible origins: a fluorescent chartreuse color which Chrysler offered on its 1971 Plymouths or the 1967 X-rated film *I Am Curious Yellow*. Accumulated 572 flight hours from January 1971 to June 1971. Loss to inventory on June 4, 1971. DAVE HANSEN

Another look at CURIOUS YELLOW. KEN WARNER

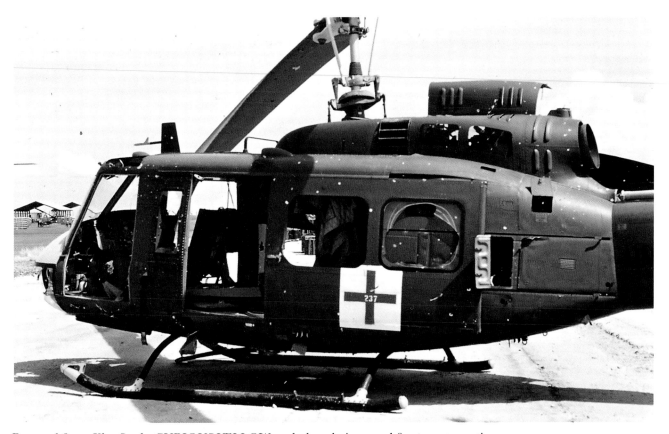

Rescued from Khe Sanh, CURIOUS YELLOW ended up being used for target practice. KEN WARNER

THE PEACE SEEKERS. UH-1H, 69-15216. 237th Medical Detachment. Camp Evans, 1970. Crewed by Jerry Graff CE and medic Wayne Gordon. Survived Vietnam with 1,157 flight hours, all spent in DMZ Dustoff with the 237th.
WAYNE GORDON

Says Wayne Gordon: "Every time we took a hit, we painted a busted cherry on our helmets. Many pilots thought we were crazy to paint the helmets orange—targets, they said. We replied, 'What about the red cross?'" WAYNE GORDON

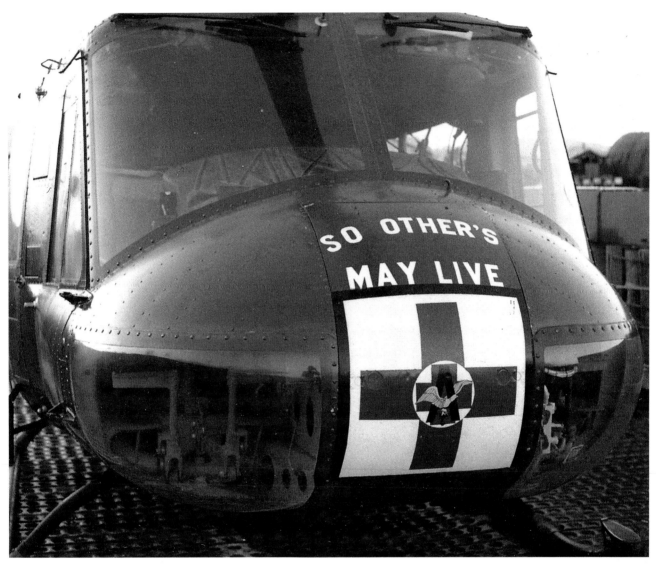

SO OTHER'S MAY LIVE. UH-1H, 69-15096. 247th Medical Detachment. Nha Trang, 1970. Crewed by J. Jones CE. Name was a unit slogan that appeared on the nose of more than one unit dustoff ship. Accumulated 1,872 flight hours from March 1970 to January 1973, including two years in the 247th from January 1971 to January 1973. DALE LACHER

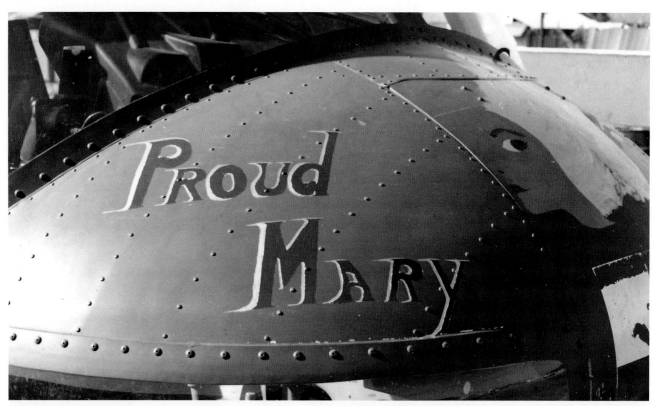

PROUD MARY. UH-1H, 68-16476. 254th Medical Detachment. Nha Trang, 1970. Crewed by Tom Roberts CE and medic Dale Lacher. Artwork by Lacher, inspired by the 1969 song by Creedence Clearwater Revival. Survived Vietnam from December 1969 to March 1972, with 1,658 flight hours, serving in the 254th from December 1969 to September 1970. DALE LACHER

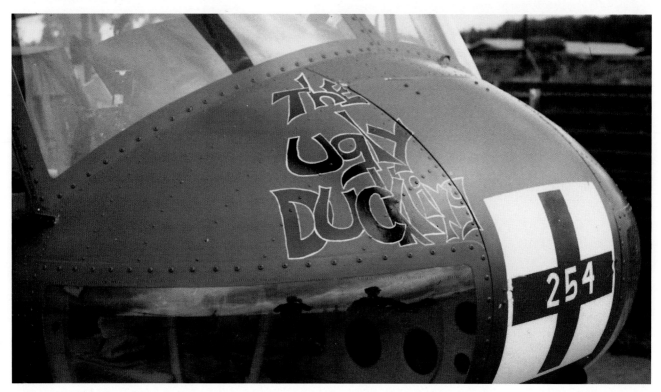

THE UGLY DUCKLING. UH-1H. 254th Medical Detachment. Nha Trang, 1970. Crewed by Eric Porter CE. DALE LACHER

BELL'S MISFIT. UH-1H. 283rd Medical Detachment. Weight-Davis Compound, Pleiku Province, 1970. Named after the helicopter's manufacturer. Apparently, it suffered a hard landing while the blades were turning, pushing the transmission forward into the firewall. GARY DRAPER

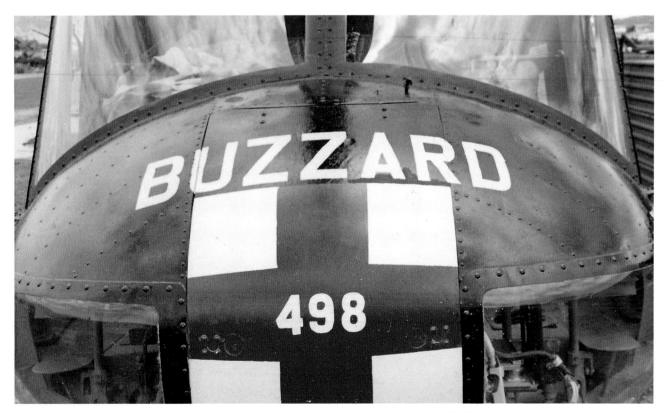

BUZZARD. UH-1H, 66-16632. 498th Medical Company. Pleiku, 1970. Crewed by Terry Boese CE and medic Maloy. Accumulated 1,254 flight hours, all with the 498th from November 1967 to July 1970. Loss to inventory on July 26, 1970. JERRY PAUL

HAIR. UH-1H, 66-16063. 498th Medical Company. Pleiku, 1970. Crewed by Jerry Paul CE and medic Dennis Parker. The 1967 Broadway musical *Hair* spawned several hit tunes, including the title song. Served in Vietnam from May 1967 to April 1971, all of its 1,685 dustoff flight hours with the 498th. Loss to inventory on April 12, 1971. JERRY PAUL

THE PROVIDER. UH-1H. 498th Medical Company. Pleiku, 1970. More often than not, Dustoff names expressed some aspect of their role in the air ambulance business. JERRY PAUL

PATRIOT. UH-1H. 498th Medical Company. 71st Evac Hospital, Pleiku, April 1970.
Crewed by medic Lyle Condon. Crew and maintenance gang are seen working on the
Jesus nut (main rotor retaining nut). DENNIS BISHOP

WHY. UH-1H. 498th Medical Company. An Khe, 1970. MIKE HASTIE

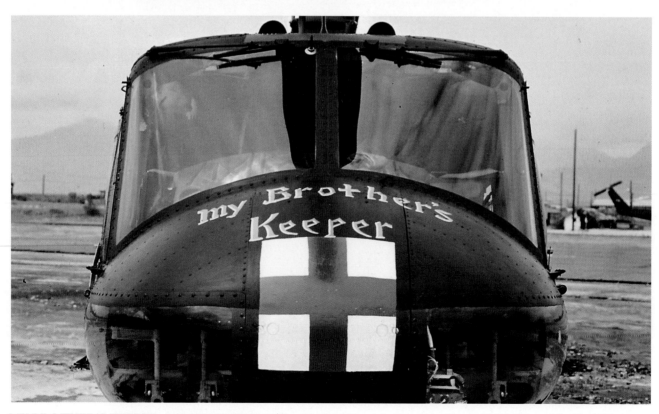

MY BROTHER'S KEEPER. UH-1H, 69-16651. 571st Medical Detachment. Da Nang, 1972. Piloted by Ken Warner AC and crewed by Ken Bohrman CE and medic Robert Clabby. Artwork by Bohrman. Accumulated 1,153 flight hours from February 1971 and February 1973, serving in the 571st from March 1971 to September 1972. KEN WARNER

OTHER ROTOR MEMORIES

Thousands of Vietnam War helicopter stories remain untold, despite all the human expenditure and effort in that distant time and place. Much the same could be said for the war in general. This is beginning to change, however. A steadily growing number of retired Vietnam-era helicopters are being placed on viewing pedestals and in museums across the United States—a welcome sight. Filmmaker Ken Burns is working on a documentary about Vietnam, and a Vietnam Memorial Visitors Center is planned in Washington, DC, so there is a sense that this war might finally sort itself out in a mature manner.

HO CHI MINH. 539th Transportation Company. Phu Loi, 1967–68. This poster adorned any copter that languished beyond a respectable turnaround repair date. JIM ERICKSON

THE JUDGE. UH-1H, 66-16265. 129th Assault Helicopter Company. Lane Army Airfield, An Son, 1969. Crewed by Lloyd Robinson CE (pictured). A Korean artist initially painted "The Fudge" by mistake. Survived Vietnam from May 1968 to February 1971, amassing 3,274 flight hours, all with the 129th. LLOYD ROBINSON

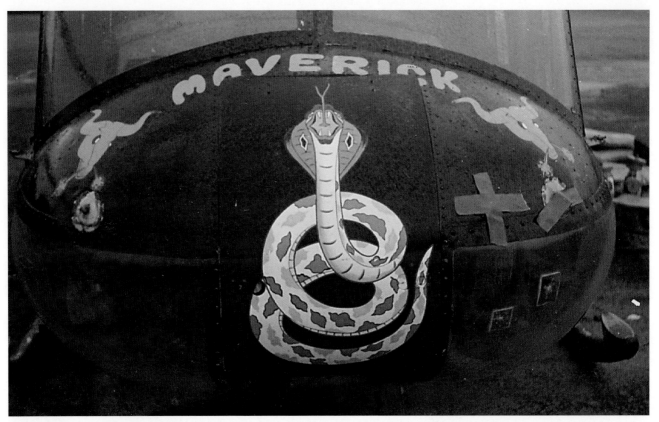

MAVERICK. UH-1C. 1967. A 175th Assault Helicopter Company gunship boasts a nose panel from the 114th. Says Bob Chenoweth: "Blasphemous perhaps, expedient yes." BOB CHENOWETH

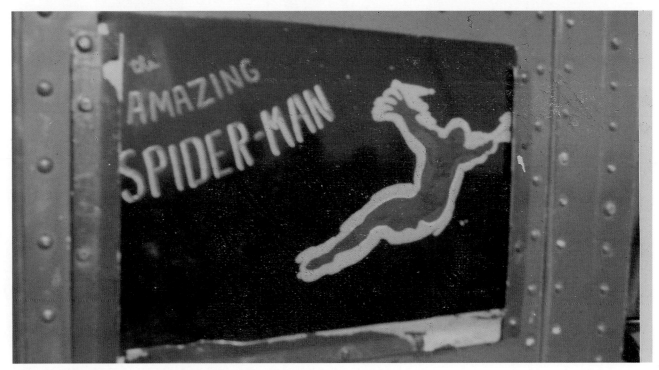

THE AMAZING SPIDER-MAN. UH-1H, 67-17678. A Company, 158th Assault Helicopter Battalion. Camp Evans, I Corps, 1970. This painted nameplate represents the call sign of aircraft commander Eugene Franck. Survived Vietnam from February 1969 to July 1972, accruing 2,490 flight hours, serving in A Company from February 1969 to March 1971. Shot down in Laos on March 19, 1971, and sent stateside for repairs. EUGENE FRANCK

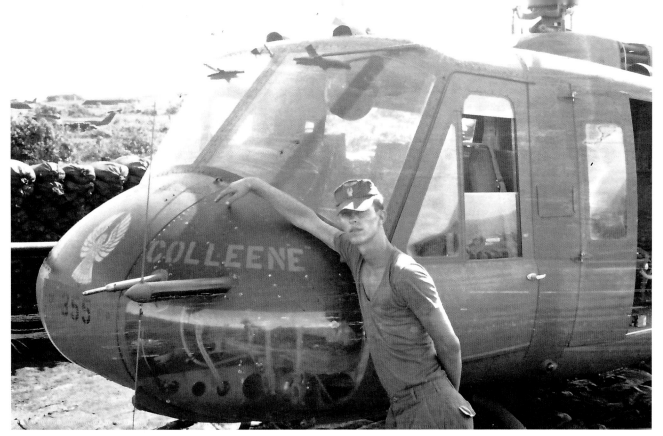

COLLEENE. UH-1D, 62-12355. A Company, 227th Assault Helicopter Battalion. Phan Thiet, July 1967. Crewed by Dennis Burden CE (pictured), who named the aircraft for his sweetheart, whom he married upon returning home. Survived Vietnam from September 1963 to July 1967, with 2,139 flight hours, serving in A Company from 1965 to 1967. DENNIS BURDEN

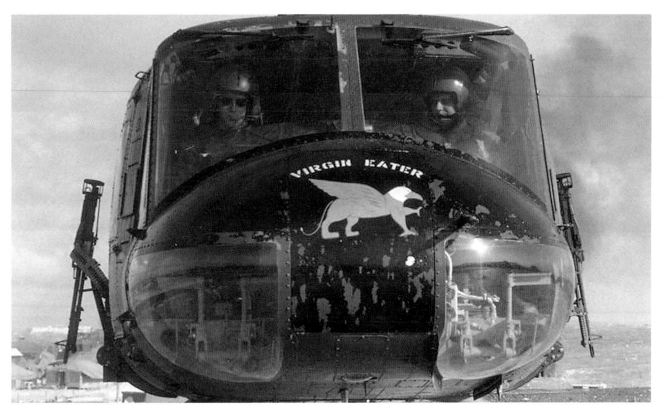

VIRGIN EATER. UH-1H, 64-13736. Headquarters and Headquarters Company, 1st Brigade, 101st Airborne Division. Camp Eagle, I Corps, fall 1969. The pilots shown here are Richard von Hatton and Bruce Sutton. Survived Vietnam from 1965 to January 1972, amassing 3,267 flight hours and serving in HHC/1/101 from September 1968 to July 1969. PETE RZEMINSKI

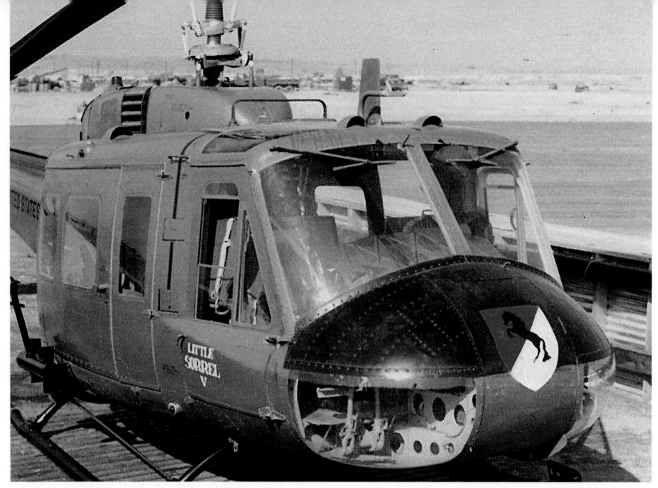

LITTLE SORREL V. UH-1H, 66-16552. 11th Armored Cavalry Regiment. Bien Hoa, 1968. Crewed by Tom Vogt. This aircraft was used by Col. George S. Patton as his mobile command post; he named it after Civil War general Stonewall Jackson's horse. Survived Vietnam from August 1967 to February 1971, accruing 2,404 flight hours, serving in the 11th from December 1968 to February 1971. TOM VOGT

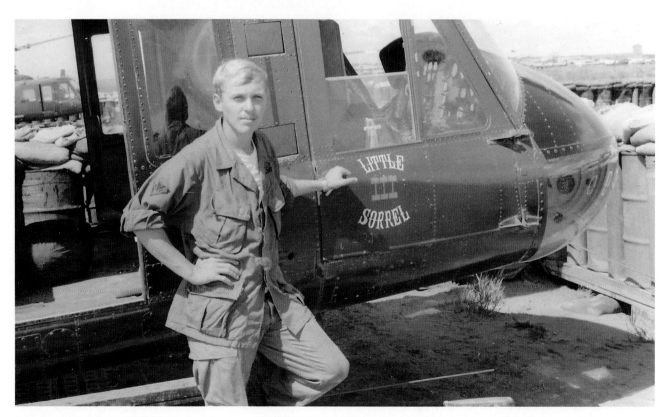

A look at LITTLE SORREL V's predecessor, LITTLE SORREL III. Pictured is crew chief Tom Vogt. TOM VOGT

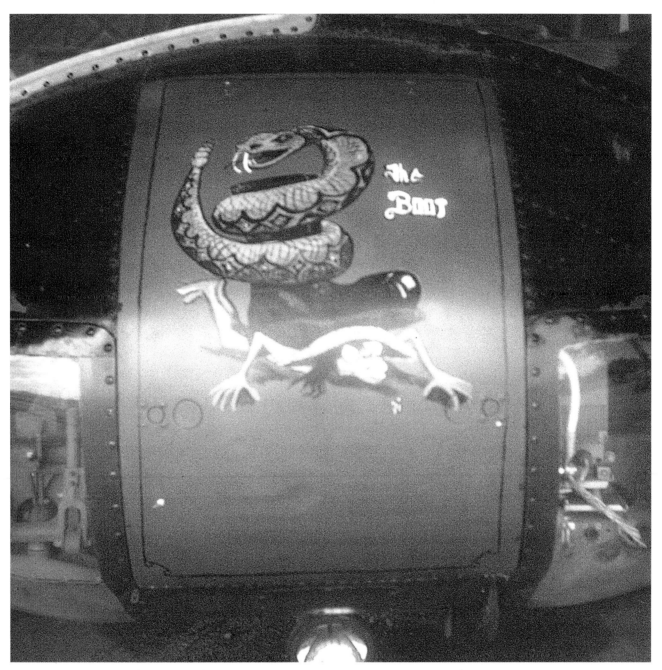

THE BOOT. UH-1H. 71st Assault Helicopter Company. Chu Lai, 1970. Nose art painted by Anthony Jones. DON PRIDDY

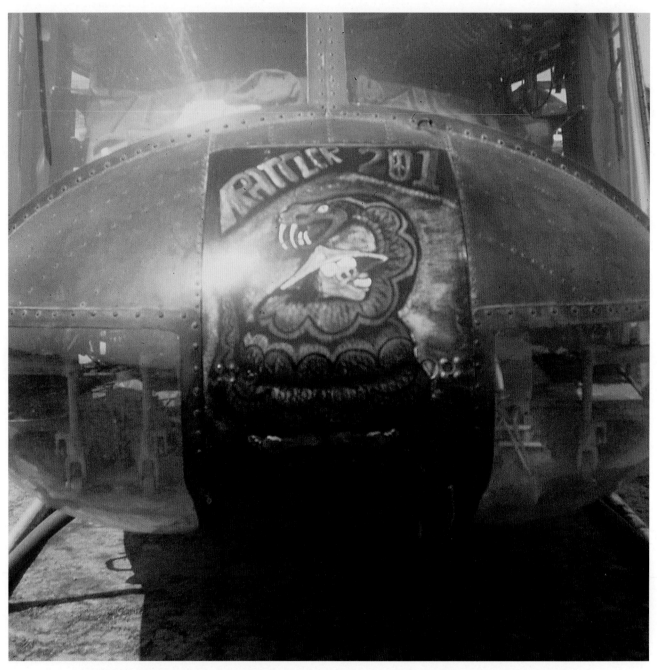

RATTLER 201. UH-1H, 68-16201. 71st Assault Helicopter Company. Chu Lai, 1970. Nose art by Anthony Jones, who said, "The crew told me that a captured VC told them there was a ransom for that ship because of the cover." Accrued 866 flight hours from September 1969 to May 1970. Loss to inventory on May 2, 1970. DON PRIDDY

ART and ARTIST

Beyond the official military markings that each helicopter in Vietnam carried to identify its origin and age, the unofficial markings—undocumented by the army—gave an aircraft an additional identity, not to mention a personality. This chapter collects some of this unofficial artwork and tells the stories of how they were painted during wartime in Southeast Asia.

AMERICA: LOVE IT OR LEAVE IT.
UH-1H, 69-15739. C Troop, 3rd Squadron, 17th Cavalry. Vinh Long, 1971. Piloted by Jack Hosmer AC and crewed by Ralph Chapman CE. After the original nose panel was damaged, a Vinh Long artist was compensated a case of beer to create a second one; according to Rex Gooch, the artist did not understand proper phrasing. Accumulated 1,794 flight hours from November 1970 to February 1973, serving with C Troop from July 1971 to February 1972.
REX GOOCH

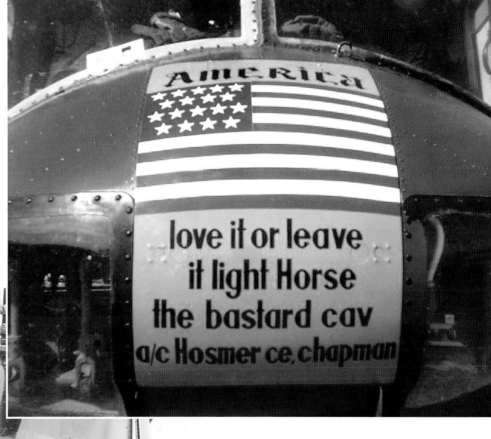

Paul Phillippi CE (left) and Ralph Chapman DG (right) with AMERICA: LOVE IT OR LEAVE IT. This is the first of two avionics panels that carried this politically charged slogan. This one (pictured above) was commissioned in early 1971. JACK HOSMER

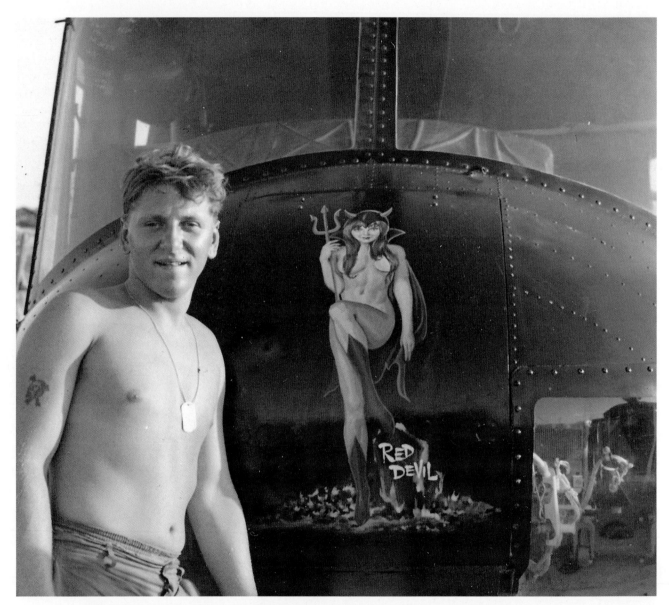

RED DEVIL. UH-1H. 336th Assault Helicopter Company. Soc Trang, 1968. Crewed by Scott Woodworth CE. Unknown door gunner pictured. According to Woodworth, he paid $150 for a local artist to paint this, based partly on a Vargas rendering from *Playboy*. He then had the ship repainted in gloss olive drab. "None of it authorized, but the AC loved it." SCOTT WOODWORTH

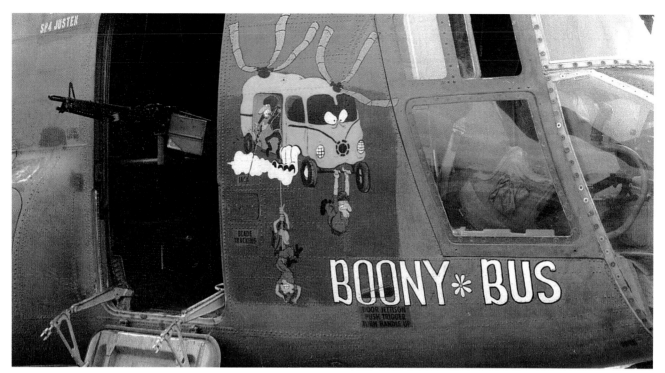

BOONY BUS. CH-47B, 67-18452. 132nd Assault Support Helicopter Company. Chu Lai, 1971. Name was slang for the jungle or field—anywhere the infantry operated. According to Clarke Davis, after My Lai, "orders came down to remove all 'mascot' art in the division. It took a lot of badgering and vocal outcry to re-establish the 'tradition' of GIs personalizing their equipment. BOONY BUS was the beginning of the return." Survived Vietnam from May 1968 to July 1971, with 2,367 flight hours, exclusively with the 132nd. LARRY SEEGER

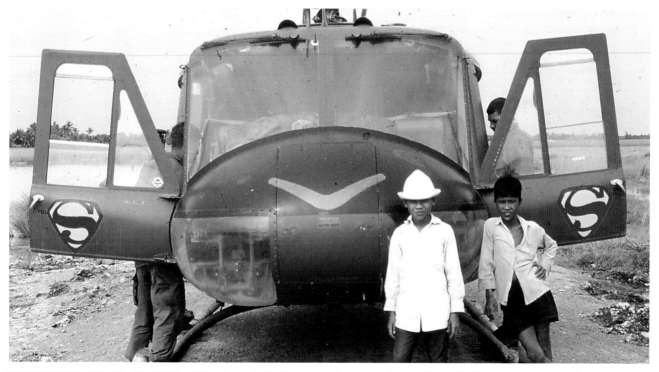

SUPERSHIP. UH-1D, 66-00817. 191st Assault Helicopter Company. Rach Kien, III Corps, late 1967. Piloted by Harold Stitt AC and crewed by Roger Barkley CE. Artwork painted by Richard Weske. Name refers to the Superman logo on the pilot doors. According to Barkley, the platoon also included BATSHIP, with the Batman symbol. HAROLD STITT

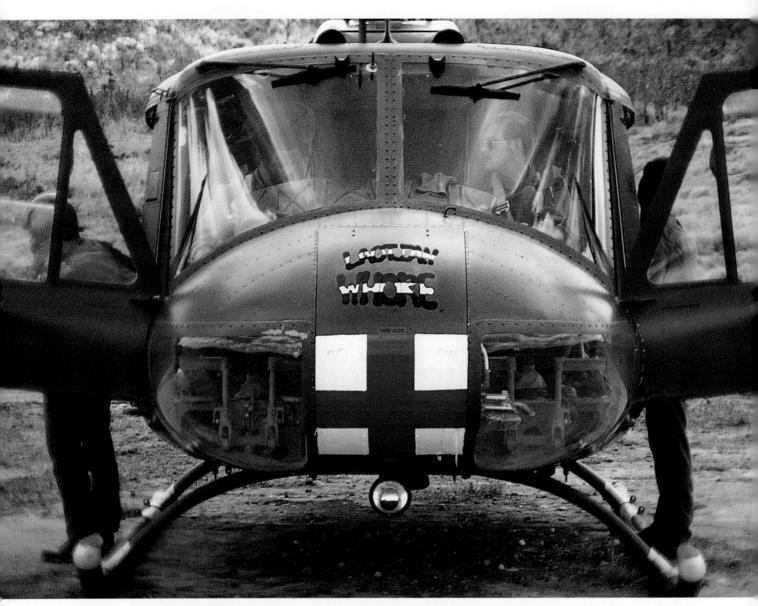

LAOTIAN WHORE. UH-1H, 69-15717. 498th Medical Company. Fire Support Base Action, near An Khe, 1970. Piloted by Mike Piazza AC, who also painted this design. Served exclusively in the 498th from October 1970 to May 1971, accruing 463 flight hours. Loss to inventory because of engine failure at LZ Uplift on May 27, 1971.
MIKE HASTIE

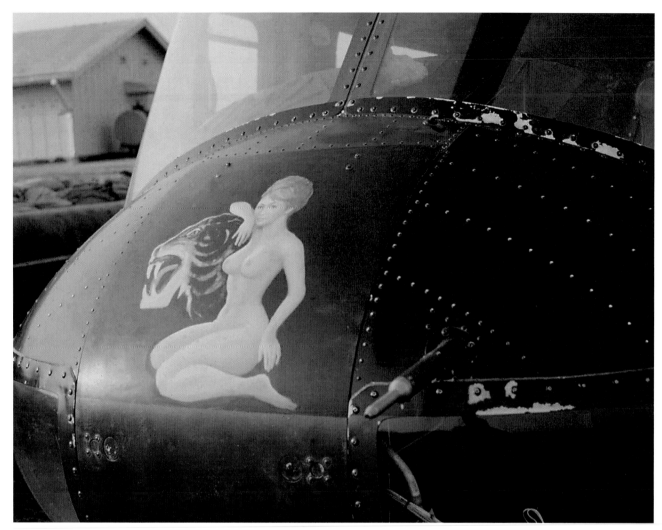

TOP TIGER TAIL. UH-1D, 65-09836. 68th Assault Helicopter Company. Bien Hoa, January 1968. Crewed by Gary Robertson CE & David Green DG. Maintenance ship utilized by the 391st Transportation Company, which was attached to the 68th. "This was the only helicopter under the command of the 1st Aviation Brigade allowed to have an image of a nude female," says Green. DAVID GREEN

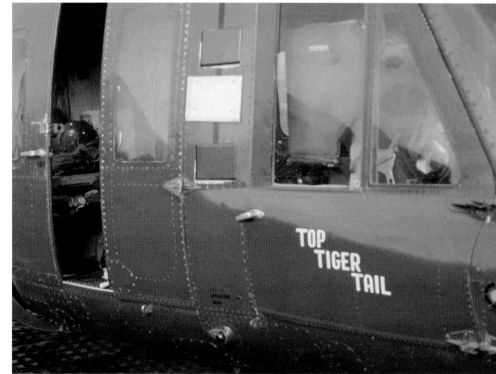

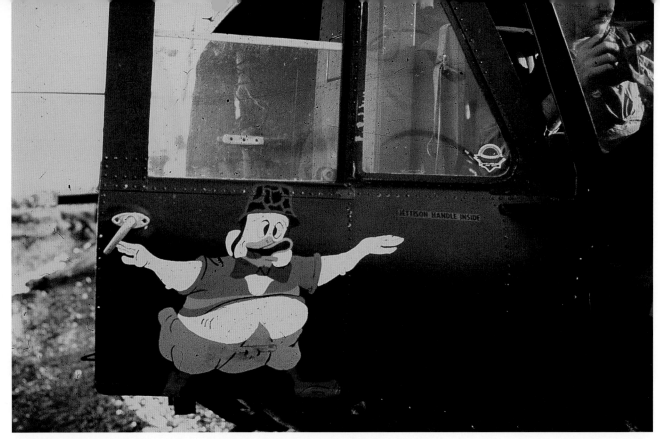

BABY HUEY. UH-1D, 66-00825. 191st Assault Helicopter Company. Dong Tam, 1968. Piloted by Don Nicholas AC and crewed by Bob Walker CE. Door art by Richard Weske. Named after the powerful but self-destructive cartoon character known as Baby Huey, after whom Nicholas was nicknamed because he was "shaped like Baby Huey," according to Don Williams. Survived Vietnam from June 1967 to November 1968, with 2,035 flight hours, all with the 191st. ROGER BARKLEY

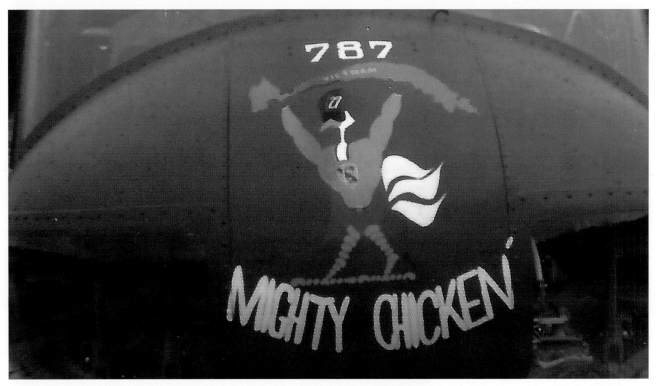

MIGHTY CHICKEN. UH-1H, 69-15787. A Company, 227th Assault Helicopter Battalion. Lai Khe, 1971. Crewed by Joe Paranal CE and Rick Long DG. Nose art painted by Joe Paranal. Survived Vietnam from December 1970 to April 1972, with 1,541 flight hours, serving in A Company from December 1970 to September 1971. DON WYROSDICK VIA P. J. TOBIAS

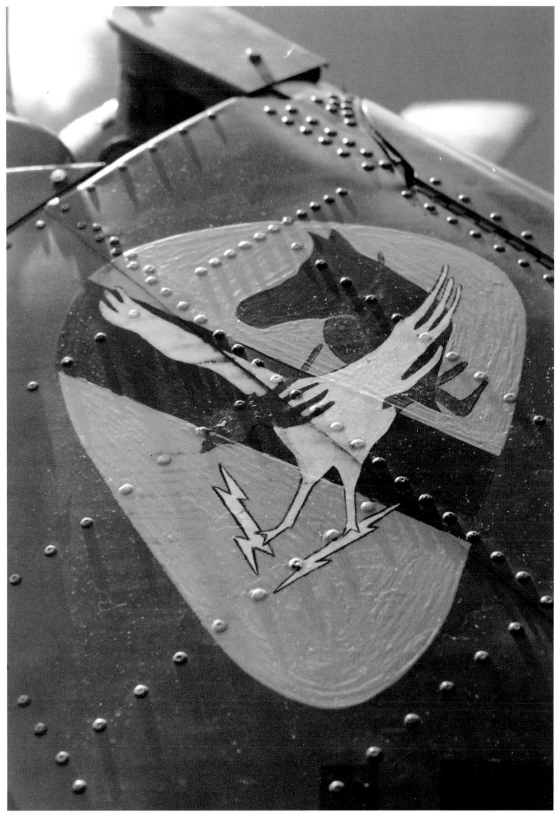

Another view of MIGHTY CHICKEN showing the chicken that was added to the fin (vertical stabilizer). TERRY MOORE

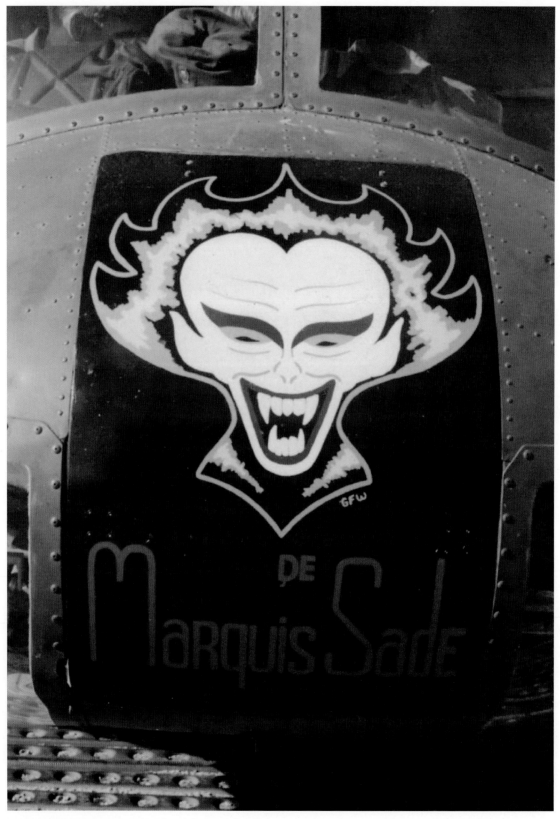

MARQUIS DE SADE. UH-1C. 48th Assault Helicopter Company. Ninh Hoa, 1970. Piloted by Fred Few AC and crewed by James Jackson CE. Named after the French aristocrat whose sexual behavior gave rise to the term "sadism." CURTIS HAWS

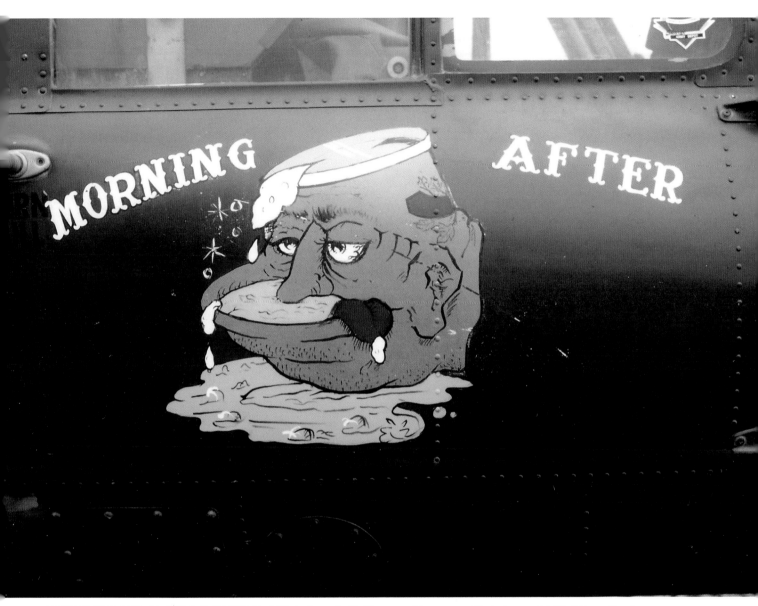

MORNING AFTER. UH-1C, 66-15044. 175th Assault Helicopter Company. Vinh Long, 1967. Piloted by Dwayne Williams AC and crewed by Dave Osbourne CE. Formerly named IN COLD BLOOD. Accrued 1,229 flight hours from April 1967 to September 1968, all with the 175th. According to Williams, one of the crew chiefs or gunners returned from an R&R trip and had a T-shirt with this print on it. The rest of the crew were admiring it alongside the aircraft one day, and Williams commented that it was on the mark because they all felt like that almost every morning since they always closed the O Club or EM Club every night. DAN ALDRIDGE

Richard Weske of the 191st Assault Helicopter Company, 1967–68. He was the artist responsible for SUPERSHIP and BABY HUEY and was also "one hell of a crew chief," according to Don Sandrock. He was "a hippie's hippie," said pilot Don Williams, who added, "He was a good man and the only hippie I ever liked." Weske was killed on his DEROS day. ROGER BARKLEY

MALTESE CROSS. UH-1D, 66-00831. 191st Assault Helicopter Company. Dong Tam, 1968. Piloted by Don Williams AC, who chose the cross because he was married to a German woman. Survived Vietnam from June 1967 to April 1970, with 2,712 flight hours, serving in the 191st from June 1967 to December 1968. The artist was Richard Weske. ROGER BARKLEY

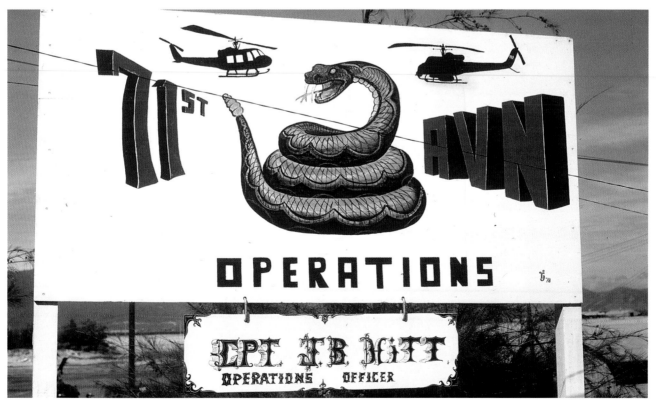

Sign painted by unit artist Anthony Jones for the 71st Assault Helicopter Company at Chu Lai, 1970. Jones "painted on everything from helmets to spent brass rounds, company signs, T-shirts, and avionics covers on our ships." He charged $50 for nose art and $5 for helmets. DON PRIDDY

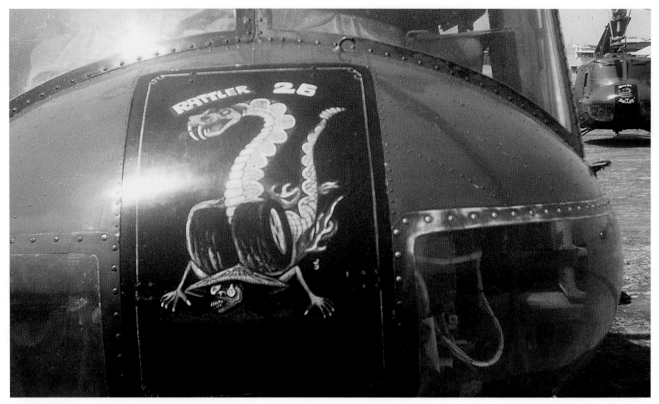

RATTLER 25. UH-1H. 71st Assault Helicopter Company. UH-1H, 1970, Chu Lai. Nose art by Anthony Jones.
DON PRIDDY

THE FAMILY CAR. UH-1H, 69-15165. 165th Transportation Company. Phu Loi, 1971. Crewed by Patrick Lund CE (pictured). Accumulated 1,214 hours from February 1970 to July 1972, more than half that time (February 1970 to August 1971) with the 165th. Loss to inventory on July 12, 1972. PATRICK LUND

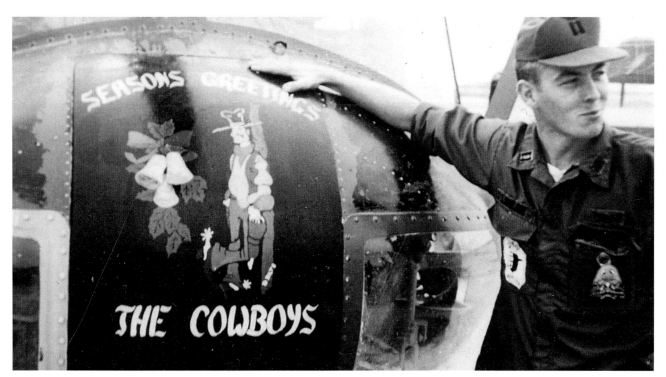

SEASONS GREETINGS. UH-1H. 335th Assault Helicopter Company. Bear Cat, 1969. Piloted by John Lawler AC (pictured). Lawler had the nose cover painted for the Christmas holidays in 1969. He says, "We received a different aircraft every day, so we kept the nose cover hidden and would put it on before we took off and remove it after landing on every flight." JOHN LAWLER

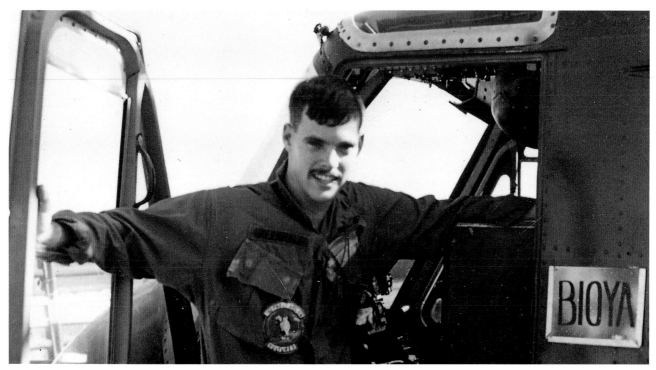

BIOYA. UH-1D, 65-12775. 162nd Assault Helicopter Company. Dong Tam, 1968. Piloted by Bill Greenhalgh AC (pictured). According to Greenhalgh, the name stood for "Blow It Out Your Ass." "One full colonel I had to fly around one day saw it," he remembers, "and smiled and chuckled when he asked, 'Want to tell me what it means?' He already knew—I could tell by his expression." Survived Vietnam from November 1966 to March 1970, with 2,780 flight hours, serving with the 162nd from November 1966 to August 1968. BILL GREENHALGH

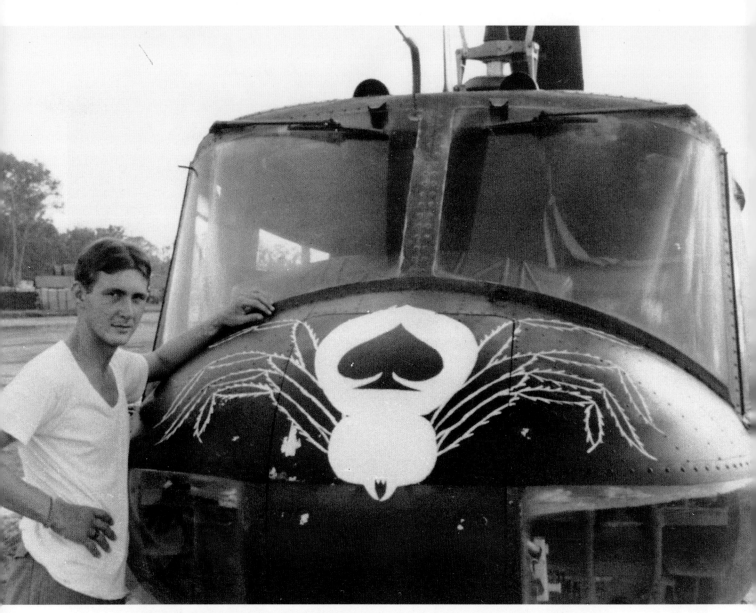

LUCY IN THE SKY WITH DIAMONDS. UH-1H, 66-16119. 188th Assault Helicopter Company. Dau Tieng, November 1967. Aircraft artwork by door gunner Dick Detra (pictured). DICK DETRA

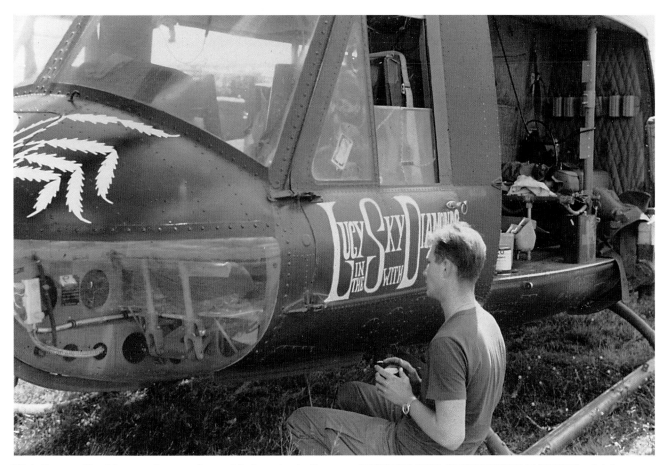

Dick Detra plies his part-time trade on his favorite helicopter, LUCY IN THE SKY WITH DIAMONDS, which became a giant aluminum canvas for his paints and brushes. DICK DETRA

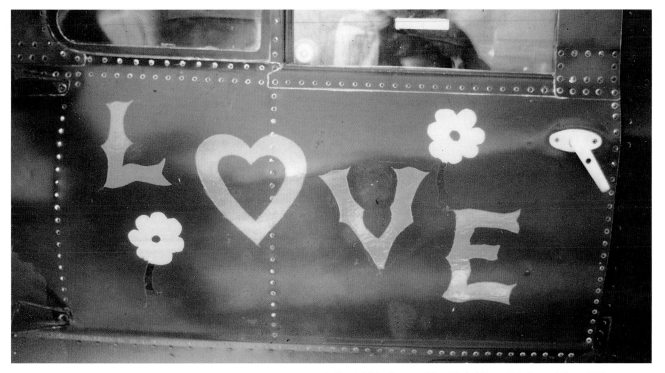

LOVE. UH-1H. 188th Assault Helicopter Company. LZ Sally, 1968. Crewed by Ted Alley CE. Says Alley: "The commanding general of the 101st saw it and went ballistic. Made us take all the names off." DICK DETRA

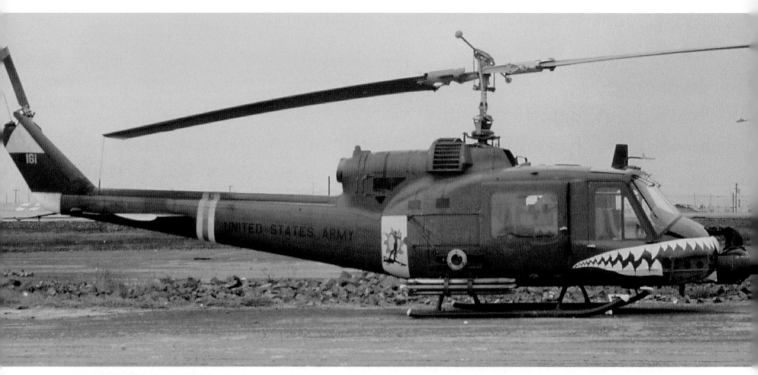

SURFER. UH-1C, 66-15161. 174th Assault Helicopter Company. Duc Pho, 1971. Piloted by James Souder and Bruce Marshall. Accrued 1,396 flight hours from August 1967 to March 1970, serving in the 174th from December 1970 to February 1971. Shot down and destroyed in Laos on February 21, 1971; the crew was rescued. ROBERT BRACKENHOFF

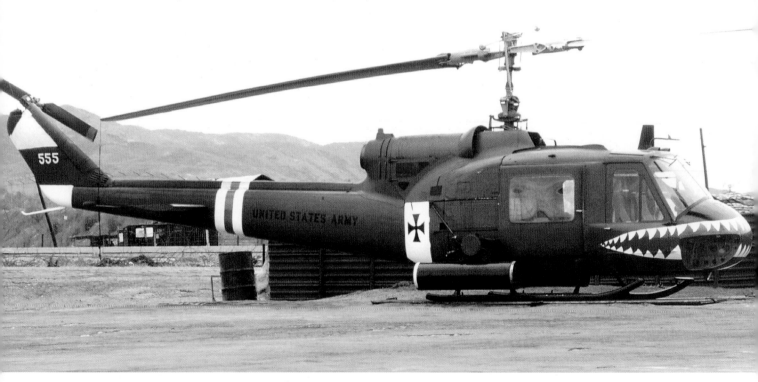

MALTESE CROSS. UH-1C, 65-09555. 174th Assault Helicopter Company. Duc Pho, 1970. Piloted by Fred Thompson. Also known as TRIPLE NICKEL. Survived Vietnam from May 1966 to January 1971, with 1,871 flight hours, serving in the 174th from May 1970 to December 1970. ROBERT BRACKENHOFF

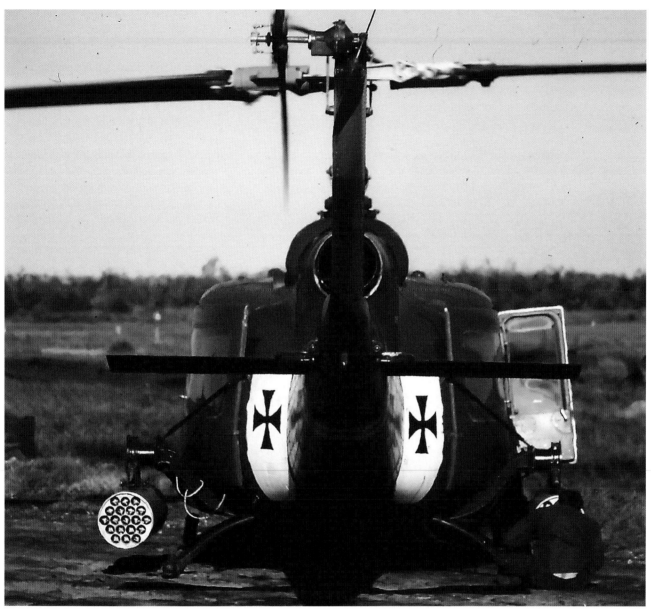

A rear view of MALTESE CROSS. FRED THOMPSON

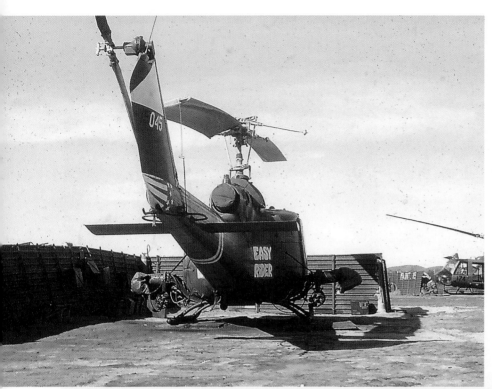

EASY RIDER. UH-1C, 66-15045. 174th Assault Helicopter Company. Duc Pho, 1970. Named for the iconic 1969 road movie. Tallied 2,535 flight hours from April 1967 to November 1970, serving in the 174th from March to November 1970. Involved in a tail rotor strike on November 23, 1970, which permanently knocked it out of commission. UH-1M 66-15242 was named EASY RIDER in its honor.
ROBIN BENTON

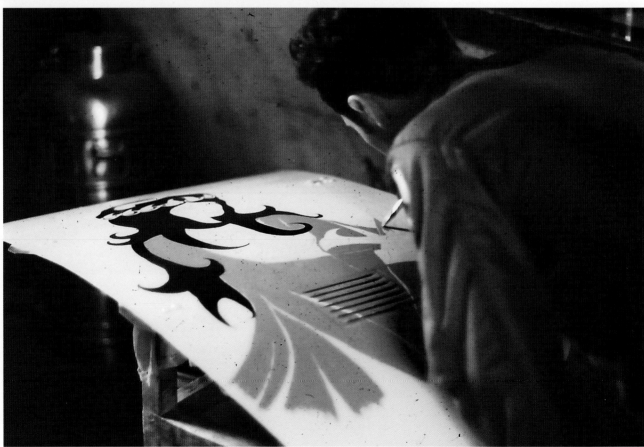

BATTLIN BITCH. UH-1C, 65-09507. 174th Assault Helicopter Company. Duc Pho, 1970. Gary Harter applies the finishing brushstrokes to a masterpiece of in-country art. Survived Vietnam from May 1966 to October 1971, with 3,318 flight hours, serving in the 174th from August 1970 to February 1971. (See page 62 for finished result.)
FRED THOMPSON

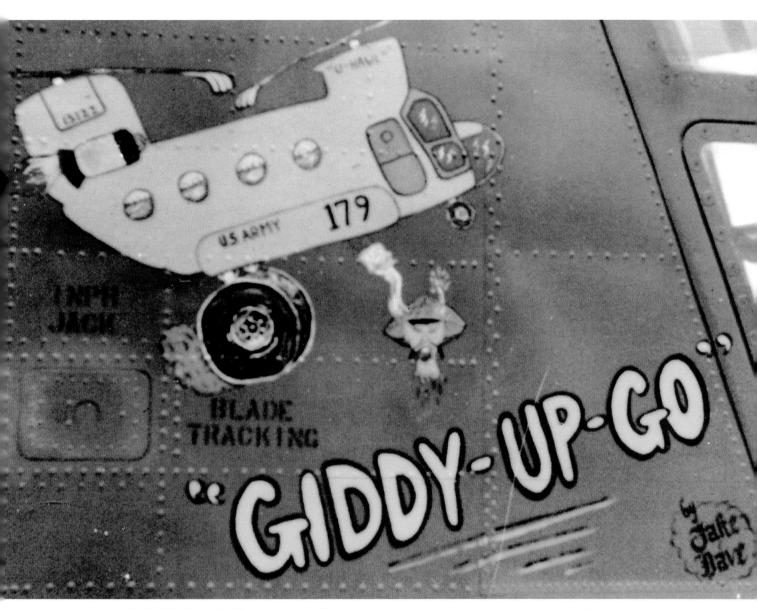

GIDDY-UP-GO. CH-47A, 64-13122. 179th Assault Support Helicopter Company. Pleiku, 1968. Crewed by Roy Jacobs CE and Dave Halder FE, who collaborated on the artwork. The name originated from a country-western song of the same name by Red Sovine. Jacobs's "father loved the song because it was about a truck driver (which is what he did for a living) whose son would ride with his father and say 'Giddy up go, Dad, giddy up go.' The rest is history." Survived Vietnam from July 1965 to April 1969, with 1,507 flight hours, serving in the 179th from June 1968 to February 1969. ROY JACOBS

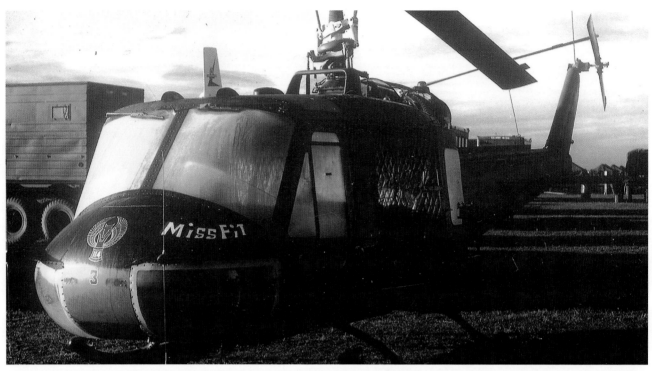

MISS FIT. UH-1B, 62-01968. 114th Assault Helicopter Company. Vinh Long, September 1966. Piloted by William McVeigh AC and crewed by Howard Chambers CE. The aircraft later had a Hollywood movie career, appearing in *China Beach, Die Hard, Outbreak, The Rock,* and *Under Siege.* HOWARD CHAMBERS

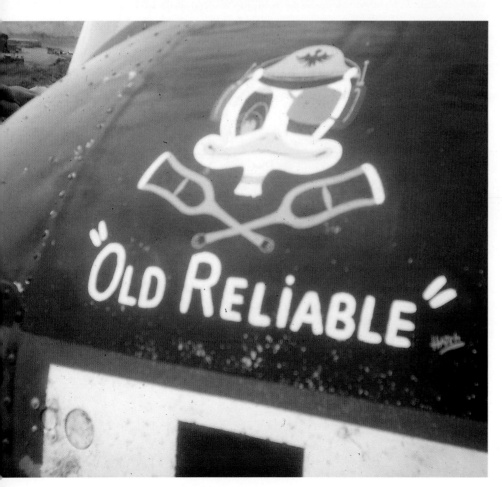

OLD RELIABLE. UH-1D, 62-12370, 1967. 15th Medical Battalion. An Khe, The Golf Course. Piloted by Larry Hatch AC and crewed by Ron Trodgon CE (killed on June 19, 1967). According to Hatch, the name "represents the reliability of the UH-1D Huey and the reliability of the medevac crews to respond to missions when called." Survived Vietnam from December 1963 to February 1968, accruing 2,078 flight hours. LARRY HATCH

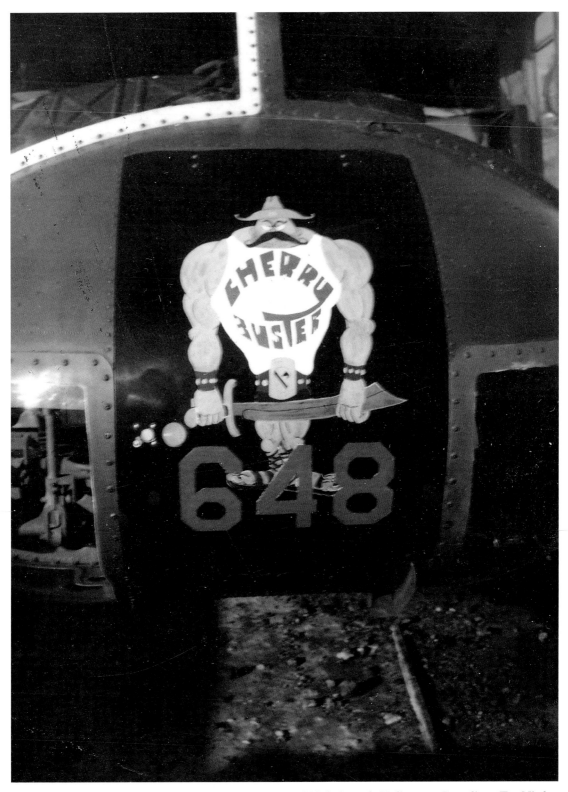

CHERRY BUSTER. UH-1H, 68-15648. C Company, 229th Assault Helicopter Battalion. Tay Ninh, 1970. Piloted by Roger Baker AC and crewed by David Holte CE and Robert Painter DG. The name, according to Baker, "came from the fact that more crew members seemed to receive their baptism of ground-to-air fire in that aircraft." Accumulated all of its 1,500 flight hours with C Company from June 1969 to September 1970. Involved in a mid-air collision with UH-1H 68-16123, with both crews KIA (Painter was killed on '123, but Baker and Holte were not on either crew). ROGER BAKER

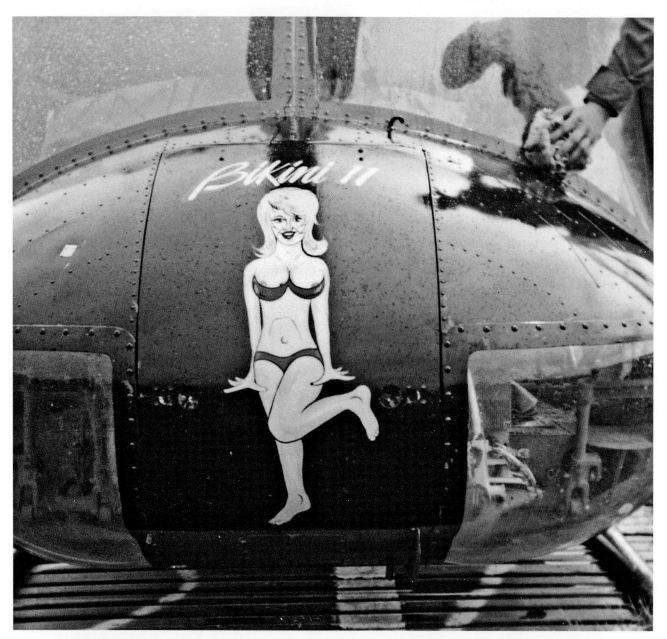

THE BITCH. UH-1H, 68-15262. 170th Assault Helicopter Company. Pleiku, 1969. Piloted by Dave Baker AC and crewed by Ron Sanders CE. Inspired in part by *Playboy* magazine's *Little Annie Fanny* comic strip, the artwork turned out to be more like "Annie Fanny's ugly stepsister." Accumulated 1,731 flight hours from January 1969 to March 1970, serving exclusively with the 170th. RON SANDERS

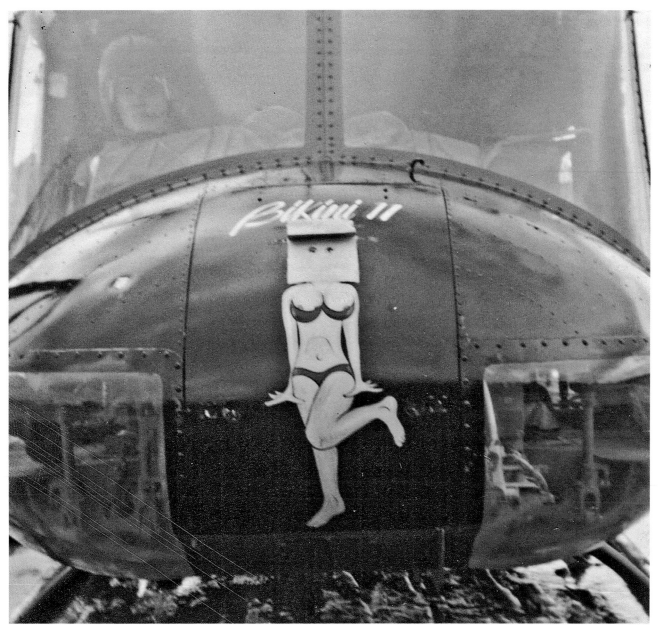

Another view of THE BITCH, with a brown paper bag covering the unsightly artwork.
RON SANDERS

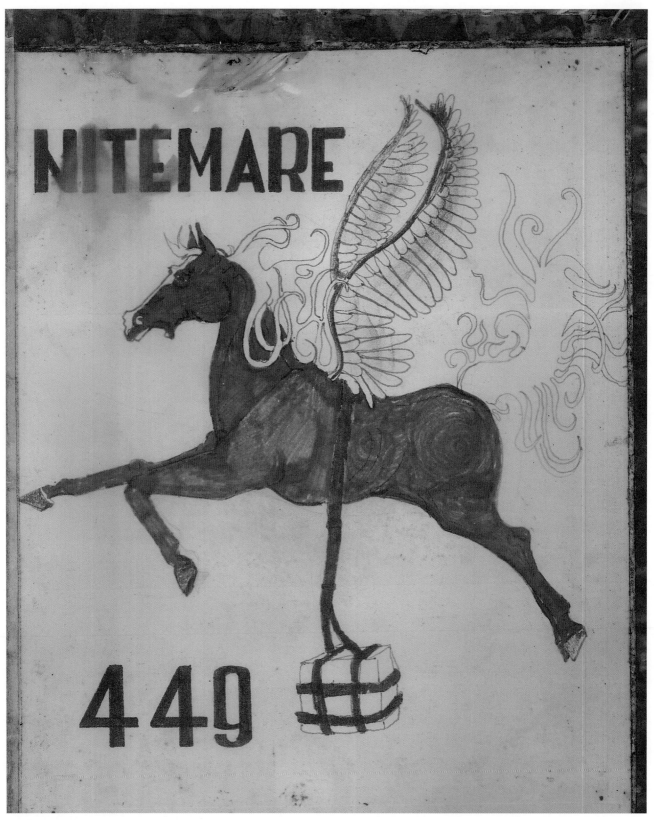

NITEMARE. CH-47B, 67-18449. 132nd Assault Support Helicopter Company. Chu Lai, February 1971. Piloted by Greg Cook AC and Larry Seeger CP and crewed by Hancock FE, Padilla CE, and Worrell DG. This is the artist's original design as sketched on rigid paperboard. Accrued 1,828 flight hours, exclusively with the 132nd, from May 1968 until shot down and destroyed in Laos on February 27, 1971 (crew survived). LARRY SEEGER

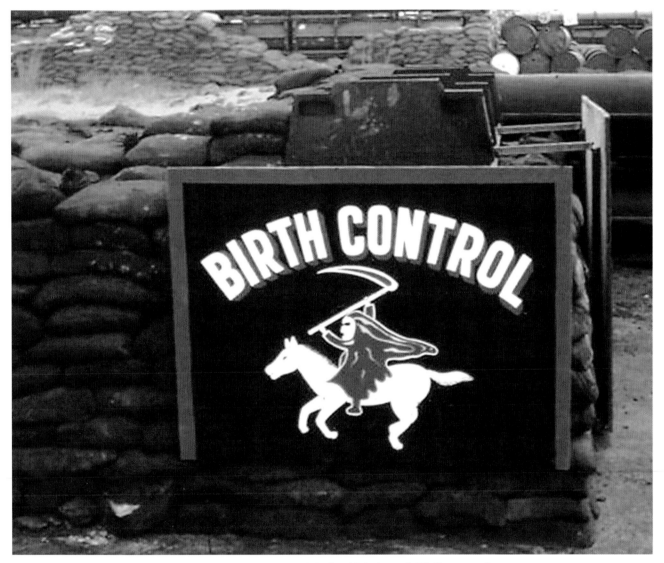

Ralph Noyes remembers: "When I was with the 68th Assault Helicopter Company, we never had any names or artwork painted on the helicopters that I can recall. A few of the ships had Mustangs painted on their rocket pods, and a couple had some offensive writing on the belly of the aircraft. We had the names painted on plywood signs on our respective revetments." JOE MATUSZ

HO CHI SUCKS. UH-1C, 66-00654. 68th Assault Helicopter Company. Bien Hoa, 1967. Crewed by Jamie Poston CE and Dave Henderson DG. Suffered the same fate as sister gunship SAT-CONG ("Kill VC"), whose politically incorrect name was ordered removed. Loss to inventory on March 8, 1968. JAMIE POSTON

THE GOOD WIDOW MRS. JONES. UH-1D, 65-09777. 121st Assault Helicopter Company. Soc Trang, 1968. Piloted by Rick Thomas AC (right) and crewed by Chris Chrisafully CE (left). According to Thomas, he found the painted avionics door, which was adapted from a Vargas painting in a 1964 issue of *Playboy*, in a Vietnamese paint shop in downtown Soc Trang, bought it, and installed it on his aircraft. Destroyed while landing in a mine field in July 1968. The nose panel was salvaged and transferred to a Viking UH-1B (63-08733) when Thomas transferred to the 3rd Platoon in early 1969.
RICK THOMAS

Carl Mumaw, Company artist of F Troop, 8 Cavalry, is caught in the act with brushes, paints, and stencils.
CARL MUMAW

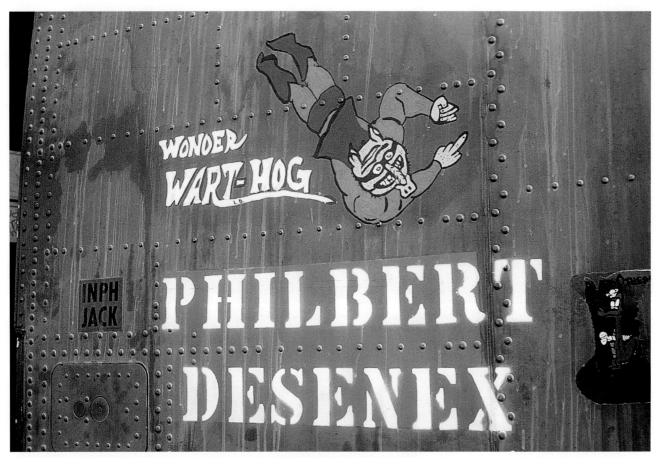

PHILBERT DESENEX. CH-47A, 66-00094. 200th Assault Support Helicopter Company. Bear Cat, 1968. Philbert Desenex was the alter-ego of the Wonder Wart-Hog, the focus of a parodic comic book of the same name. According to George Miller, Wonder Wart-Hog was the men's nickname for the unit's commander. The lettering at the right of the photo reads, "Do Unto Others Before They Do Unto You." Accrued 1,446 flight hours from approximately March 1967 to June 1970, serving in the 200th from 1967 until July 1968. LENNY BREEDEN

LOH RETRIEVER. UH-1H, 66-16919. Headquarters and Headquarters Troop, 7th Squadron, 1st Cavalry. Vinh Long, 1969. Piloted by Ed Walker AC. Accrued 2,046 flight hours, exclusively in the 7th Squadron. Named for its job of recovering light observation helicopters (LOH)—thirty-seven by October 1968, according to Walker. ED WALKER

SAT-CONG. UH-1C, 66-00624. 190th Assault Helicopter Company. Bien Hoa, 1968. Piloted by Bob Coveney AC. The name translates as "Kill VC." According to Coveney, "Little kids always stopped to point at the dead VC painting." Accrued 533 flight hours while serving all of its in-country time (November 1968 to April 1969) in the 190th. Experienced engine failure on April 24, 1969. BOB COVENEY

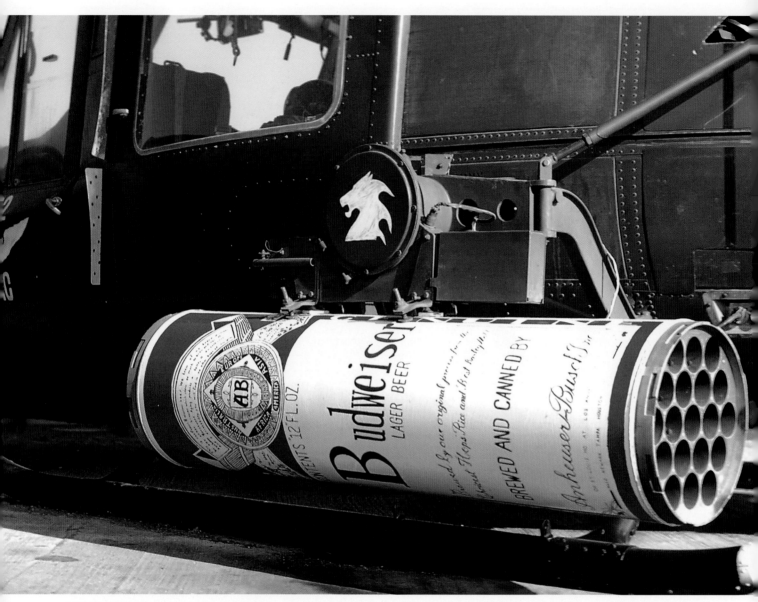

BUDWEISER. UH-1C, 66-15113. 92nd Assault Helicopter Company. Dong Ba Thin, 1968. Crewed by Tom Tucker CE and John Horn DG. Artist Denny Turner says, "The white one-part epoxy background was done with aerosol spray cans, and the red and blue lettering and graphics were hand-painted with oil-based hobby enamels over the white. A few careful top coats of clear satin acrylic aerosol spray sealed it all." Accumulated 1,196 flight hours, exclusively with the 92nd, from November 1967 to September 1969. Loss to inventory on September 7, 1969. BILL ROBIE

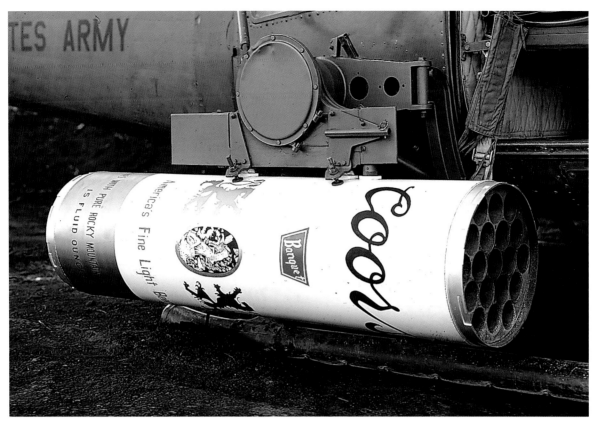

COORS. UH-1C, 66-15113. 92nd Assault Helicopter Company. Dong Ba Thin, 1968. Painted by crew chief Tom Tucker. BILL ROBIE

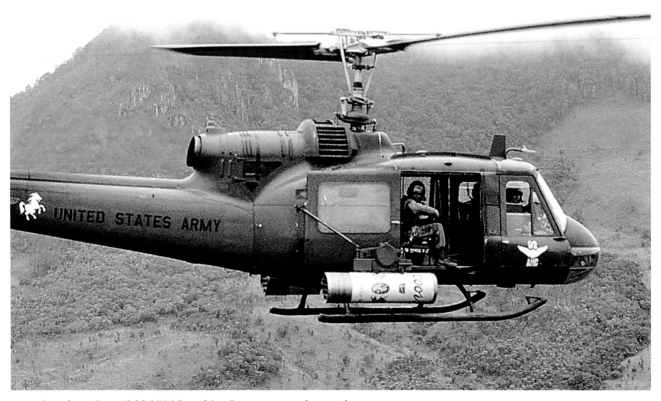

Another view of 66-15113 and its Coors-can rocket pod. BOB HARRINGTON

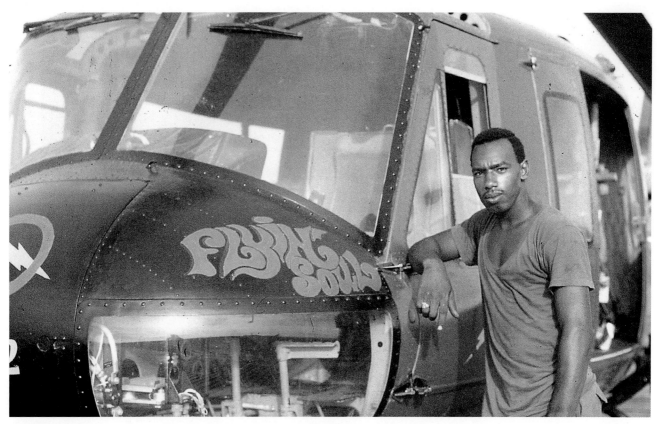

FLYIN' SOUL. UH-1H, 67-17412. C Company, 227th Assault Helicopter Battalion. Phuoc Vinh, 1969. Compiled 920 flight hours, all with C Company, from August 1968 to July 1969. Loss to inventory because of mechanical failure on July 15, 1969. DENNIS BECKLER

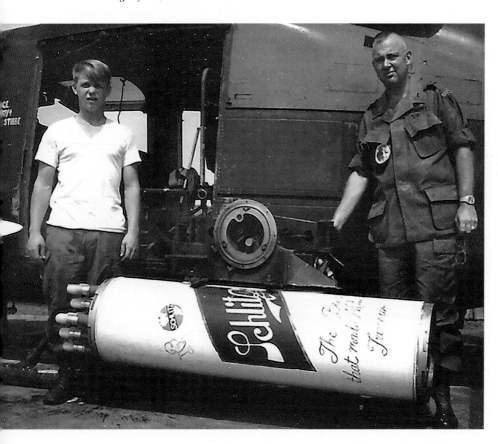

SCHLITZ. UH-1B, 62-04592. 335th Assault Helicopter Company. Bear Cat, 1969. Crewed by Russell Stibbe CE (left). Howard Stiles (right) was commander of the 335th. Survived Vietnam from September 1963 to August 1970, with an astonishing 3,781 flight hours, serving in the 335th from August 1968 to August 1970. HOWARD STILES

HELICOPTER NOSE ART BROUGHT HOME

Countless souvenirs made their way home from tours in Vietnam, but such mementos seldom included a large piece of a helicopter. Perhaps a few dozen UH-1 Huey nose compartment panels came home to the States—and thank goodness they did. Their uniqueness as folk art and their historical value as war relics thrust them to the top tier of Americana. Rare and highly prized, most remain in private hands.

SNAKE DOCTOR. UH-1H, 69-15376. 71st Assault Helicopter Company. Chu Lai, 1970. Crewed by Tom Bokkes CE, who brought home this avionics cover and hung it in his business. Painted by Anthony Jones. ANTHONY JONES

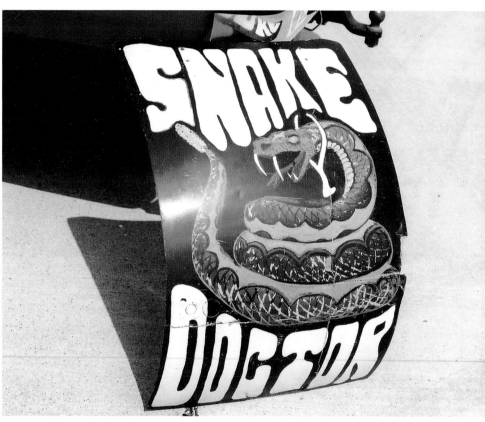

BLACKJACK 496. UH-1H, 68-16496. A Company, 4th Aviation Battalion. An Khe, 1970. Crewed by Donnie Lail CE. Accumulated 1,350 flight hours from December 1969 to September 1971, spending half that time with A Company from January to September 1970. Loss to inventory in September 1971. DONNIE LAIL

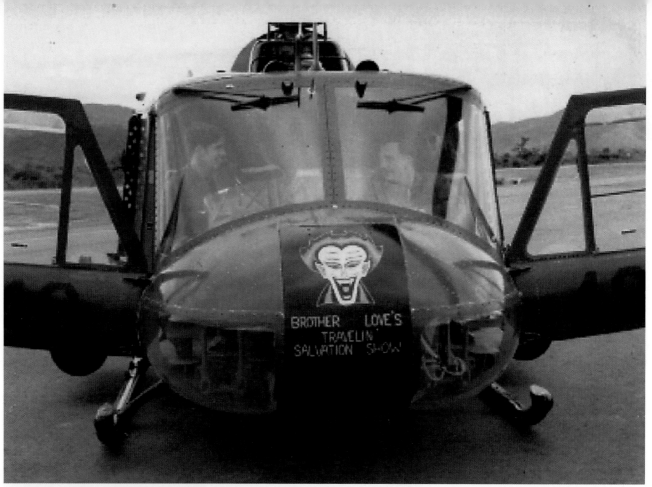

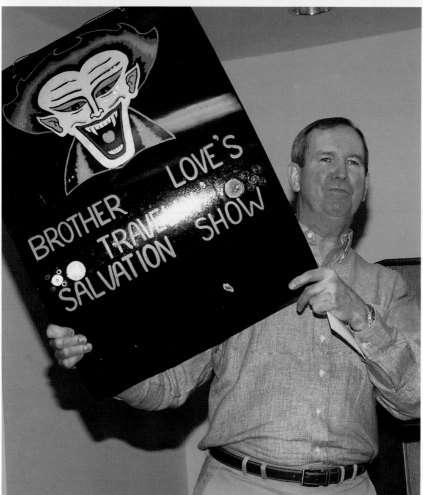

BROTHER LOVE'S TRAVELIN' SALVATION SHOW. UH-1C, 66-00520. 48th Assault Helicopter Company. Ninh Hoa, 1970. Piloted by Rick Lester AC and crewed by Jerry Winchester CE and Curtis Haws DG. Named after the 1969 album and song by Neil Diamond; the joker face appeared on all the aircraft in the platoon. Survived Vietnam from September 1966 to November 1971, with 1,046 flight hours, serving in the 48th from March 1970 to May 1971.
CURTIS HAWS

Rick Lester with the avionics cover in 2009. RICK LESTER

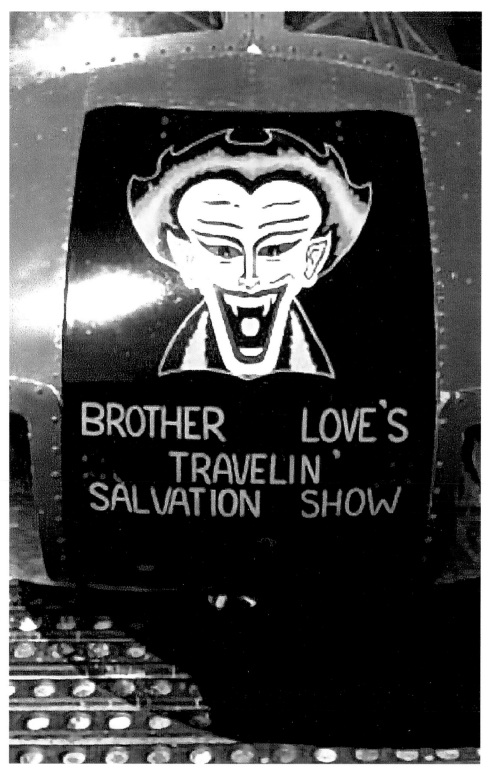

A closer look at the art from BROTHER LOVE'S TRAVELIN' SALVATION SHOW.
CURTIS HAWS

THE MAGNIFICENT MEN AND THEIR FLYING MACHINE. UH-1H, 67-17346. 175th Assault Helicopter Company. Vinh Long, 1971. Piloted by Edmund Hubard AC and crewed by Ivey Miller CE (pictured) and Jim Klink DG. Named after a 1965 British comedy film about a London-to-Paris air race set in 1910. Also known as Outlaw 13. Accumulated 2,088 flight hours from July 1968 to May 1972, serving with the 175th from May 1971 to February 1972. IVEY MILLER

Harry Khachadourian and the cover at a unit reunion. HARRY KHACHADOURIAN

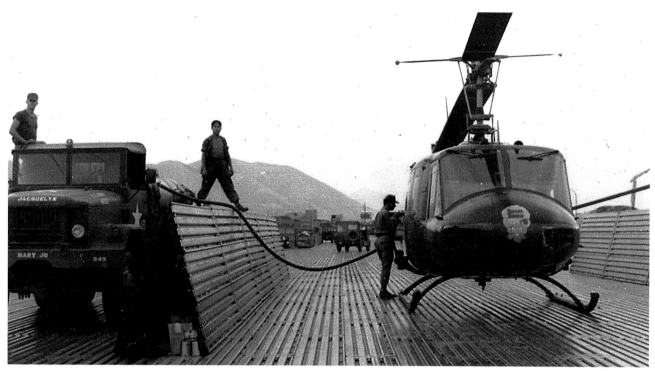

BOOM BOOM 6. UH-1H, 66-16984. 15th Transportation Battalion. Da Nang, 1967. Crewed by Jimmy Shows CE. Name is Vietnamese slang for sex. BOOM BOOM 6 was the call sign of the unit's commanding officer. JIMMY SHOWS

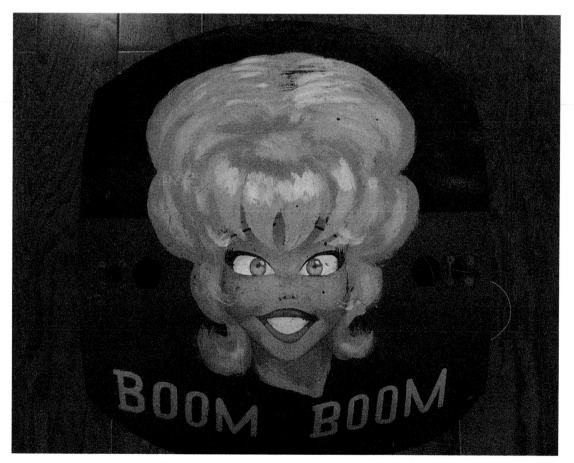

One of two avionics access doors presented to Albert Schlim, commander of the 15th Transportation Battalion, upon his departure from Vietnam in 1968. JOSEPH SCHLIM

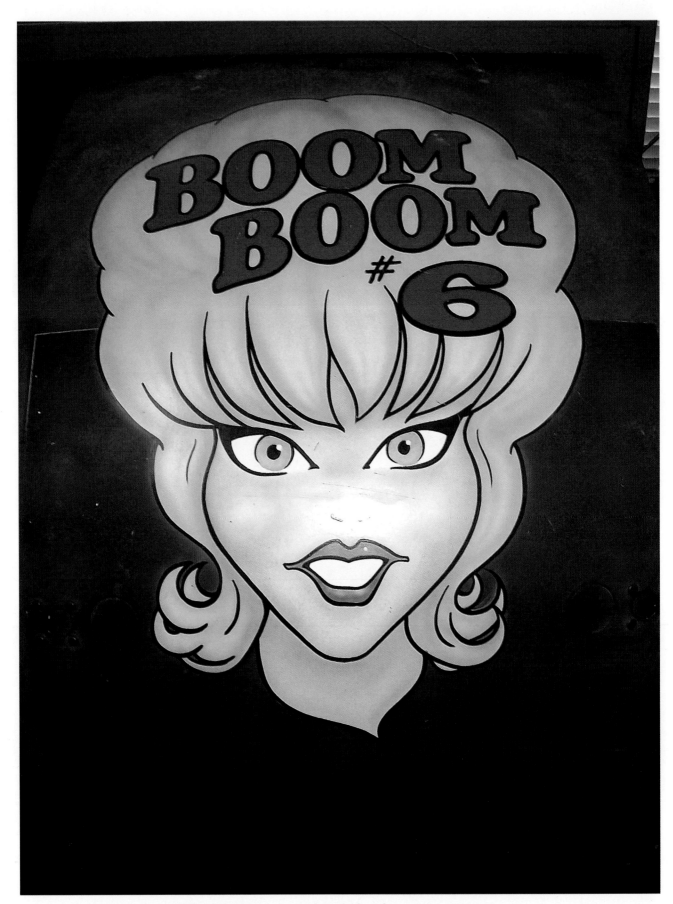

Nose art from BOOM BOOM 6 as reproduced after the war. JIMMY SHOWS

TAIL WIND. UH-1H, 66-16984. 15th Transportation Battalion. Da Nang, 1968. This was the call sign for Headquarters and Headquarters Company and the battalion commander's ship. The art depicts Little Annie Fanny from the *Playboy* comic strip of the same name. Accumulated 1,591 flight hours from December 1967 to May 1970, serving in the 15th from December 1967 to November 1969. Destroyed in a flying accident on May 21, 1970. JOSEPH SCHLIM

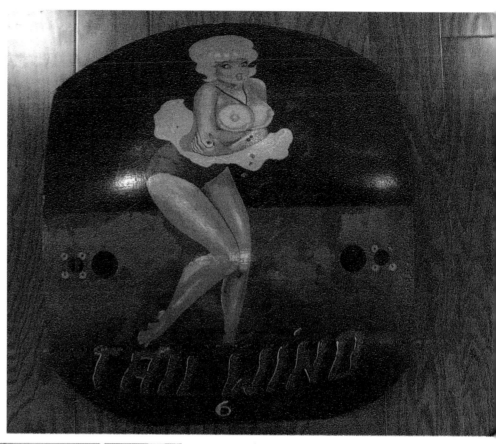

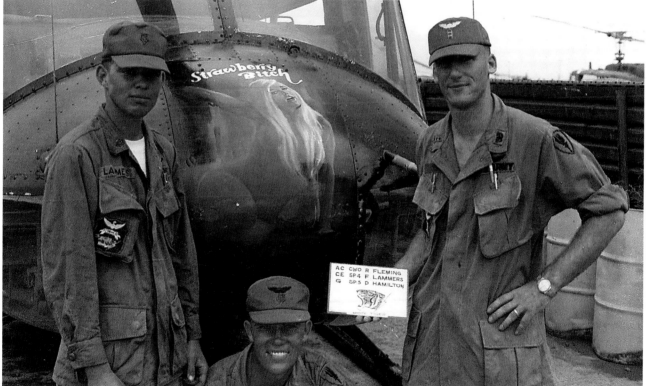

STRAWBERRY BITCH. UH-1D, 64-13822. 121st Assault Helicopter Company. Soc Trang, March 1968. Piloted by Robert Fleming AC (right) and Mike Shakocius CP and crewed by Fred Lammers CE (left) and Daniel Hamilton DG (middle). The image is *Playboy* model Elke Sommer. This older D model featured two attached antennae on the nose. Fleming took the nose panel home. MIKE SHAKOCIUS

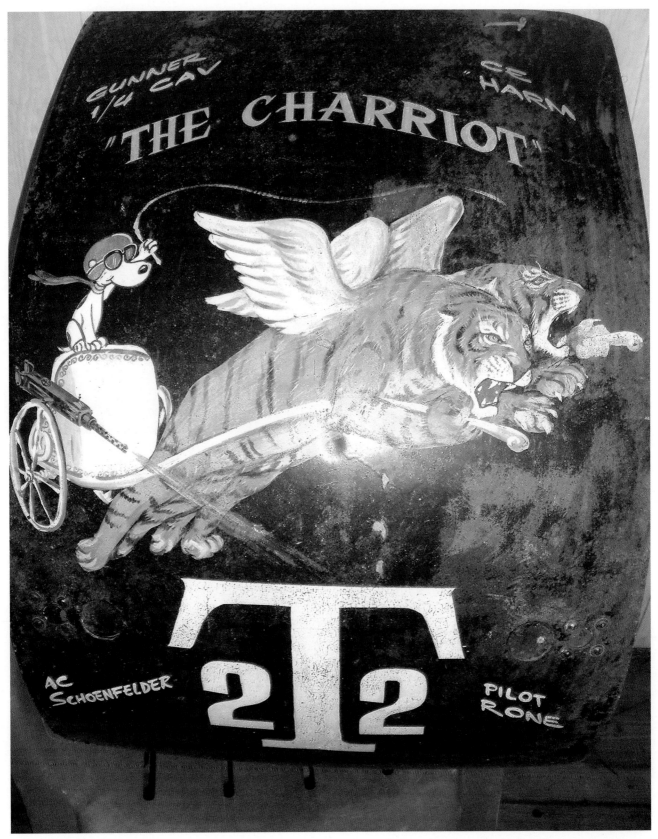

THE CHARRIOT. UH-1D. 121st Assault Helicopter Company. Soc Trang, 1970. Crewed by Ray Burke CE, who took it home. *RAY BURKE*

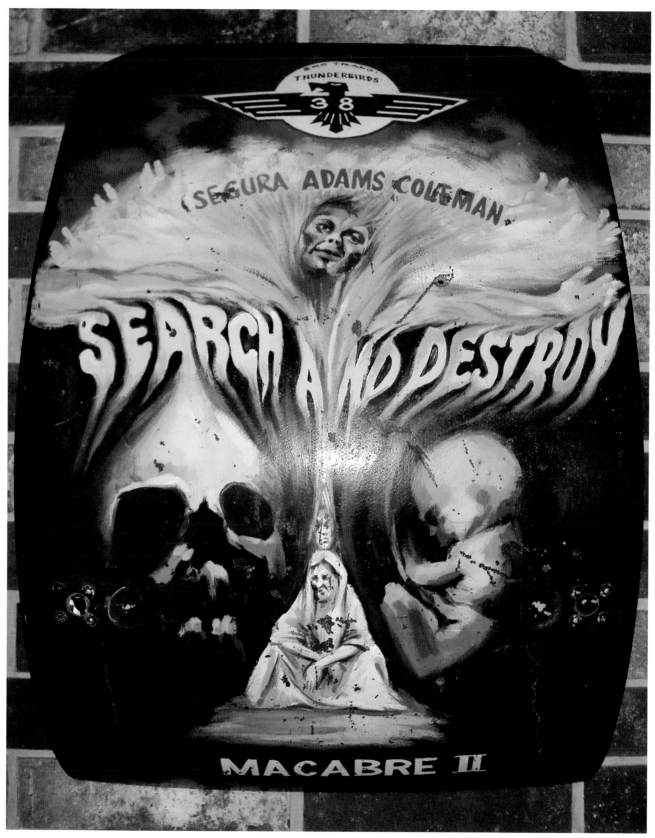

MACABRE II. UH-1C, 66-00564. 336th Assault Helicopter Company, Soc Trang, 1970. Crewed by Bill Coleman CE. Art inspired by the cover of *In Search of the Lost Chord*, a 1968 album by The Moody Blues. Accumulated 2,650 flight hours from August 1966 to September 1970, serving in the 336th from March 1970 to September 1970. Loss to inventory on September 6, 1970. BILL COLEMAN

RED DEVIL. UH-1H. 336th Assault Helicopter Company. Loren Harmon, former 336th maintenance pilot, holds the artwork. (See page 152 for original art circa 1968.)

LOREN HARMON

GLOSSARY

A/C	Aircraft
AA	Air ambulance
AB/ABN	Airborne
AC	Aircraft Commander
ACAV	Armored Cavalry Assault Vehicle
ACD	Armored Cavalry Division
ACR	Armored Cavalry Regiment
AFA	Aerial Field Artillery
AFB	Air Force Base
AH-1G	Attack helicopter (Bell) gunship; HueyCobra, Cobra, Snake
AHB	Assault Helicopter Battalion
AHC	Assault Helicopter Company
ARA	Aerial Rocket Artillery
ASHB	Assault Support Helicopter Battalion
ASHC	Assault Support Helicopter Company
ATC	Air Traffic Control
Avionics	Aircraft electronic systems
AVN	Aviation
AWC	Aerial Weapons Company
BDE	Brigade
Blooper	40mm grenade launcher
BN	Battalion
Bug	Helicopter equipped with powerful Xenon searchlight and night-vision gear
C&C	Command and Control
C.O.	Commanding Officer
CA	Combat Assault
CAB	Combat Aviation Battalion
CAC	Corps Aviation Company
CAG	Combat Aviation Group
CAV	Cavalry
CE	Crew Chief
CH-21	Twin-rotor (Piasecki) helicopter utilized for supply and transport
CH-47	Twin-rotor (Boeing) helicopter utilized for supply and transport
CH-54	Super-heavy lifter (Sikorsky), mostly external loads; Sky Crane
Chinook	Boeing CH-47, tandem rotor cargo helicopter
Chunker	Grenade launcher in nose turret
Clamshell	Engine access doors on the OH-6A
CO	Company
Cobra	AH-1 (Bell) gunship
CP	Co-Pilot
CSAB	Combat Support Aviation Battalion
CSB	Combat Support Battalion
CSBN	Composite Services Battalion
CWO	Chief Warrant Officer
DEROS	Date eligible for return from overseas service
DET	Detachment
DG	Door Gunner
Dog house	Rotor housing area
Dustoff	Air ambulance
EVAC	Evacuation
FE	Flight Engineer
FFAR	Folded fin aerial rocket
Firefly	Helicopter equipped with powerful Xenon searchlight and night-vision optics
Frog	UH-1B/C with 14 rockets, grenade launcher, and M60 machine guns
FSB	Fire support base
GS	General Support
H&HC	Headquarters & Headquarters Company
H&HT	Headquarters & Headquarters Troop
HA	Helicopter ambulance
HHC	Heavy Helicopter Company
Hog	UH-1B/C with 48 rockets and M60 machine guns
Hook	CH-47 Chinook
Hot refuel	Fueling an aircraft with the engine running
Huey	UH-1A, B, C, D, H, M
I Corps	Military Region (MR) nearest the DMZ
II Corps	Military Region (MR) nearest the Central Highlands
III Corps	Military Region (MR) nearest the Iron Triangle, Saigon area

VIETNAM WAR HELICOPTER ART

IV Corps	Military Region (MR) nearest the Mekong Delta		RRC	Radio Research Company
JP4	Aircraft fuel		RVN	Republic of Vietnam
KBA	Killed by air		S-1	Administration
KIA	Killed in action		S-2	Intelligence
LBJ	Long Binh (jail)		S-3	Operations
Lead	Flight platoon leader		S-4	Logistics
LIB	Light Infantry Brigade		SAC	Surveillance Aviation Company (fixed wing)
Lift	UH-1 troop carrier		SAM	Surface-to-air missile
Light ship	UH-1 mounted with seven landing lights for night missions		Scout	Observation helicopters: OH-6 Cayuse, OH-13 Sioux, OH-23 Raven, OH-58 Kiowa
Loach	OH-6A light observation helicopter			
LOH	Light observation helicopter		Skids	Non-wheeled landing gear on helicopters
Loss to inventory	Destroyed or sent stateside for repairs		Slick	UH-1 Huey helicopter utilized for carrying troops
LZ	Landing Zone		Smoke	Smoke ship; UH-1 utilized for laying down a billowing screen of smoke to blind the enemy to trailing troop carrying aircraft
M-5	40mm grenade launcher			
MACV	Military Assistance Command, Vietnam			
Mav	Maverick, 175 AHC, gunship platoon			
MB	Medical Battalion		Snake	AH-1 Cobra gunship
MC	Medical Company		TB	Transportation Battalion
Medevac	Air ambulance, 1st Cavalry Division		TC	Transportation Company
Mohawk	Grumman OV-1, twin engine, fixed-wing photo surveillance aircraft		TDY	Temporary Duty
			TI	Tech Inspector
NCO	Non-Commissioned Officer		TOW	Tube launched, optically tracked, wire guided antitank missile
NETT	New Equipment Training Team			
Nighthawk	UH-1 with spotlight and Starlight (light-intensifier) capabilities		TRP	Troop
			UH-1	Utility helicopter (Bell); Huey
NOMEX	Fire retardant flight uniform		USARV	U.S. Army, Vietnam
NVA	North Vietnamese Army		UTT	Utility Tactical Transport
OH-6A	Observation helicopter (Hughes), aka "Loach"		VLAAF	Vinh Long Army Airfield (Mekong Delta area)
P	Pilot			
POW	Prisoner of War		VNAF	South Vietnamese Air Force
R&R	Rest and Recreation		WIA	Wounded in action
RAC	Reconnaissance Aviation Company		WO	Warrant Officer
Recovery	Heavy lifters: CH-37 Mojave, CH-47 Chinook, CH-54 Sky Crane		WOC	Warrant Officer Candidate
			WP	White phosphorus
Revetment	Fortified walled parking area for aircraft		Xenon	High-intensity searchlight
RPG	Rocket-propelled grenade		XO	Executive Officer

CONTRIBUTORS

200 ASHC Association
Adams, Clif, 45 Med Co, CE, 1968
Adams, David, D Trp 1/1, P, 1969–70
Adams, Tom, 282 AHC, CE, 1965–66
Aeilts, Mike, 117 AHC, CE, 1969–70
Aldridge, Dan, 199 RAC, P, 1967–68
Alleger, Keith, 117 AHC, P, 1968–69
Alley, Ted, 188 AHC, CE, 1968
Allred, Nancy, sister of KIA Ron Trogdon,
 15 Med Bn, CE
Anderson, Paul, 2 Bde 1 Cav, P, 1969–70
Anderson, Roger, 175 AHC, CE, 1967–69
Aretz, Jim, 334 AHC, CE, 1967–68
Arruda, Larry, 120 AHC, CE, 1964–65
Asberry, Andy, B Co 25 Avn Bn, CE, 1969
Atanian, Bud, 282 AHC, CE, 1967–68
Avery, Dennis, 187 AHC, P, 1969–70
Babb, Michael, 187 AHC, P, 1970–71
Bailey, John, 174 AHC, P, 1969–70
Baker, Roger, C Co 229 AHB, P, 1969–70
Barkley, Roger, 191 AHC, CE, 1967–68
Barrera, John, 116 AHC, CE, 1970–71
Barrie, Jim, 117 AHC, CE, 1970–71
Bartlett, Robert, A Co 228 ASHB, FE, 1967–68
Bascom, Don, 117 AHC, CE, 1967
Bauer, Jim, 610 TC, P, 1973
Beckler, Dennis, C Co 227 AHB, CE, 1968–69
Belkin, Howie, C Co 227 Cav, DG, 1969–70
Bell, Carl, C Trp 3/17 Cav, P, 1972
Benton, Robin, 11 LIB, Arty, 1969–70
Betsill, Carl, F Trp 4 Cav, Avionics, 1971
Bills, Allen, C Trp 7/1, P, 1970–71
Bishop, Dennis, 498 Med Co, MD, 1970–71
Blickenstaff, Jon, 159 Med Det, CE, 1970–71
Boese, Terry, 498 Med Co, CE, 1969–71
Boettger, Tim, 176 AHC, CE, 1971
Bokkes, Tom, 71 AHC, CE, 1970–71
Bollens, Al, 155 AHC, P, 1968–69
Bowser, Dan, 128 AHC, P, 1970–71
Boxley, Joe, 200 ASHC, DG/FE, 1967–68
Boyd, Barc, 8 TC, P, 1962–63

Boyd, Timmy, 237 Med Det, CE, 1970–71
Boyle, Ray, 282 AHC, CE, 1969–70
Brackenhoff, Robert, 409 TC/174 AHC, Maint,
 1970–71
Braddock, John, 236 Med Det, MD, 1971–72
Bradley, Dave, A Trp 7/1 Cav, P, 1970–71
Bradley, Jerome, C Trp 1/9 Cav, P, 1968–69
Bradley, Lee, 117 AHC, CE, 1970–71
Bramuchi, David, D Trp 1/10 Cav, CE, 1969–70
Brant, Butch, 176 AHC, CE, 1970–71
Bratkovic, Bob, 135 AHC, P, 1970–71
Bray, Bill, 200/205 ASHC, CE/FE, 1967–68
Bray, Eric, 162 AHC, P, 1970
Breeden, Lenny, 200 ASHC, DG, 1967–68
Brennan, John, 114 AHC, Opns, 1970–71
Brethen, Eric, D Trp 3/4 Cav, P, 1969–70
Brewer, Gary, D Trp 1/4 Cav, CE, 1969–70
Brinn, Joe, A Trp 7/17 Cav, P, 1968–69
Brown, Danny, E Co 704 Maint Bn, CE, 1969–70
Brown, Fred, 129 AHC, Armorer, 1970–71
Brown, Rodney, 147 ASHC, FE, 1967–68
Buchheister, Bill, B/2/5 Cav, Inf, 1968–69
Bullen, John, 174 AHC, CE, 1970
Bunger, Bill, 243 ASHC, FE, 1968
Burbank, Howard, A Co 227 AHB, P, 1968–69
Burden, Dennis, A Co 227 AHB, CE, 1966–67
Burgess, Chris, B Trp 1/9 Cav, P, 1968–69
Burk, Wayne, C Trp 16 Cav, P, 1970–71
Burke, Ray, 121 AHC, CE, 1970
Burkhalter, Darrell, 118 AHC, P, 1969–70
Burrow, Roy, 243 ASHC, FE, 1968–70
Caine, Vaughn, E Trp 1/9 Cav, P, 1970–71
Callaghan, Bob, 2 Signal Gp, CE, 1966–67
Campbell, Bruce, C Trp 1/9 Cav, P, 1970–71
Cano, Jose, 282 AHC, CE, 1971–72
Cardinal, Patrick, 215 CSB, CE, 1971–72
Carlton, Ken, 191 AHC, P, 1969–70
Carter, Tommy, 117 Avn Co, CE, 1965–66
Casey, Matt, 129 AHC, CE, 1970
Cathey, George, 116 AHC, DG, 1967–70
Cattilini, John, A Trp 7/1 Cav, P, 1970–71

Chambers, Howard, 114 Avn Co, CE, 1965–66
Chappell, Mel, C Co 228 ASHB, FE, 1968–69
Chenoweth, Bob, 4 TC/120 AHC/58 Avn Det, CE, 1967–68
Cherrie, Stan, 191 AHC, P, 1967–68
Chilton, Dick, B Trp 1/9 Cav, P, 1965–66
Clark, Wayne, B Co 159 ASHB, DG, 1969
Cockrell, Gordon, 189 AHC, P, 1970–71
Coe, Don, 114 AHC, P, 1970–71
Cole, Mike, B Btry 2/20 ARA, CE, 1969–70
Coleman, Bill, 336 AHC, CE, 1969–71
Comrey, Bill, 21 Sig Gp, A/C Material Supply, 1969
Comstock, Daniel, A Co 159 ASHB, FE, 1971–72
Coogan, Tim, 498 Med Co, MD, 1969–70
Coombs, Ed, 119 AHC, P, 1965–66
Cope, William, 192 AHC, P, 1971
Copley, Todd, USAF(R), Dobbins ARB
Corbin, Ron, 119 AHC, P, 1966–67
Cornwell, Jim, 2/7 + 1/12 1st Air Cav, 1970–71
Coveney, Bob, 190 AHC, P, 1968
Cowan, Sidney, A Co 229 AHB, P, 1965–66
Cox, Jeff, 114 AHC, P, 1970–71
Crews, Tom, 21 Sig Gp, CE/Maint, 1969
Croley, Chuck, 195 AHC, CE, 1970
Crow, Dick, 173 AHC, P, 1970
Cupp, Paul, A Trp 7/1 Cav, CE, 1969–70
Curtis, Grant, B Trp 1/9 Cav, P, 1969–70
Davis, Clarke, 132 ASHC, 1970–71
Davis, Robert, 192 AHC, CE, 1969–70
Davis, Willie, MACV Flight Det, P, 1965–66
Demumbreum, Jim, 57 AHC, CE, 1971–72
DePerro, John, 15 Trans Bn, P, 1968–69
Detra, Dick, 188 AHC, DG, 1967–68
Dillon, Frank, F Trp 4 Cav, Electrician, 1971–72
Dize, Jesse, 48 AHC, P, 1970–71
Doke, Richard, 187 AHC, CE, 1971
Donnelly, James, 175 AHC, DG, 1971–72
Doucette, Al, 81 TC, DG, 1962–63
Doudna, Dean, C Btry 2/20 ARA, CE, 1971–72
Dougan, Pat, 187 AHC, P, 1968–69
Dowler, Gary, 121 AHC, P, 1966–67
Draper, Gary, 20 Engineer Bn, 1970–71
Drury, Doug, 119 AHC, P, 1967–68
Dumford, Larry, 200 ASHC, 1967–68
Dunlap, Bud, 48 AHC, CE, 1970–71
Dunn, Wes, 45 Med Co, CE, 1967–68
Dutson, Dick, 117 AHC, P, 1970–71
Eastman, Wellesley, 173 Abn Bde, CE, 1966–67
Eaton, Bruce, 11 ACR, CE, 1968–69
Effenberger, Frank, 175 AHC, P, 1970–71
Elderbaum, Russ, D Trp 1/1 Cav, 1969–70
Ellis, Tom, A Co 228 ASHB, P, 1968–70
Ellzey, Thomas, B Trp 2/17 Cav, P, 1970–71
Erickson, Jim, 539 TC, Maint, 1967–68
Escher, Doug, 21 Sig Gp, CE, 1969–70
Esposito, Frank, A Trp 2/17 Cav, P, 1970–71

Estes, Sam, HHC 1 Bde 1 Cav, DG, 1968–69
Evangelho, Daryl, 281 AHC, CE, 1969
Ewing, Edward, 128 AHC, P, 1968–69
Fairchild, Lee, 174 AHC, CE, 1970–71
Farrell, Kirk, 116 AHC, P, 1969–71
Faux, Tom, C Co 227 AHB, CE, 1967
Ferrara, John, 118 AHC, CE, 1969
Ferry, Frank, 339 TC, DG, 1964–65
Fields III, Joseph, A Co 82 Avn Bn/335 Avn Co, DG/CE, 1965–67
Floyd, Bob, 200 ASHC, Electrician, 1967–68
Foss, Kenny, E Co 709 Maint Bn, P, 1966–67
Franck, Eugene, A Co 158 AHB, P, 1969–70
Gachich, John 281, AHC, DG, 1968–69
Gallipeau, Charles, 498 Med Co, CE, 1968
Gannon, Terry, 1st Air TOW Det, P, 1972–73
Garcia, Juan, 116 AHC, CE, 1970–71
Gaylord, Bruce, 244 Avn Co, Aerial Observer, 1968
Gibbons, Will, A Trp 7/1 Cav, P, 1970–71
Gipson, Beck, A Co 4 Avn Bn, P, 1968–69
Gomes, Abe, 174 AHC, CE, 1970–71
Gooch, Rex, C Trp 3/17 Cav, P, 1971–72
Goodwin, Paul, 117 AHC, CE, 1971–72
Goolsby, Bobby, 192 AHC, P, 1970–71
Gordon, Wayne, 237 Med Det, MD, 1970–71
Grant, Cleveland, 1 Bde 1 Cav, CE, 1968–69
Graves, David, C Co 159 ASHB, FE, 1971
Gray, Randy, 11 ACR, P, 1969
Green, David, 68 AHC, CE, 1967–68
Greenhalgh, Bill, 162 AHC, P, 1968–69
Griffin, Bob, 13 Sig Corps, Army Photog, 1967–68
Grimm, Barry, 128 AHC, P, 1967
Gross, Fred, 8 TC, DG, 1963
Gross, Joe, 176 AHC, P, 1970
Guard, Michael, 135 AHC, CE, 1969–70
Gustin, Mike, D Trp 1/1, CE, 1970–71
Haddon, Ray, 174 AHC, DG, 1965–66
Hahn, Gordon, 191 AHC, CE, 1968–69
Hamlin, Ned, Army Concept Team, DG, 1967–68
Handel, Geoff, 188 AHC, P, 1967
Hannon, Ron, 254 Med Det, CE, 1966
Hansen, Chris, A Btry 4/77 ARA, P, 1970
Hansen, Dave, 237 Med Det, P, 1970–71
Hanson, Scott, 571 Med Det, MD, 1972
Harelson, Dave, 335 AHC, DG, 1970–71
Harmon, Dave, 92 AHC, DG, 1967–68
Harmon, Loren, 336 AHC, P, 1968–69
Harney, Tom, 190 AHC, P, 1970
Harrington, Bob, 92 AHC, P, 1967
Harris, Ed, 68 AHC, P, 1965–66
Hastie, Mike "Doc," 4 Inf Div, MD, 1970–71
Hatch, Larry, 15 Med Bn, P, 1966–67
Hawkins, George, C Trp 16 Cav, P, 1970–71
Haws, Curtis, 48 AHC, DG, 1970–71
Helms, Nat, 282 AHC, DG, 1968–69
Herndon, Robert, 92 AHC, CE, 1967–68

Herrera, Michael "Doc," 45 Med Co, MD, 1968
Hien, John, H Co 2/11 ACR, Tank Crew, 1967–68
Hodges, Don, C Trp 16 Cav, P, 1971–72
Hodgson, Jim, 120 AHC/59 CAC, P, 1972–73
Hogan, Jeremy, son of Jerry Hogan, B/1/9, DG, 1969–71
Hogan, Steve, A Co 123 Avn Bn, P, 1970–71
Holder, Rick, C Trp 7/1 Cav, P, 1970–71
Holt, John, D Co 229 AHB, CE, 1966
Honara, Michael, 128 AHC, P, 1971–72
Honl, Jim, S-1 Advisor, III Corps, 1968
Hosmer, Jack, C Trp 3/17 Cav, P, 1970–71
Hoza, John, 335 AHC, P, 1966
Huckleberry, Paula, B Btry 2/20 ARA, P, 1970–71
Hudak, Ron, 117 AHC, P, 1965–66
Hudspeth, Lew, 114 AHC, P, 1967–68
Hufford, Kent, 68 AHC, P, 1967–68
Hughes, Bill, 57 Med Det, CE, 1965
Hulbert, John, 18 CAC, CE, 1972–73
Humphreys, Jack, 273 Avn Co, FE, 1970–71
Hutson, Bill, 271 ASHC, FE, 1968
Iacobacci, Ed, 237 Med Det, MD, 1971–72
Jackson, Clarence, 17 AHC, CE, 1967–68
Jackson, Jack, of Lee-Jackson Militaria, San Jose, CA
Jackson, Thomas "Wayne," A Co 227 AHB, CE, 1969–70
Jacobs, Roy, 179 ASHC, CE, 1968–69
Jester, Jim, A Co 227 AHB, P, 1970–71
Jetter, Art, C Btry 2/20 ARA, P, 1970–71
Johnson, Jim, 116 AHC, CE, 1967–68
Jones, Anthony, 71 AHC, Opns, 1969–70
Jones, Dale, 4/47 Inf, 9 Inf Div, MD, 1968–69
Jones, Walker, C Trp 1/9 Cav, P, 1970–71
Jorgenson, Doug, A Co 229 AHB, P, 1971
Kammers, Tom, 121 AHC, CE, 1969–70
Keirsey, Dan, F Trp 4 Cav, P, 1972–73
Kelley, Mike, C Trp 1/9 Cav, CE, 1965–66
Ketcham, Jim, C Co 228 ASHB, FE, 1967–68
Khachadourian, Harry, 175 AHC, Tech Inspect, 1971–72
Kibbey, Doug, 2/17ACD+2/11 ACR, Scout/Tank Crew, 1971–72
Kilborn, David, 147 ASHC, CE, 1966–67
Kilpatrick, Bob, 119 AHC, CE, 1969
Klann, Michelle, niece of Martin Klann (KIA), 240 AHC, CE
Koenig, Dick, 175 AHC, P, 1967–68
Koonce, Bob, 150 TC, CE, 1964–65
Kopperude, Mike, 117 AHC, CE, 1971–72
Krothe, Trubee, 281 AHC, CE, 1967–68
Labriola, Mike, B Co 228 ASHB, FE, 1966–67
Lacher, Dale, 254 Med Det, MD, 1969–70
Lail, Donnie, A Co 4 Avn Bn, CE, 1970
Lambert, Morris, 92 AHC, CE, 1970–71
Lammers, Fred, 121 AHC, CE, 1967–68
Langolis, Lucien, A Co 101 Avn Bn, Maint, 1965–66

Law, Anthony, 175 AHC, Armorer, 1968
Lawler, John, 335 AHC, P, 1969–70
Layden, Jim, D Co 227 AHB, DG, 1967–68
Lehman, Phil, 155 AHC, P, 1967–68
Leirer, Richard, 170 AHC, Avionics, 1967–68
Lemons, Dennis, 117 AHC, P, 1970–71
Lemp, Ed, E Btry 82 Arty, CE, 1965–66
Lenning, Don, 114 AHC, DG, 1966–67
Lesemann, Milton, C Co 227 AHB, P, 1968–69
Lester, Richard, 48 AHC, P, 1970–71
Lipford, Ben, C Co 227 AHB, Maint, 1970–71
Livingston, Del, 82 Med Det, P, 1968–69
Lockhart, Ken, A Trp 1/9 Cav, CE, 1970–71
Lohman, Jim, 121 Avn Co, CE, 1964–65
Lokey, George, C Co 15 Trans Bn, Maint, 1967–68
Lund, Patrick, 165 TC, CE, 1970–71
Lundh, Lennart, author
Lundquist, Pat, 61/155 AHCs, Maint, 1970–71
Luttrell, James, 179 ASHC, CE, 1968–69
Lynn, Walter, B Co 123 Avn Bn, CE, 1969–71
Lyons, Ed, B Co 25 Avn Bn, DG, 1968–69
Maddock, John, C Co 159 ASHB, FE, 1969
Mahler, Godfrey, B Co 123 Avn Bn, DG, 1971–72
Mahoney, Jim, D Trp 1/1 Cav, P, 1969–70
Marcieski, Stan, 326 Med Bn, P, 1971
Markell, Dan, 271 ASHC, FE, 1968
Markovich, Craig, 271 ASHC, FE, 1969–70
Marriott, Eric, 179 ASHC, CE, 1970–71
Matheny, Pat, 118 AHC, CE, 1965–66
Mather, Don, C Btry 2/20 ARA, CE, 1970–71
Matusz, Joe, 68 AHC, Maint, 1967–68
Maxham, R. S., USAAM
McBride, Norman "Doc," D/5/7 Cav, MD, 1967
McCollum, Jim, 498/45 Med Co's, P, 1968–69
McCurry, Rick, 334 AHC, CE, 1967–68
McDaniel, Jim, 174 AHC, P, 1967–68
McFarland, Tom, COBRA NETT, P, 1970
McIntyre, Patrick, E Btry 82 Arty, DG/Avn Supply, 1968–69
McKee, Ed, 191 AHC, P, 1967–68
McKellar, Fred, 15 Med Bn, P, 1966–67
McMillan, Neil "Mac," C Btry 2/20 ARA, P, 1970–71
Meadows, Al, 155+48 AHCs, CE, 1970–71
Meeker, George, 189 AHC, CE, 1968–69
Melvin, Brad, D Troop 1/10 Cav, DG, 1969–70
Mendez, Ray, 198 LIB, Inf, 1970–71
Mercer, Eric, 187 AHC, P, 1967–68
Messenger, Tom, 179 ASHC, FE, 1970–71
Mikulski, Tom, D Trp 1/4 Cav, Avionics, 1968–70
Miller, George, 200 ASHC, P, 1967
Miller, Ivey, 175 AHC, CE, 1971–72
Miller, Mel, 147 ASHC, FE, 1969
Miller, Rick, C Trp 2/17 Cav, CE, 1970–71
Mills, Hugh, D/3/5+C/16 Cav, P, 1971–72/1972
Minda, George, B Trp 1/9 Cav, CE, 1970–71
Mirati, Al, 114 AHC, P, 1970–71

Mitchell, Roger "Woody," 192 AHC, P, 1969–71

Molish, Mick, HHC 1 ACD /180 ASHC, P,
 1968–69/71–72

Monroe, Greg, 187 AHC, DG, 1971–72

Moon, Terry, 1 Cav Div, PIO Photog, 1969

Moore, John, 571 Med Det, CE, 1970–71

Moore, Larry, B Trp 2/17 Cav, CE, 1969–70

Moore, Terry, A Co 227 AHB, CE, 1970–71

Morley, Cliff, C Co 228 ASHB, FE, 1968–69

Morley, Tom, 118 AHC, P, 1970

Morrison, Larry, 335 AHC, P, 1969

Mount, Gary, 129 AHC, CE, 1970–71

Muccianti, George, 80 Trans Det/121 Avn Co, Maint,
 1963–64

Mull, Chip, 195 AHC, P, 1969–70

Mumaw, Carl, F Trp 8 Cav, Maint, 1968–70

Munsell, David, 189 AHC, CE, 1968–69

Murtha, Paul, H/16+F/9 Cav, P, 1971–72

Myers, Richard, 173 AHC, CE, 1970–71

Nancarrow, Dave, 116 AHC, CE, 1968–69

Neal, Lawrence, 71 AHC/C Trp 1/9, CE,
 1968–70/1971

Nelson, Rob, A Trp 7/1 Cav, P, 1969–70

Nichols, Dave, 610 TC, DG, 1968

Nickel, Dave, A Trp 3/17 Cav, P, 1970–71

Noble, Jeff, B Co 9 Avn Bn, P, 1968–69

Norton, Dave, 118 AHC, CE, 1968–70

Noyes, Ralph, 68 AHC, CE, 1967–68

O'Brien, Mike, 45 Med Co, CE, 1969–70

O'Connell, Rick, C Trp 7/1 Cav, CE, 1970–71

Oden, James, 478 Avn Co, P, 1968–69

Oder, Dick, C Co 158 AHB, CE, 1971

Olesko, Peter, 135 AHC, CE, 1970–72

Ortolano, Alex, 57 Med Det, P, 1965

Paranal, Joe, A Co 227 AHB, CE, 1970–71

Parker, Dale, 174 AHC, CE, 1970–71

Parks, Dave, 15 Med Bn, CE, 1969–70

Parra, Frank, C Co 227 AHB, CE, 1968–69

Patrick, Rod, 184 RAC, P, 1966

Patton, George, via wife Joanne, 11 ACR, C.O.,
 1968–69

Paul, Jerry, 498 Med Co, CE, 1970–71

Penny, John, A Btry 3/77 Arty, P, 1971–72

Pender, Don, D Trp 1/10 Cav, P, 1971

Petersen, Roger, 175 AHC, CE, 1970–71

Peterson, Mike, C Trp 7/1 Cav, CE, 1968–69

Petty, Thomas, B/3/1 Americal Div, Inf, 1969

Phillipson, Charles, E Co 123 Avn Bn, Tech Supply,
 1970

Piazza, Pete, 498 Med Co, P, 1970–71

Pickett, Larry, 116 AHC, P, 1970–71

Platacis, Andrew, 68 AHC, Opns, 1965–66

Post, James, 17 AHC, P, 1967–68

Poston, Jamie, 68 AHC, CE, 1966–67

Powell, Bruce, D Trp 3/4 Cav, P, 1967–68

Powis, William, 11 ACR/ACAV Scouts, 1970–72

Pratt, Jim, B Trp 1/9 Cav, P, 1967–68

Pratt, Tom, 175 AHC, CE, 1969–70

Priddy, Don, 71 AHC, P, 1969–70

Pruett, Norm, 71 AHC, CE, 1970–71

Putnam, Tom, A Trp 7/1 Cav, P, 1971–72

Reasoner, John, A Co 158 AHB, P, 1969–70

Reeves, George, 335 TC, Maint, 1966–67

Reigel, Jay, 173 AHC, DG, 1968–69

Reinhart, Bill, 11 ACR, P, 1970–71

Renaud, Rick, 187 AHC, P, 1970–71

Reynolds, Dave, 178 ASHC, FE, 1970–71

Rhinehart, Mike, 283 Med Det, P, 1969

Rhodes, Allen, 237 Med Det, P, 1970

Roberts, Garry, 176 AHC, CE, 1970–71

Roberts, Tom, 254 Med Det, MD, 1970–71

Robie, William, 92 AHC, P, 1968–69

Robinson, John, D Trp 17 Cav, P, 1972–73

Robinson, Lloyd, 129 AHC, CE, 1969–70

Rochat, Lou, A/E Trp 1/9 Cav, P, 1970–71

Rock, Thomas, Mil Intell, Can Tho, 1968–70

Rogers, Peter, B Trp 3/17 Cav, P, 1969

Roscoe, Phil, 200 ASHC, FE, 1967–68

Roush, Gary, VHPA Database Chairman

Ryan, Gary, B Trp 2/17 Cav, P, 1970–71

Rzeminski, Pete, HHC 1 Bde, 101 Abn Div, P, 1968–69

Sabanosh, John, 45 Med Co, CE, 1969–70

Sanders, Ron, 170 AHC, CE, 1969–70

Sandrock, Don, 191 AHC, P, 1967–68

Sangl, Rudy, 281 AHC, P, 1970

Sartor, John, 129 AHC, CE, 1969–70

Scales, Ken, 117 AHC, CE, 1970–71

Scates, Lester, 336 AHC, P, 1968–69

Schlaudraff, Mike, A Co 227 AHB, CE, 1965–66

Schlim, Al, via son Joe Schlim, 15 Trans Bn, C.O., 1968

Schmidt, Gary, D Trp 3/4 Cav, CE, 1969–71

Schmied, John, 121 AHC, Maint, 1966–67

Schultze, Paul, B Btry 4/77 ARA, P, 1970–71

Scott, John, 175 AHC, DG, 1966–67

Scovel, Mike, A Co 227 AHB, Maint 1968–69

Seabolt, Ron, 71 AHC, CE, 1966–67

Seabourn, Joe, A Co 159 ASHB, FE, 1969–71

Seeger, Lawrence, 132 ASHC, P, 1970–71

Seelig, Russ, A Co 228 ASHB, FE, 1967–68

Seifert, Bill, 68 AHC, P, 1970

Senatore, Dale, 175 AHC, DG, 1967–68

Seney, Gary, C Trp 7/1 Cav, P, 1970–71

Senkowski, Glen, A Trp 1/9 Cav, P, 1969–70

Shakocius, Mike, 121 AHC, P, 1967–68

Shatto, Larry, 176 AHC, CE, 1969–70

Shemley, Larry, C Co 229 AHB, P, 1969–70

Sheridan, Jim, 355 Avn Co, FE, 1968–69

Shows, Jimmy, 15 Trans Bn, CE, 1966–68

Sikkema, Bruce, D Trp 3/4 Cav, P, 1969–71

Simcoe, Paul, 237 Med Det, MD, 1970–71

Simmons, Bill, B Trp 3/17 Cav, P, 1971–72

Simmons, Michael, B Co 4 Avn Bn, DG, 1967

Skarda, Joe, 116 AHC, DG, 1968–69
Smith, Dayne, C Trp 7/1 Cav, P, 1971–72
Smith, J. T., A Co 1 Bn 1 Inf, CE, 1965–66
Smith, Jack, 121 AHC, DG, 1967–69
Smith, Larry, 147 ASHC, FE, 1968–69
Smith, Larry, A Co 158 AHB, P, 1969–70
Smith, Robert, 335 AHC, DG, 1969–70
Souza, Louis, 335 AHC, CE, 1969–70
Spears, Jon, 121 Avn Co, CE, 1963–64
Speer, Stephen, 361 AWC, P, 1971–72
Spiers, Jim, 175 AHC, P, 1968–69
Stanis, John, 114 AHC, CE, 1970–71
Stedman, Craig, 595 Signal Co, Commo Repair, 1969
Stiles, Howard, 335 AHC, C. O., 1969
Stitt, Harold, 191 AHC, P, 1967–68
Stoehr, Bruce, 162 AHC, P, 1967–68
Stogner, Grady, 398 Trans Det/11 ACR, Maint,
 1968–69
Stowell, Keith, 187 AHC, DG, 1967–68
Studer, Mike, 243 ASHC, DG, 1968–69
Sullivan, George, 187 AHC, Tech Rep Lycoming,
 1969–70
Swain, Robert, A Trp 1/9 Cav, P, 1966–67
Tabor, Rick, 335 AHC, CE, 1969–70
Taglauer, Richard, A Btry 4/77 ARA, Maint, 1970–71
Talley, Bill, 498/45 Med Co's, CE, 1967–68/1970–71
Tarnovsky, Joe, 240 AHC, CE, 1969–70
Tartar, Mike, A Co 227 AHB, DG, 1969
Taylor, Ron, 71 AHC, CE, 1970–71
Taylor, Tom, B Co 159 ASHB, FE, 1970
Telfair, Dan, 68 Avn Co, P, 1965–66
Tepper, Art, 610 TC, TI, 1968–70
Terry, Don, 57 AHC, CE, 1971
Terry, Wayne, 135 AHC, DG, 1969–70
Thacker, Greg, C Trp 16 Cav, CE, 1972–73
Thayer, Ed, 175 AHC, DG, 1966–67
Thomas, Craig, 229 AHB Flight Surgeon, 1969–70
Thomas, Rick, 121 AHC, P, 1968
Thompson, Fred, 174 AHC, P, 1970–71
Thrift, John, 240 AHC, CE, 1967–68
Tobias, P. J., son of Don Wyrosdick, A Co 227 AHB,
 CE, 1970–71
Tollefsen, Kjell, 188 AHC, P, 1967–68
Tonjes, Craig, A Co 227 AHB, CE, 1970–71
Topping, Mike, 48 AHC, CE, 1971–72
Towle, Jim, 174 AHC, P, 1968–69
Tracey, Johnson, 128 AHC, CE, 1971
Tucker, Bill, D Trp 1/1 Cav, DG, 1970–71
Tucker, Tom, 92 AHC, CE, 1967–68
Tunnell, Roger, 121 AHC, P, 1969–70
Turner, Denny, 92 AHC, P, 1968–69
Turner, Jerry, A Co 101 Avn Bn, P, 1965–66
Tyler, Dan, C Co 229 AHB, P, 1970–71

U.S. Army Aviation Museum
Van Dine, Howard, C Co 159 ASHB, P, 1969
Vanatta, Frank, 1 Bde 1 Cav, P, 1967–68
Vick, Jack, C Trp 16 Cav, CE, 1970–71
Vierra, Damien, 15 Med Bn, CE, 1970–71
Vietnam Helicopter Crew Members Association
Vietnam Helicopter Flight Crew Network
Vietnam Helicopter Pilots Association
Vogt, Tom, 11 ACR, CE, 1968
Wagner, Dawn, daughter of Ray Rupcic (KIA), Pilot
Walker, Ed, HHT 7/1 Cav, P, 1967–69
Walker, Joe, 188 AHC, P, 1967–68
Walton, Bill, D Co 229 AHB, CE, 1970–71
Ward, Jay, B Troop 3/17 Cav, P, 1970–72
Warner, Ken, 571 Med Det, P, 1971–72
Weber, Bill, B Co 229 AHB, CE, 1965–66
Weddle, Carl, 162 AHC, CE, 1967–68
Welsh, Bob, 61 AHC, CE, 1969–71
White, John, 57 AHC, P, 1968–69
Whiteley, Dave, B Co 101 AHB, CE, 1970–71
Whitney, Bruce, 192 AHC, P, 1970–71
Wilhite, Ray, USAAM
Williams, Don, 191 AHC, P, 1967–68
Williams, Dwayne, 175 AHC, P, 1966–67
Willis, Randy, A Trp 7/1 Cav, P, 1969–70
Wilson, Doug, A Co 502 Avn Bn/114+175 AHC/326
 MB, CE, 1965–71
Wilton, Mike, 173 AHC, P, 1966–67
Windsand, Doug, 187 AHC/602 TC, Maint, 1970
Winge, Larry, A Co 227 AHB, CE, 1966–67
Wingrove, James, 135 AHC, CE, 1971
Wisell, George, 335 AHC, P, 1968–69
Wizard, Brian, 118 AHC, DG, 1968–69
Wolak, Steve, 178 ASHC, FE, 1970–71
Wolf, Bill, 129 AHC, CE, 1969–70
Wolk, Richie, 173 AHC, CE, 1968–69
Wood, Dennis, 117 Avn Co, CE, 1965–66
Woodring, Charles, 247 Med Det, MD, 1970–71
Woodworth, Scott, 167 TC/336 AHC, CE, 1968–69
Woolley, Bill, 57 AHC, CE, 1969–70
Workman, James, 150 TC, Maint, 1964–65
Wright, Grover, C Trp 1/9 Cav, P, 1969–70
Wyrosdick, Don, A Co 227 AHB, CE, 1970–71
Yee, Brian, 92 AHC, CE, 1968–69
Yeltsen, Mike, 189 AHC, DG, 1968
Young, Jerry, 498 Med Co, CE, 1968
Young, Ralph, author
Ytsen, Mike, 92 AHC, DG, 1969
Zanfardino, Tony, 173 AHC, CE, 1966–67
Ziemba, Rick, 45 Med Co, P, 1970
Zierdt, Bill, C Trp 2/17 Cav, C.O., 1969–70
Zipperer, Carl, 176 AHC, P, 1970–71